PENGUIN BOOKS

Bernini

`F S(

The son of B. H. Hibbard (1870–19⁵⁵) a pione⁻ ⁻ ᵃᵍʳⁱᶜul-
tural economist, Howard Hibbard was descei
Robert Hibbard of Salisbury, who emigrated to Salem, Mas-
sachusetts, in 1630. He was best known for his books on
great artists, such as *Bernini* (Pelican 1965) and *Michelangelo*
(Pelican 1978), but he also published many scholarly works
and articles, ranging from *Carlo Maderno and Roman Archi-
tecture, 1580–1630* (1972) to *Poussin: The Holy Family on the
Steps* (Art in Context, 1974). His later books include *The
Metropolitan Museum of Art* (1980) and *Caravaggio* (1⸏ ̄3).

Howard Hibbard taught at Columbia Universit ̄
1959 and was Chairman of the Department of Art History
and Archaeology from 1978 to 1981. He was Editor-in-Chief
of *The Art Bulletin* (1974–8), Slade Professor of Fine Art at
Oxford (1976–7), and was a Fellow of the American
Academy in Rome and of the American Academy of Arts and
Sciences. Howard Hibbard died in October 1984. He was
married with three daughters.

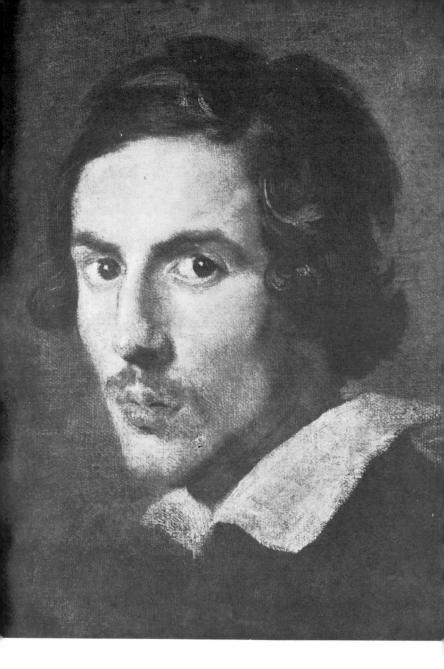

Self-Portrait, 1620s. Galleria Borghese

Howard Hibbard

Bernini

Penguin Books

PENGUIN BOOKS

Published by the Penguin Group
Penguin Books Ltd, 27 Wrights Lane, London w8 5TZ, England
Penguin Putnam Inc., 375 Hudson Street, New York, New York 10014, USA
Penguin Books Australia Ltd, Ringwood, Victoria, Australia
Penguin Books Canada Ltd, 10 Alcorn Avenue, Toronto, Ontario, Canada M4V 3B2
Penguin Books (NZ) Ltd, 182–190 Wairau Road, Auckland 10, New Zealand

Penguin Books Ltd, Registered Offices: Harmondsworth, Middlesex, England

First published in Pelican Books 1965
Reprinted in Penguin Books 1990
10 9 8

Printed in Singapore by Kyodo Printing Co. Ltd
Typeset in Monotype Plantin

TO MY MOTHER

Contents

LIST OF PLATES, 9

LIST OF TEXT FIGURES, 15

FOREWORD, 17

Introduction, 19
1 The Prodigy, 23
2 Bernini in Command, 68
3 Disaster and Triumph, 116
4 Two Churches and St Peter's, 142
5 Le Cavalier en France, 168
6 The Late Works, 185

BIBLIOGRAPHICAL NOTE, 231

NOTES TO THE TEXT, 233

INDEX, 247

List of Plates

Unless otherwise specified, works are in Rome and by Bernini and works of sculpture (except *bozzetti*) are of marble.

GFN = Gabinetto Fotografico Nazionale

The cover shows *The Ecstasy of St Teresa* (see plate 71) and *Self-Portrait* (plate 91)

FRONTISPIECE

Self-Portrait Oil on canvas. 1620s. Galleria Borghese (Anderson)

CHAPTER I *The Prodigy*

1 frontis: *Pope Paul V. c.* 1618. Galleria Borghese (Anderson)
2 *The Goat Amalthea with the Infant Jupiter and a Faun.* 1609? Galleria Borghese (Anderson)
3 *Martyrdom of St Lawrence. c.* 1614–15. Florence, Contini Bonacossi Collection (GFN)
4 *Martyrdom of St Sebastian. c.* 1615–16. Lugano, Thyssen Bornemisza Collection (Alinari)
5 *Bishop Giovanni Battista Santori. c.* 1610? Santa Prassede (Renzetti)
6 *'Anima Dannata'. c.* 1619. Palazzo di Spagna (Renzetti)
7 Michelangelo da Caravaggio, *Boy Bitten by a Lizard* (detail). Oil on canvas. *c.* 1596. Florence, Roberto Longhi Collection (Alinari)
8 *Aeneas, Anchises, and Ascanius Fleeing Troy.* 1619. Galleria Borghese (Anderson)
9 Raphael, *Fire in the Borgo* (detail). Fresco. *c.* 1516. Vatican City, Stanza dell'Incendio (Anderson)
10 Detail of plate 8. Aeneas and Anchises (GFN)
11 Detail of plate 8. Ascanius (GFN)
12 Detail of plate 13. *Neptune and Triton* (Museum photo)

13 *Neptune and Triton. c.* 1620. London, Victoria and Albert Museum (Museum photo)

14 View of the *Neptune* and pond in the Villa Montalto in the later seventeenth century, engraved by Francesco Venturini (G. B. Falda, *Le fontane di Roma*, III, pl. 17)

15 *Neptune and Triton* (Museum photo)

16 *Pluto and Persephone.* 1621–2. Galleria Borghese (GFN)

17 Giovanni Bologna, *The Rape of a Sabine Woman.* 1579–83. Florence, Loggia dei Lanzi (Alinari)

18 Detail of plate 16 (GFN)

19 Detail of plate 16 (Marker)

20 *Apollo and Daphne.* 1622–5. Galleria Borghese (Anderson)

21 Detail of plate 20 (Marker)

22 Detail of plate 20 (Marker)

23 'Leochares', *Apollo Belvedere* (Roman copy of a Greek bronze of the fourth century B.C.). Vatican Museum (Alinari)

24 *David.* 1623–4. Galleria Borghese (Rudolf Wittkower)

25 Michelangelo Buonarroti, *David.* 1502–4. Florence, Galleria dell'Accademia (Alinari)

26 Detail of plate 24 (Anderson)

27 Detail of plate 24 (Marker)

28 Annibale Carracci, *Polyphemus Attacking Acis and Galatea.* Fresco. *c.* 1600. Palazzo Farnese, Galleria (GFN)

29 *Monsignor Pedro de Foix Montoya.* 1622. Monastery of Santa Maria di Monserrato (Renzetti)

30 Camillo Mariani (?), *Fabio de Amicis.* Santa Maria sopra Minerva (GFN)

CHAPTER 2 *Bernini in Command*

31 frontis: *Urban VIII* (detail). *c.* 1637–8. Heirs of Prince Enrico Barberini (GFN)

32 Santa Bibiana, façade. 1624–6 (GFN)

33 *Santa Bibiana.* 1624–6. Santa Bibiana (Anderson)

34 Detail of plate 33 (Anderson)

35 Guido Reni, *Massacre of the Innocents* (detail). Oil on canvas. 1611. Bologna, Pinacoteca (Anderson)

36 Baldacchino. Gilt bronze. 1624–33. St Peter's (Anderson)

37 Ciborium. 1614–15. Sant'Agnese fuori le mura. (Archivio Fotografico Vaticano)

38 St Peter's, crossing with baldacchino, *St Helena* by Andrea Bolgi, and *St Longinus* by Bernini

39 *St Longinus*. 1629–38. St Peter's (Alinari)

40 *Bozzetto* for *Longinus*. Fogg Art Museum, Harvard University (Museum photo)

41 Detail of plate 39 (Sansaini)

42 Francesco Mochi, *St Veronica*. 1629–40. St Peter's (Anderson)

43 Michelangelo Buonarroti, unfinished '*Slave*' for Tomb of Julius II. *c.* 1519(?) Florence, Galleria dell'Accademia (Alinari)

44 *Monsignor Francesco Barberini. c.* 1623. Washington, National Gallery (Museum photo)

45 *Cardinal Scipione Borghese.* 1632. Galleria Borghese (Anderson)

46 *Cardinal Scipione Borghese.* Red and black chalk on paper. New York, Pierpont Morgan Library (Library photo)

47 Domenichino, '*Sibyl*' (detail). Oil on canvas. 1618. Galleria Borghese (Anderson)

48 Detail of plate 45 (Vasari)

49 *Thomas Baker* (detail). *c.* 1638. London, Victoria and Albert Museum (Museum photo)

50 *Paolo Giordano Orsini* (detail). *c.* 1635 (?). Bracciano, Castello (GFN)

51 Caricature of a cardinal ('Scipione Borghese'). Quill pen on paper. Bibl. Vat., *cod. Chig*. P. VI 4 (Library photo)

52 Tomb of Countess Matilda of Tuscany. 1633–7. St Peter's (Alinari)

53 *Costanza Bonarelli. c.* 1635. Florence, Bargello (GFN)

54 Detail of plate 53 (GFN)

55 Tomb of Urban VIII. Marble and gilt bronze. 1628–47. St Peter's (Anderson)

56 Guglielmo della Porta, Tomb of Paul III Farnese. Marble and bronze. 1549–75, with changes made under Urban VIII. St Peter's (Anderson)

57 Alessandro Algardi, Tomb of Leo XI Medici. 1634–52. St Peter's (Anderson)

58 Tomb of Maria Raggi. Marble and gilt bronze. *c.* 1648. Santa Maria sopra Minerva (GFN)

59 Detail of plate 58 (GFN)

60 Triton fountain. 1642–3. Piazza Barberini (in distance, to the right of Triton, Api fountain, 1644). (Anderson)

61 Detail of plate 60 (Alinari)

CHAPTER 3 *Disaster and Triumph*

62 frontis: *Innocent X. c.* 1647. Galleria Doria-Pamphilj (GFN)

63 Four Rivers Fountain. Travertine; marble figures; granite Egyptian obelisk. 1648–51. Piazza Navona (GFN)

64 Detail of plate 63 (Alinari)

65 Detail of plate 63 (Marker)

66 Moro Fountain (detail), executed by G. A. Mari. 1653–5. Piazza Navona (Anderson)

67 Alessandro Algardi, *Innocent X. c.* 1646. Palazzo Doria-Pamphilj (Anderson)

68 *Francesco I d'Este, Duke of Modena.* 1650–1. Modena, Galleria Estense (Alinari)

69 Cornaro Chapel, Santa Maria della Vittoria (from an anon. eighteenth-century painting in Schwerin). (Museum photo)

70 Cornaro Chapel, Santa Maria della Vittoria. Detail of Cornaro Cardinals (Anderson)

71 Cornaro Chapel, Santa Maria della Vittoria, *The Ecstasy of St Teresa.* 1645–52. (Renzetti)

72 Detail of plate 71 (Alinari)

73 Giovanni Lanfranco, *The Ecstasy of St Margaret of Cortona.* Oil on canvas. *c.* 1620 (?). Florence, Galleria Pitti (GFN)

74 Detail of plate 71 (Alinari)

CHAPTER 4 *Two Churches and St Peter's*

75 frontis: *Alexander VII. Bozzetto* for figure on tomb (plate 118). 1669–70. London, Victoria and Albert Museum (Museum photo)

76 Sant'Andrea al Quirinale, façade. 1658–70. (Anderson)

77 Sant'Andrea al Quirinale, interior (Oscar Savio)

78 Ariccia, Santa Maria dell' Assunzione, façade. 1662–4. (Renzetti)

79 Ariccia, Santa Maria dell' Assunzione, interior (Renzetti)

80 Piazza before St Peter's. 1656–67. (Time Inc.)

81 St Peter's and the Vatican. Air view with Bernini's piazza (Alinari)

82 Piazza looking toward Palazzo Vaticano (Alinari)

83 Cathedra Petri, 1657–66. Marble, gilt stucco, gilt bronze. St Peter's (Alinari)

84 Drawing of Cathedra seen through Baldacchino. Bibl. Vat. *cod. Chig.* a. I 19 (Library photo)

85 Scala Regia, Vatican (at far right, *Constantine*). 1663–6 (Alinari)

86 *Constantine*. 1654–70. Vatican, Scala Regia (Sansaini)

CHAPTER 5 *Le Cavalier en France*

87 frontis: *Louis XIV*. 1665. Versailles, Château (Alinari)

88 Louvre façade project, first stage. Pen on paper. 1664. London, Sir Anthony Blunt Collection (Courtauld Institute photo)

89 Second project for Louvre façade. Pencil on paper. 1665. Stockholm Museum (Museum photo)

90 Palazzo Chigi-Odescalchi as built in 1664, engraved by Alessandro Specchi

CHAPTER 6 *The Late Works*

91 frontis: *Self-Portrait. c.* 1665. Black chalk heightened with white. Windsor Castle (Official photo)

92 *Truth*. 1646–52. Galleria Borghese (GFN)

93 *Daniel*. 1655–7. Santa Maria del Popolo, Chigi Chapel (Anderson)

94 *Habakkuk and the Angel*. 1655–61. Santa Maria del Popolo, Chigi Chapel (Anderson)

95 Detail of plate 94 (GFN)

96 Agesandros, Polydoros, and Athenodoros of Rhodes, *Laocoön* (detail). *c.* 150–100 B.C. Vatican Museums (Anderson)

97 Drawing after *Laocoön*. Red chalk heightened with white. Leipzig, City Library (from Brauer-Wittkower, pl. 42)

98 Drawing for *Daniel*. Red chalk. Leipzig, City Library (from Brauer-Wittkower, pl. 44)

99 Drawing for *Daniel*. Red chalk. Leipzig, City Library (from Brauer-Wittkower, pl. 45)

100 *St Mary Magdalen*. 1661–3. Siena, Cathedral, Chigi Chapel (Anderson)

101 *St Jerome*. 1661–3. Siena, Cathedral, Chigi Chapel (Anderson)

102 Cathedra (detail of plate 83). (Anderson)

103 Cathedra (detail of plate 83). (Alinari)

104 Ponte Sant'Angelo (the ancient Pons Aelius, A.D. 136) and the Castel Sant'Angelo (Hadrian's tomb, A.D. 135–9, with later additions), *St Peter* by Lorenzetto (set up 1530), *Angels*, 1667–71 (Anderson)

105 *Angel with the Crown of Thorns*. 1668–9. Sant'Andrea delle Fratte (Anderson)

106 *Angel with the Superscription 'I.N.R.I.'*. 1668–9. Sant' Andrea delle Fratte (Anderson)

107 108 *Bozzetti* for *Angel with the Crown*. Fogg Art Museum, Harvard University (Museum photo)

109 *Angel with the Superscription 'I.N.R.I.'* (in part by Giulio Cartari). 1670–1. Ponte Sant'Angelo (Renzetti)

110 Antonio Raggi, *Angel with the Column*. 1668–9. Ponte Sant'Angelo

111 Altar and ciborium, Cappella del SS. Sacramento, St Peter's. Marble, gilt bronze, lapis lazuli. 1673–4 (Alinari)

112 Follower of Jacopo Tatti Sansovino, tomb of Cardinal Quignone (detail). *c.* 1536. Santa Croce in Gerusalemme (GFN).

113 *Bozzetto* for *Angel* in Cappella del SS. Sacramento. Fogg Art Museum, Harvard University (Museum photo)

114 *Constantine* (detail of plate 86)

115 *Bozzetto* for equestrian *Louis XIV*. *c.* 1670. Galleria Borghese (Anderson)

116 Drawing for equestrian *Louis XIV*. Pen and wash on paper mounted on canvas. *c.* 1673. Bassano, Museo Civico (GFN)

117 Elephant carrying obelisk (executed by Ercole Ferrata). 1666–7. Piazza Santa Maria sopra Minerva (Renzetti)

118 Tomb of Alexander VII. 1671–8. St Peter's (Sansaini)

119 *Gabriele Fonseca*. 1668–75 (?). San Lorenzo in Lucina, Fonseca Chapel (Renzetti)

120 Fonseca Chapel, San Lorenzo in Lucina. Begun 1663–4 (bust of Fonseca is at left, to the right of door within Chapel, at left); *Annunciation* by Lodovico Gimignani after Guido Reni (Renzetti)

121 Altieri Chapel, San Francesco a Ripa. 1674 (Renzetti)

122 *Death of the Blessed Ludovica Albertoni* (detail of plate 121), *Holy Family*, oil on canvas, by G. B. Gaulli, *c.* 1665 (Renzetti)

123 124 Details of plate 122 (Anderson)

125 Detail of plate 71, *The Ecstasy of St Teresa* (Anderson)

126 Stefano Maderno, *Santa Cecilia*. 1600. Santa Cecilia in Trastevere (Archivio Fotografico Vaticano)

127 Francesco Aprile, *Sant'Anastasia* (finished by Ercole Ferrata). 1685. Sant'Anastasia (Alinari)

Note: the photographs by Benedetto Renzetti, Chris Marker, Sansaini and Vasari were taken especially for this book

List of Figures

1 Rome, Villa Borghese
Plan of room
showing original position
of *Apollo and Daphne*, 54

2 Rome, Cornaro Chapel,
Santa Maria della Vittoria
Plan, 134

3 Rome, Sant'Andrea al Quirinale
Plan, 144

4 Ariccia, Santa Maria del-
l'Assunzione
Plan, 148

5 Vatican, Scala Regia
Plan and Elevation, 163

Foreword

In the following pages I have tried to present Bernini's sculpture in an organic, which is to say chronological, order. This method has drawbacks with so fertile an artist and to avoid them as much as possible I have omitted doubtful, minor, or otherwise second-ary works. Even so, the flood became unmanageable and I have therefore grouped similar pieces done in the same span of years and referred back to sculptures of the same genre done earlier. My hope was to give some idea of the growth and development of Bernini's artistic vision. In order to do this it was impossible to confine the text to a discussion of sculpture alone, although I was asked to write specifically about that aspect of Bernini's work. There is a vital connexion between Bernini's sculpture and his architecture. I have not approached the buildings as' an archi-tectural historian, but rather tried to show how Bernini's archi-tecture arises out of his novel approach to artistic problems. His other activities – painting, decorative works in perishable materi-als, theatrical career and plays – are mentioned only in passing. They are of great interest but they are not the main stream.

My primary aim has been to diffuse known information rather than to break new ground, and like every writer on Bernini I owe a major debt of gratitude to Rudolf Wittkower, whose publications, listed in the bibliography and notes, are especially recommended. I am also grateful to the kind friends who tried to prune and weed my text: Ann Freeman, Irving Lavin, and in particular Milton Lewine, who left his mark on every page. Heinrich Thelen taught me much about Bernini as well as Borromini. My greatest debt is to my wife, whose enthusiasm for Bernini first stimulated my own.

HOWARD HIBBARD

Introduction

Bernini was one of those rare prodigies who continued to grow in artistic stature after he reached maturity. Like Mozart a century and a half later, he added the highest degree of intelligence and profound emotional insight to innate virtuosity. It is this seemingly easy, but inimitable, combination that set these men apart from the other artists of their times.* More than one contemporary thought Bernini was not merely the greatest artist of the century but the greatest man. Pope Alexander VII said that Bernini would have excelled in any kind of endeavour, and in fact Bernini was not only the great sculptor of the seventeenth century, but also an architect, painter, playwright, and stage designer. John Evelyn wrote in his *Diary* that 'Bernini . . . gave a public opera wherein he painted the scenes, cut the statues, invented the engines, composed the music, writ the comedy, and built the theatre'. Bernini was the last of the dazzling universal geniuses who had made Italy the artistic and intellectual centre of Europe for more than three hundred years.

Modern histories of seventeenth-century culture do not give Bernini so outstanding a role as these statements imply. Not only is he not the protagonist, he barely gets on stage. If, as Basil Willey has asserted,* the main intellectual problem of the seventeenth century was the separation of the 'true' from the 'false', Bernini cannot be claimed to have played even a part in the intellectual history of his age. Looking back, we seek the men whose thought was important for the development of our culture – we are today largely interested in those few and sometimes obscure philosophers and scientists who prepared the way for eighteenth-century rationalism and modern science. So seventeenth-century

background becomes twentieth-century foreground. This point of view is, however, utterly different from that of the seventeenth century; Bernini's contemporaries found him outstanding because he so obviously fulfilled the creative ideals of their time. Unlike Leonardo da Vinci and Michelangelo, the Italian artists to whom he is most readily compared, Bernini was a completely realized person perfectly in step with his time. This clearly separates him from many other creative personalities and actually limits his appeal. Bernini's unhesitating acceptance of the *status quo* is probably the most striking difference between him and his predecessors, the more obviously complex men of the Renaissance The Counter-Reformation seems to have siphoned off those doubts and speculations that had made sixteenth-century thinkers so individual. 'Better a poor Catholic than a good heretic' Bernini once remarked (he was referring to Borromini's architecture) and he shared this attitude with another astoundingly successful Baroque artist, Peter Paul Rubens (1577–1640), the only contemporary with whom Bernini can be compared. Both men unquestioningly accepted the current philosophies and theologies of absolute church and state; neither was a speculative thinker.

We may admit that Italian art of the seventeenth and eighteenth centuries is a glorious sunset – certainly it is not a dawn. And yet most of the visual art of high quality that was produced in Europe still came from the old, Renaissance-cradling Catholic countries, and chiefly from Italy. Baroque art is primarily – almost by definition – Catholic and absolutist rather than Protestant, rational, or democratic, although it has some common ground with the contemporary arts of the Protestant countries, which were and still are typically verbal rather than visual. However, after 1600 a kind of international style of painting had come into existence, a style influenced by Italy that grew strongly and independently in many places. Alongside Caravaggio, Annibale Carracci, Guido Reni, Poussin, Claude, and Pietro da Cortona in Rome must be mentioned the Flemish painters Rubens and Van Dyck, whose art was chiefly indebted to Italian inspiration. And apart from these Italianate artists, Velázquez in Spain and Rembrandt in Holland created individual styles of genius with less debt to Italy. But if

painting was flowering all over Western Europe, there were no sculptors or architects comparable to Bernini and his Roman contemporaries.

Bernini was the great exponent of triumphant Catholicism in the period following the Catholic Counter-Reformation. His personal qualities made him a favourite and leader: he served eight popes, several monarchs, and uncounted cardinals and princes with almost uninterrupted success. His capacity for work matched his virtuosity; when even he could not keep up with the commissions, his executive abilities so transformed the lesser talents of his students and assistants that work from his shop often bears the unmistakable stamp of his genius.

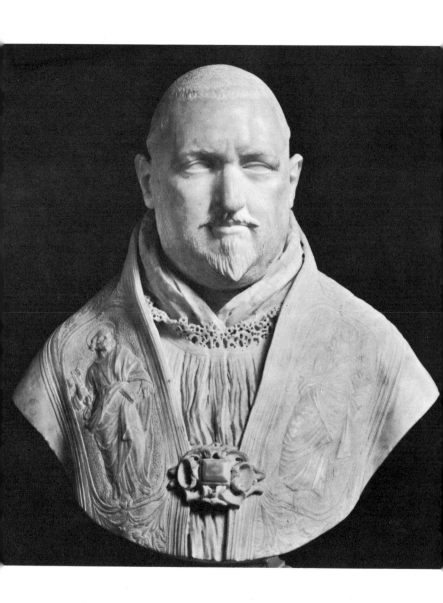

1 *Pope Paul V. c.* 1618. Galleria Borghese

1. The Prodigy

Gian Lorenzo Bernini was born in Naples on 7 December 1598. His father Pietro* (1562–1629) was a Florentine sculptor of some talent who, like others of his city, was attracted to the court of Naples in the last decades of the sixteenth century. In Naples he produced works that are now almost forgotten and married a local girl, Angelica Galante. So Bernini's origins were humble, his birth inauspicious. His fortune was determined by his father's move to Rome in 1605 or 1606. In 1605 a young and ambitious Cardinal, Camillo Borghese, assumed the papal throne as Paul V. During the sixteen years of his papacy he completed the church of St Peter's, enlarged the papal palace on the Quirinal, and enriched Rome with churches, palaces, and fountains. His most cherished project was the erection of a magnificent funeral chapel, the Cappella Paolina, in the church of Santa Maria Maggiore. Pietro Bernini first appears on the papal payroll as a decorator in this chapel and it was probably this task that called him to Rome. Had he not produced a famous son we would hardly pay attention to Pietro Bernini's works today; he was a typical craftsman of the period, trained in a late version of that elegant but sometimes superficial style that has come to be called Mannerist. A facile workman, his reputation was good because the competition was poor. Before going to Naples Pietro had studied in Rome; a much later source tells us that he was also a painter, and had great renown.

Pietro is interesting to us as the teacher of his son. All of our sources agree that the boy was a prodigy, perhaps one of the outstanding artistic prodigies of all time. His first biographer, the Florentine Filippo Baldinucci, speaks of a little marble head of a boy done when Bernini was eight. Baldinucci and Bernini's son

Domenico both date surviving works from his tenth year. Domenico quotes the painter Annibale Carracci, who died in 1609, as saying that Bernini had arrived in his childhood where others might glory to be in old age; this must be exaggeration, but Annibale does seem to have known the child. Bernini himself is responsible for much of what is overstated in the story; with advancing age he forgot just when some of his earlier works had been done, and so the legend of his precocity grew. The anecdotes, even when false, have a poetic truth. From the beginning Bernini showed signs of genius. 'He had as a gift what others acquire by sweat.' Pietro, at the beginning, was an ideal guide: the mediocre artist was an admirable father and a fine teacher. What he personally had to teach – an almost legendary facility in cutting marble without prior planning – the boy soon learned. Bernini later told the

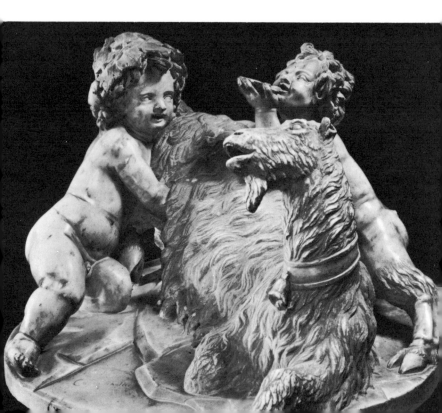

story of a meeting between his great friend Cardinal Barberini and Pietro when Bernini was only eight. The Cardinal said, 'Watch out, he will surpass his master', but Pietro replied, 'It doesn't bother me, for as you know, in that case the loser wins'. Domenico Bernini says that the boy soon abandoned his childish pastimes and worked so long and so late that his father finally had to intervene.

For three years Bernini supposedly spent every day in the Vatican, sketching ancient marbles and modern paintings. His father constantly pricked him on to greater things, always encouraging, never satisfied. We know that Bernini's sculptural taste was formed by the late antique works in the Vatican: the *Laocoön, Apollo Belvedere*, '*Antinous*',* and the Hellenistic torsos thought to be of Hercules [23; 96]. These must have been his principal teachers; he was his father's son, a sculptor from the start. But he also drew from the paintings of Raphael, Michelangelo, and Giulio Romano. He studied the figures with special care and 'made so many sketches you wouldn't believe it' according to his son Domenico, who inherited the evidence. Bernini particularly studied the grand tradition of *disegno*: the delineation of noble figures in poise and equilibrium seen at its height in Raphael's Vatican *stanze* [cf. 9]. These High Renaissance paintings introduced him to a developed style of harmonious grouping not found in Hellenistic sculpture. Bernini studied the expressive, powerful works of late antiquity for their own sake, but he also saw them through the eyes of Raphael and Michelangelo: unclassic antiquity and Renaissance classicism were his models.

Bernini seems to have been uniquely precocious; he may have had a commission from the papal family while still a child, since *The Goat Amalthea with the Infant Jupiter and a Faun* * may have been carved in 1609 [2]. Pietro's continuous employment by the Pope and his nephew, Cardinal Scipione Borghese, explains Gian Lorenzo's early entry into the circle of Borghese patronage. The young Bernini, like Michelangelo, established his claim to artistic importance by rivalling antiquity; the *Amalthea* was long mistaken for an ancient work, although we do not know whether it was carved as a deliberate forgery. Its owner, Cardinal Borghese, was

2 *The Goat Amalthea with the Infant Jupiter and a Faun.* 1609? Galleria Borghese

the greatest collector of antiquities of his time; what may be the earliest surviving sculpture from Bernini's hand has the realistic surface quality usually associated with Hellenistic carving. The subject, from Vergil, is thus illustrated in a manner appropriate in style and iconography – an early example of the decorum or suitability that was an important artistic goal throughout the century. The late-antique realism of this work alone would assure us that Bernini had studied Hellenistic sculpture with care. Domenico Bernini tells us that in addition to the works in the

Vatican his father went to school to Scipione's collection: the so-called *Seneca* in the bath, a work of uncompromising realism; the *Venus and Cupid* long attributed to Praxiteles; the *Warrior* by Agasios of Ephesus; and the *Hermaphrodite* (for which Bernini carved a highly realistic marble cushion) were special objects of his study.

3 *Martyrdom of St Lawrence.* c. 1614–15

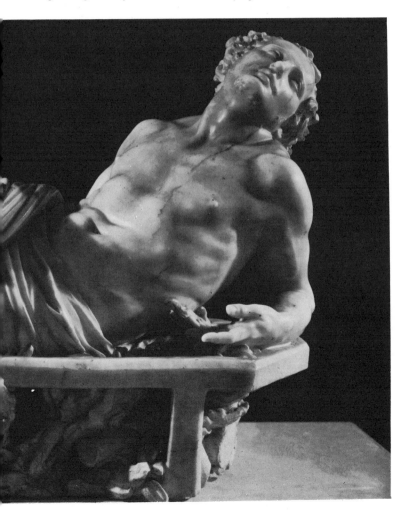

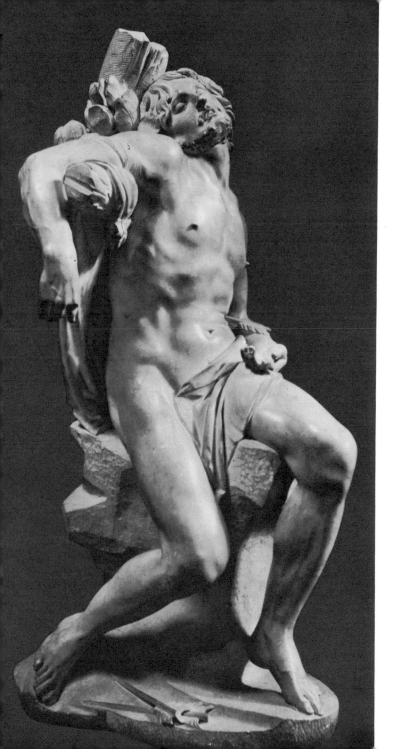

At about the same time – Baldinucci says he was fifteen – Bernini carved a figure of his name saint, Lawrence, martyred on the flames [3]. In style the work seems later than the *Amalthea*. The realistic marble flames are an early indication of Bernini's constant attempts at enlarging the realism of his art by rivalling painting. The saint looks upward, demonstrating the triumph of believing spirit over tortured flesh. Nevertheless, Domenico tells us that Bernini put his own leg into the fire in order to observe the expression on his agonized face. Whether or not this is true, it would have been typical of the young Bernini, who practised similar stunts on other occasions for the sake of truthful expression. The highly polished surface of the *St Lawrence* reveals carefully observed anatomy and a pose that probably derives from statues of wounded or dying warriors of antiquity. A closely related work, a martyred *St Sebastian*, shows a similar but more advanced style [4]. In pose, surface, and treatment of the hair it again relates to Hellenistic models. Although vertical, the *Sebastian* has a similar twisted pose to the *Lawrence*; almost all the changes were made in the interest of more powerful expression. The *Lawrence*'s head and neck look tentative and dainty by comparison. In addition to his own quick artistic growth the influence of Michelangelo seems to have worked the change. Bernini of course knew the figure of Christ in Michelangelo's early *Pietà* in St Peter's, which may have inspired both of these early martyrdoms. There are also recollections of Michelangelo's late *Pietà*, now in the Cathedral of Florence but then in Rome. The increased mastery of the *Sebastian* demonstrates how quickly Bernini learned, how easily he could rival his exemplars. The work takes on added significance because of the patron; the *Sebastian* was the first commission Bernini executed for Cardinal Maffeo Barberini who, as Urban VIII (1623–44), was to become the greatest patron of sculpture in papal history.

Perhaps as early as 1610 Bernini was also making his first essays in portrait sculpture. We have seen that the head of *St Lawrence* may relate to studies of his own expression; an interest in lifelike realism also characterizes his earliest portrait busts. Of these, the first is the portrait of Bishop Giovanni Battista Santoni*

in the church of Santa Prassede [5]. Baldinucci calls it Bernini's first work and since it was as a portraitist that Bernini first won acclaim, we might take the *Santoni*'s blunt crudeness as an indication of a date even earlier than the relatively sophisticated *Amalthea*. Were Bernini's name not attached to this bust it would hardly attract attention; it is the modest beginning of a series that includes some of the grandest and most potent images ever carved. The *Santoni* is a posthumous portrait of a bishop who had been major-domo of the energetic Sixtus V (1585–90). The merely symbolic representation of the shoulders and upper torso was traditional. *Santoni*'s head, jutting forward rather belligerently from its niche, recalls earlier examples; but the modelling shows Bernini's precocious understanding of the problems of portrait sculpture. The treatment of the hair and beard may derive from Pietro's practice. The contrast of hair and skin implies colour as well as textural differentiation; the hollowed pupils of the eyes give a more concentrated colour accent, add focus to the glance, and define a living personality that is more impressive in its elevated position than in our photograph. In cranial structure, in the depiction of skin over bones, *Santoni* is more naturalistic than contemporary busts [cf. 30]. (A large proportion of Roman portrait busts of this period are of much lower quality than our plate 30, with compact, schematic, symmetrical heads resting squarely on the shoulders and looking straight out or up.) Here, while still a child, Bernini concentrates on characterization and life-likeness, avoiding high finish for the sake of textural truth. Only in the pursed eyebrows with their slightly mannered curve and stylized indentations does he depart from sturdy realism.

Bernini was thought to have been almost in the personal care of the Pope from an early age, and the implications are partially justified by a small, almost jewel-like marble bust of Paul V that probably dates from 1618 [1]. As should be expected, the Pope is represented more traditionally than were less exalted personages. The uncut eyeballs have the blankness found in many antique works; the young Bernini must have felt such a treatment appropriately dignified. The reserve of the *Paul V* might mislead our interpretation of Bernini's development if we did not have so

many other surviving works. The years before Bernini's twentieth birthday are marked by rapid development in several directions. The impassiveness of the *Pope* derives from the greater inertia inherent in images of noble subjects. At the other extreme stand the physiognomic studies of the same years, such as the '*Damned Soul*', which is quite clearly nothing more than the grimacing face of Bernini himself, heightened and stylized [6]. The search for truth in the instantaneous, the inquiry into man's looks and reactions under changing circumstances and, in particular, the study of expressions of surprise, horror, and alarm, were all hallmarks of the painter Caravaggio (1571–1610) and his followers [7].* At this moment their influence in Rome was still close to its peak.

5 *Bishop Giovanni Battista Santoni. c.* 1610? Santa Prassede

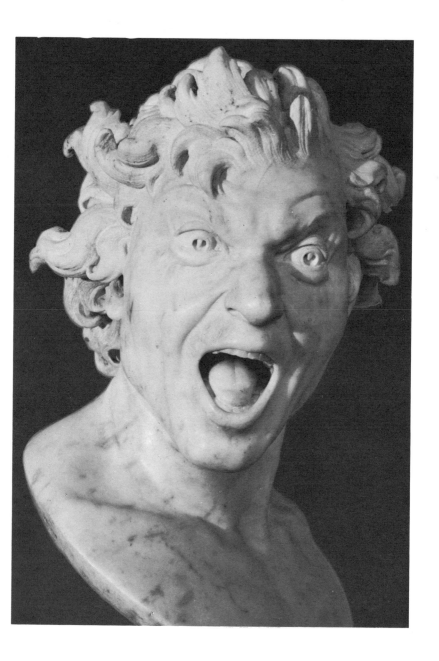

6 '*Anima Dannata*'. *c.* 1619

These painters enlarged the boundaries of art through their observation of the face under unusual circumstances: titles like *The Cardsharps* or *Laughing Gypsy* serve almost as well as a reproduction. Often their paintings were little more than life studies; frequently the expression has a 'frozen' or grimacing quality. These characteristics lurk behind the half-humorous demon known as the *Anima Dannata*, which may date before 1620. We should not be surprised to find Bernini experiment in this way, but the transfer of a typical subject for painting into three dimensions is new and portentous. The highly finished pendant to the *Anima Dannata*, the *Anima Beata*, is an image of a girl with eyes raised to heaven. It, too, is a lively study, but by comparison with its partner it suffers as the virtuous and noble usually do when translated into art – whether in marble or prose. It is a tribute to Bernini's creative ingenuity that ultimately he found means to achieve excited interest in the beatific; at this stage of his career he fell back on a traditional solution.

7 Michelangelo da Caravaggio, *Boy Bitten by a Lizard* (detail).
c. 1596

Bernini's first large-scale commission shows his strength as well as unexpected weaknesses [8; 10–11]. Baldinucci informs us that Bernini's first work for Cardinal Scipione Borghese was the group of Aeneas fleeing Troy with his father Anchises and the boy Ascanius as described in the *Aeneid*:*

'Quick, then, dear Father,' I said, 'climb onto my back, and I will
Carry you on my shoulders – that's a burden will not be burdensome.
However things turn out, at least we shall share one danger,
One way of safety, both of us. Let little Ascanius walk
Beside me, and Creusa follow my steps at a distance
Do you, my father, carry the sacred relics and home-gods:
Sinful for me to touch them, when I have just withdrawn
From battle, with blood on my hands, until in running water I am
 purified.'

This group, life size, was most probably commissioned in 1618 when Bernini was nineteen and completed the next year. It shows more of his father's old-fashioned style than the works just discussed. This was recognized by the acute Baldinucci who, nevertheless, understood its importance, singling out Bernini's progress toward the *tenero e vero*, which he noted especially in the head of the old man. With our knowledge of Bernini's previous works, particularly the *Sebastian*, his first large group poses a problem; indeed, it was long customary to attribute the *Aeneas* to Pietro. Compared with the virile group painted in Raphael's *Fire in the Borgo* [9], the composition is cramped and tentative. The three figures seem crowded, and the centre of gravity is distressingly high. In the grouping there is some of the spiralling instability that is typical of the style of Giovanni Bologna and his predecessors [17], and this is emphasized by the tiny humped-up base on which the towering group of father and son perches precariously. The fluctuating, multi-faceted harmony of Giovanni Bologna has been turned from a virtue to a defect by the young Bernini; he was out of sympathy with the aesthetic aims of Mannerism but was as yet unable to abandon its principles. The *Aeneas* itself is derived from Michelangelo's *Risen Christ* in Santa Maria sopra Minerva. Although this *Christ* is perhaps the weakest figure Michelangelo ever produced, what positive qualities the *Aeneas* does have are in part

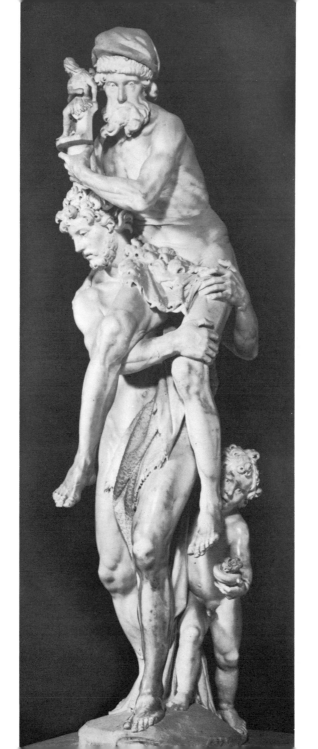

9 Raphael
Fire in the Borgo
(detail). *c.* 1516
Stanza del-
l'Incendio,
Vatican

derived from that source. Muscles, sinews, and veins play realis-
tically under the skin of Aeneas to give his body a virility lacking
in the head. The sagging skin of the old man is subtly differentiated
from that of the son and recalls Bernini's study of the antique
Seneca; the pudgy Ascanius, who gave Bernini another opportunity
for a display of surface texture, completes Bernini's three ages of
Man [11]. The tousled, leonine hair of Aeneas again shows the
young sculptor's study of Hellenistic models – in short, as
Wittkower has said, 'we are witnessing the birth of a realistic style,
ushered in by the invigorating study of classical antiquity'. The
statue has a religious importance as well: the aged man carrying
the family *penates* from the fallen city, supported by his son,
illustrates piety toward God and toward parent, and offered an
ancient example of the triumph of faith over adversity, a popular
theme in Counter-Reformation Rome.

 10 Detail of plate 8. Aeneas and Anchises →

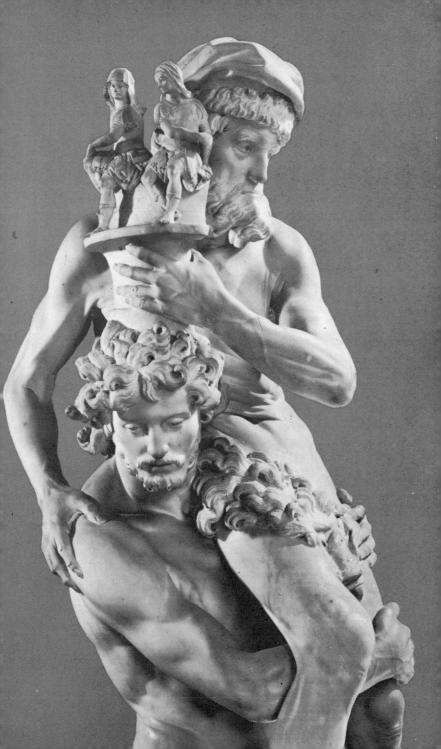

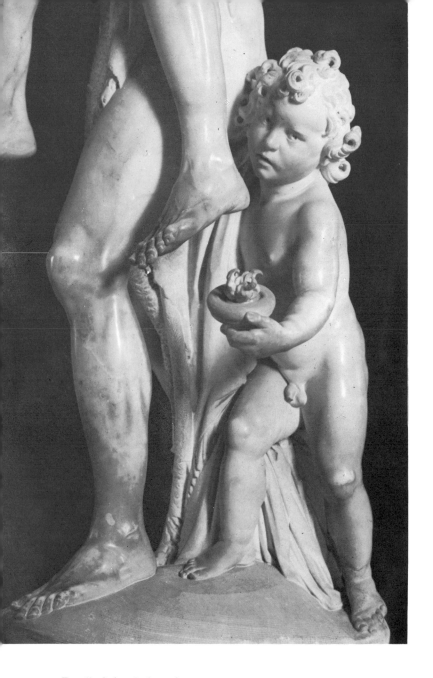

11 Detail of plate 8. Ascanius

The *Aeneas* seems to have been a success among the *cognoscenti*. Bernini's next commission, which must date from 1619–20, was from Alessandro Peretti, Cardinal Montalto, nephew of the great Sixtus V. Montalto owned a villa, now destroyed, near Bernini's house on the Esquiline hill; for this retreat Bernini created a *Neptune and Triton* to stand over a decorative oval pond. The source of the image seems to be a passage from Ovid's *Metamorphoses* that parallels the story of the flood in Genesis. Jupiter, furious after an attempt had been made on his life, determined to drown the world:

> And Jove's anger,
> Unbounded by his own domain, was given
> Help by his dark-blue brother. Neptune called
> His rivers all, and told them, very briefly,
> To loose their violence, open their houses,
> Pour over embankments, let the river horses
> Run wild as ever they would. And they obeyed him.
> His trident struck the shuddering earth; it opened
> Way for the rush of waters. . . . and everything is ocean,
> An ocean with no shore-line.

Bernini's group was related to the water below it in a scenographic way that cannot be understood without the help of old prints and a willing imagination [14]. The circumstances and his swiftly maturing genius produced a work far more advanced than the *Aeneas and Anchises*. The angry sea god strides forward, wrathfully winnowing the air with his trident; below, Triton, sounding his conch, supports the larger figure. Vigorous and positive action of the arms, balanced by the thrust of shoulders and head, gives decisive movement wholly appropriate to the subject. The *Aeneas* group exhibited something akin to introspection; its dreamy mood contrasts strangely with the emergency depicted. Bernini's *Neptune* responds naturally to the situation; as he rises wrathfully from the sea we seem to watch a spectacle that is just reaching its climax. One has, consequently, no urge to investigate the rear of the group, in spite of spiral movements in the design that still relate it to the work of Giovanni Bologna [cf. 17]. The outline of the composition is broken. The *Neptune*, in fact,

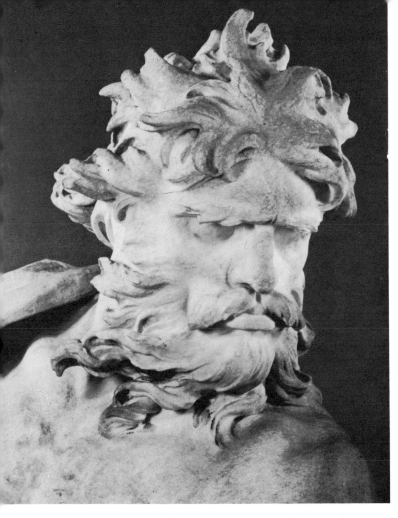

offers several views of great interest, including two expressive silhouettes. One of them has an added attraction in the trailing cloak that suddenly becomes a dolphin [15]. Whether we consider the alternate views of this figure a link with the sixteenth century or the result of its free-standing position, it must be considered a transitional work. The group's dramatic involvement with the waters of the pond below is an innovation that brings us to the threshold of Bernini's maturity.

12 (*above*) Detail of plate 13 13 *Neptune and Triton. c.* 1620 →

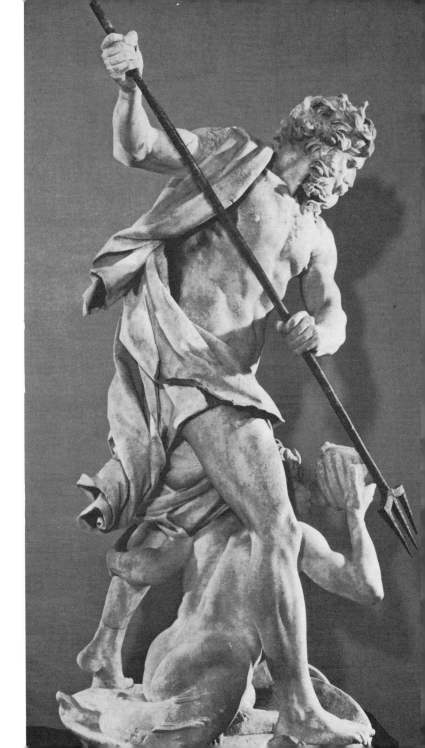

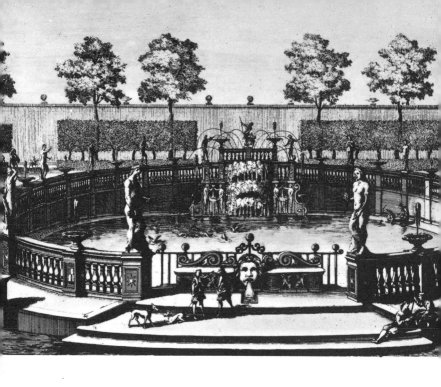

14 View of the *Neptune* and pond in the Villa Montalto in the later
 seventeenth century

Paul V died unexpectedly in January of 1621 and was succeeded
by Cardinal Alessandro Ludovisi, Gregory XV. This Bolognese
Pope ruled for just over two years, but the short pontificate was of
importance for the history of art. A stream of artists invaded Rome
from Bologna, chief among them Guercino and Domenichino;
their arrival coincided with the end of Caravaggio's influence in
Rome. Bernini's talent was given unusual recognition. The Pope
was old and infirm, and Cardinal Ludovico Ludovisi, a close
friend of the sculptor, was really the man in charge. Bernini pro-
duced a number of portraits of the Pope, in marble and bronze, and
was already knighted for this achievement by the autumn of 1621;
that same year he served as *Principe* of the Roman Academy of St
Luke – unique tributes to his genius. He was not yet twenty-three
years old.

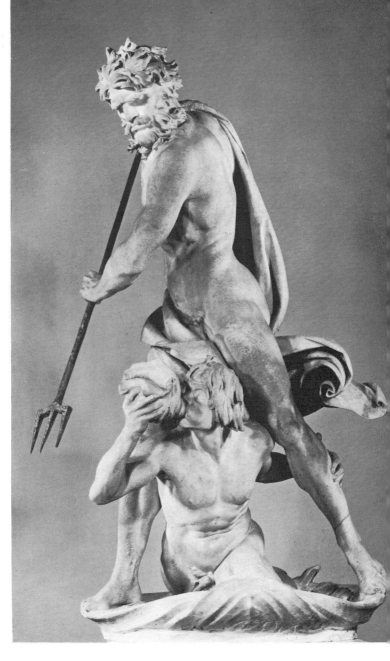

15 *Neptune and Triton*

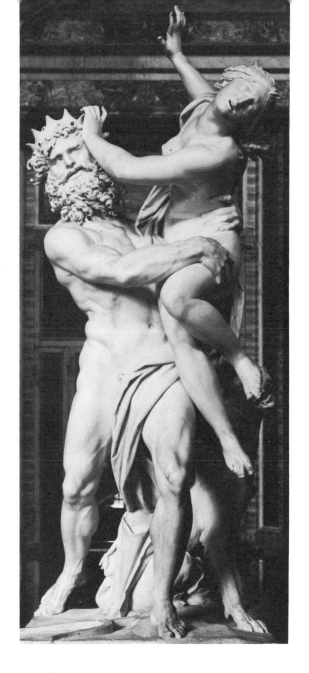

16 *Pluto and Persephone.* 1621–2. Galleria Borghese

Bernini's early development is crowned by three great works carved for Cardinal Scipione Borghese: the *Pluto and Persephone*, the *Apollo and Daphne*, the *David*.* These show successive mastery and more – the brilliant series contains within it no less than an artistic revolution. These works, which all belong essentially to the brief period of the Ludovisi papacy, are a tribute to the perspicacity of the Maecenas, Scipione Borghese, whose suburban villa (the present Galleria Borghese) they still decorate. The new style begins with the *Neptune* and achieves its first unequivocal impact with the *Pluto* (1621–2), which stuns us from the outset by its amazing virtuosity [16]. In this and succeeding works Bernini seems bent on pushing the resources of marble sculpture to their extremity. Bernini's stupendous technique as a marble cutter seemingly allowed him to model the obdurate material as if it were dough and achieve the effects of bronze, which is cast from clay or wax models. (He has been chastised for just this achievement by artistic moralists whose criteria are based on abstract conceptions such as 'truth to materials'.) The texture of the skin, the flying ropes of hair, the tears of Persephone, and above all the yielding flesh of the girl in the clutch of her divine rapist [18-19] initiate a new phase of sculptural history. Renaissance writers, basing their theory on antiquity, had contrasted the process of chipping away from a block with that of building up and modelling out of plastic material: subtraction *v.* addition. Michelangelo's disdain for the latter process is well known. Bernini here achieves the pictorial effects of clay modelling through the traditional methods of carving; and his startlingly realistic technique is at the service of a momentary vision. The action is depicted at a climactic moment: Pluto seems to have just snatched the voluptuous maiden, who twists, struggles, and cries aloud in vain as the triumphant god steps past the border of Hades, symbolized by the frightening form of Cerberus that also serves as a necessary support for the group. We can follow the evolution of Bernini's design from a drawing that seems to show that his first ideas were based on the famous group by Giovanni Bologna [17]. Such statuary remains incomplete from any one point of view: the composition sends the observer around the statue in an unrequited search for

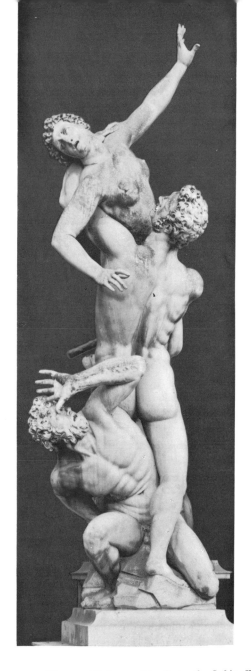

17 Giovanni Bologna, *The Rape of a Sabine Woman*. 1579–83
18 Detail of plate 16, *Pluto and Persephone* →

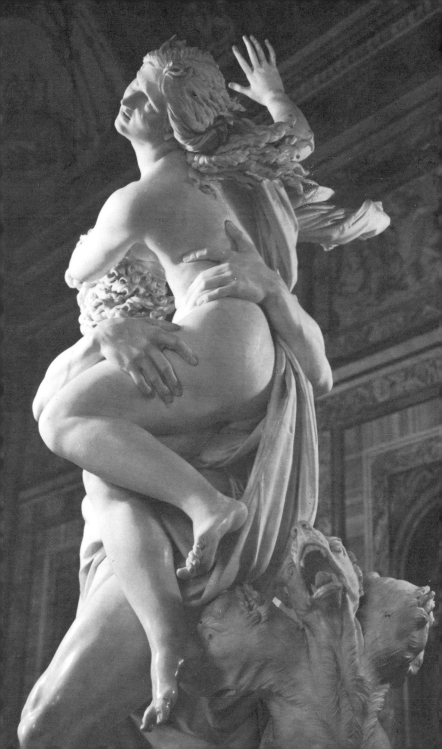

completion. This gyration prolongs and delays final comprehension of the group while enriching its meaning through innumerable views. It might be said, in fact, that the sum of these views is the work. Bernini's new approach strives above all for immediate and total impact upon the observer. In order to achieve this he needed to resolve the action as completely as possible upon one point of view. Profiting from his experience with the *Neptune*, where a focus for the composition was provided by the relationship of the sea god to the water below, Bernini next created a group with one, and only one, predominant aspect. Thus Bernini's vision is pictorial rather than conceptual. The *Pluto and Persephone* is a kind of sculptured picture, but unlike either painting or relief, the group in the round gains by the spatial immediacy of three full dimensions and by rich secondary views [18–19]. It must be emphasized that these other views are distinctly subordinate. The group was carved to be seen from the front and like the other Borghese sculptures it stood against a wall.

As a gesture of friendly good will Cardinal Borghese – temporarily out of favour – gave the newly completed group to Cardinal Ludovico Ludovisi, the Pope's nephew. To replace it, Borghese commissioned another group representing *Apollo and Daphne* (or perhaps the *Apollo and Daphne*, once begun, seemed so promising that the Cardinal felt he could afford to give the *Pluto* away). This group carries the pictorialism of the *Pluto* to heights never attempted before [20]. The Ovidian subject,* common in paintings, was rare in sculpture for reasons that can readily be imagined: neither hot pursuit nor transformation from flesh to vegetable seemed remotely suited to treatment in three frozen dimensions. Again Bernini chose the crucial moment: just as Apollo thinks he has achieved his goal, Daphne's fleeing form begins to be enveloped by the encircling bark; her fingers leaf out; her toes take root. Apollo has just caught up with his beloved and encircles her waist with a confident arm; but his facial expression indicates the beginning of an awareness that something has gone wrong [21]. Daphne seems ignorant of her transformation as she looks back over her shoulder, lips parted in fright. Her mouth seems to frame a silent scream as her face goes

19 Detail of plate 16, *Pluto and Persephone*

blank under the force of transformation – a parallel to the paradox of the form, still running, taking root before our eyes. Daphne's hair swings around as a result of her sudden arrest and blows free with a lightness that Bernini himself felt he never equalled. The whole statue is one of the most successful illustrations of a literary passage ever made:*

So ran the god and girl, one swift in hope,
The other in terror, but he ran more swiftly,
Borne on the wings of love, gave her no rest,
Shadowed her shoulder, breathed on her streaming hair.
Her strength was gone, worn out by the long effort
Of the long flight; she was deathly pale, and seeing
The river of her father, cried 'O help me,
If there is any power in the rivers,
Change and destroy the body which has given
Too much delight!' And hardly had she finished,
When her limbs grew numb and heavy, her soft breasts
Were closed with delicate bark, her hair was leaves,
Her arms were branches, and her speedy feet
Rooted and held, and her head became a tree top,
Everything gone except her grace, her shining.
Apollo loved her still. He placed his hand
Where he had hoped and felt the heart still beating
Under the bark; and he embraced the branches
As if they still were limbs, and kissed the wood,
And the wood shrank from his kisses, and the god
Exclaimed: 'Since you can never be my bride,
My tree at least you shall be! Let the laurel
Adorn, henceforth, my hair, my lyre, my quiver:
Let Roman victors, in the long procession,
Wear laurel wreaths for triumph and ovation.
Beside Augustus' portals let the laurel
Guard and watch over the oak, and as my head
Is always youthful, let the laurels always
Be green and shining!' He said no more. The laurel,
Stirring, seemed to consent, to be saying Yes.

The contrast of psychological states in the two figures is reflected in their sources of inspiration. The face of Daphne clearly derives from those studies of transitory emotions usually associated with Caravaggio and his followers, and a painting of this kind, imitating Caravaggio, was in this very room; Bernini must have known

20 *Apollo and Daphne*. 1622–5. Galleria Borghese

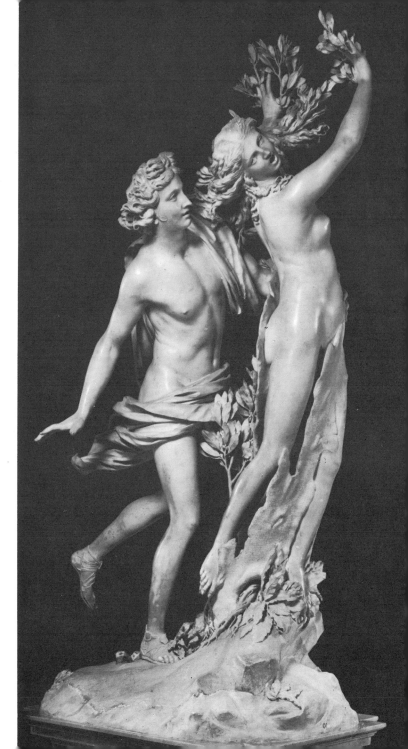

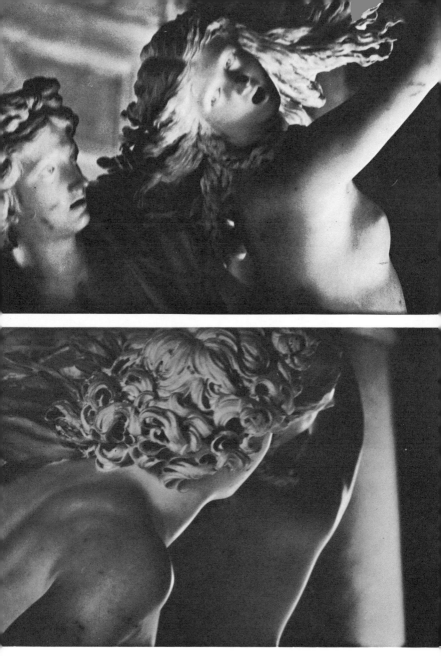

21 and 22 Details of plate 20

it [7]. The blank quality of Daphne's face is, however, closer to the transformation of such Caravaggesque themes by Guido Reni, Bernini's favourite contemporary painter [cf. 35]. The Apollo, by contrast, is a bare-faced borrowing from what was then considered *the* classical statue: the *Apollo Belvedere** [23], a restored marble copy of what must have been an important Greek bronze of the fourth century B.C. Bernini took over its stance, gesture, and features with small changes which, however, transform their meaning. The frontal, stepping figure is now seen from the side and running; with minimal modifications the antique positions of arms and legs have been adapted to their new function. The drapery, instead of cutting the statue at the shoulder, now hangs over it, whips around the hips and out into the air, heightening the impression of swift flight initiated by the running legs and sustained by the steadying gesture of the right arm. The broken, active profile of this side of the group contrasts vividly with the smoothly rising outline of the tree-trunk Daphne. These contrasting sides meet at the apex where the leaves, like little staccato explosions, pop out of Daphne's beseeching fingers.

Once again Bernini created a pictorial representation seen from one basic point of view. But while the action of *Pluto and Persephone* moves directly up and out from the front of the base, the *Apollo and Daphne* is seen from an angle. Moreover, the bit of ground on which the figures run was originally smaller than the top of the base – the extent of the modern additions to the plinth can be seen even in reproduction. The small plinth must have served to exaggerate the hallucinatory effect of the figures as they seemed to skim over the ground. Most of this effect is now lost because the group is unintelligently displayed in the centre of its small room, inviting the visitor to walk around the sculpture and to look at it from all angles. Such a group naturally offers a number of fascinating views, but inspection of the back is an unusually disillusioning experience. Far more than the *Pluto*, the *Apollo and Daphne* was conceived as a very high relief finished in the round, with the added spatial interest that such a group gains when free-standing. Originally it stood almost touching the wall; we can reconstruct its original position from the evidence of the angle view

since the room it now occupies is the one for which it was planned. To enter we must come in by one of two doors at one corner. Bernini must have wanted the group to be seen at the opposite side of the room, immediately upon entering. As the unwary visitor came in one of the doors he would look up to see the group from precisely the correct point of view, and experience an instantaneous vision [Fig. 1].

Fig. 1 Rome, Villa Borghese
Plan of room
showing original position
of *Apollo and Daphne*

The element of surprise and our involvement with the action heighten our response to these early works by Bernini and also provide their chief failing. Fascinating and brilliant as they are in conception and execution, their very immediacy and calculated shock begin to wear thin with continued association. No lover of sculpture would dream of dismissing these Borghese works as mere youthful exuberance, but there is a quality of immature excess, of virtuosity for its own sake, that contrasts with the richer works of his maturity.

For some reason the *Apollo and Daphne* was left unfinished for the better part of a year while still another work for Cardinal Borghese, the famous *David*, was begun and swiftly completed [24, 26–7]. Baldinucci tells us that it was executed in no more than seven months' time. From the payments discovered in the Borghese Archives by Dr Italo Faldi we know that the statue was begun in mid 1623; this date accords with Baldinucci's statement that Maffeo Barberini, while still a Cardinal, held a mirror while Bernini studied his own face in order to achieve the desired expression. All of these early statues were wrongly dated and their

sequence misunderstood until Faldi's discoveries clarified once and for all our picture of Bernini's Borghese works. Because the *David* is much less a relief composition with one point of view than is the *Apollo and Daphne*, almost all the critics were misled in their dating. The documents, as is so often the case, have clarified our vision as well as the facts.

The *David* is psychologically the most advanced of the Borghese statues. Feet wide apart, he twists to gain the maximum swing for his shot while his head remains fixed in his concentration on the gigantic adversary. The unruly hair, the knitted brow, and above all the clenched mouth indicate one of those moments when the complete physical and psychic resources of the will are summoned to superhuman effort [26]. The protagonist in each of Bernini's previous works had the object of his attention visible and at hand: Neptune's pond, Persephone, Daphne. *David*'s adversary is, however, not present. As spectators we must imagine a Goliath towering somewhere behind us; we too become physically involved with the action of the statue. *David*'s eyes sight past us: our space is his and will soon be the stone's; we are in an activated space embracing a statue, real spectators, and an unseen adversary who cannot be far away – three levels of existence fused into one. The spatial continuity was originally emphasized by the small plinth (now enlarged), whose edge was gripped by David's toes. A single, heightened moment in time is conveyed even more dramatically by the *David* than by the *Apollo and Daphne* or the other groups; the decisive action is not taking place but *about to occur*. The wracking tension of this moment is far greater than at actual consummation. Our experience of the work was calculated as it was for the other statues: the *David*, too, was originally against a wall. Like the others, the split second of time captured in the marble demands a single, clear point of view. This view is achieved as it was for the *Pluto and Persephone*, by standing directly in front of the base.* But the single twisting figure necessarily introduces a number of subordinate views that are intrinsically more meaningful than those of the previous groups, and so the progression we have followed seems to be reversed. The *David* is a variation on the *Neptune* [15], another example of a

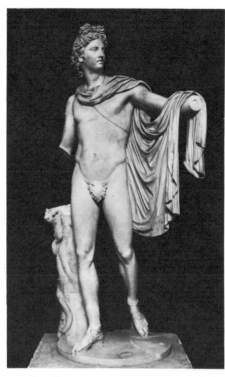

23 'Leochares',
*Apollo
Belvedere*

practice that occurs over and over during Bernini's career: the recapitulation of an earlier work (his own or an antique, like the *Apollo Belvedere*) with completely changed meaning. The relationship is clear but the psychology of the two statues is so different that the similarity has rarely been noticed.

Bernini's *David* is novel in another way. Early Renaissance artists had shown a triumphant boy hero, work done, with Goliath's head at his feet. Michelangelo introduced a new tension in his huge figure of *David* [25] by showing him shortly before the encounter; but no sculptor had depicted the actual moment of the shot. Bernini's novel form is the direct result of novel content.

The *David* was the last large-scale commission Cardinal Scipione Borghese could give to Bernini. Months before it was finished the sculptor's great friend and protector, Cardinal Maffeo

Barberini, was elected Pope Urban VIII. This signalled a new, official, and more demanding role for the young genius; he was soon to be in charge of the Pope's entire artistic programme. By the time *David* was finished, early in 1624, he no longer had time for private commissions and even the completion of *Apollo and Daphne* dragged on for another year and a half. The *David*, consequently, marks a real break in Bernini's life; we may pause to consider his accomplishment up to this time.

When he began his career, Bernini found a developed tradition of autonomous, self-sufficient statuary that existed only for the delight of the sophisticated aristocracy who had commissioned it. Whether free-standing or architectural, much of the sculpture of the later sixteenth century concentrated on a goal of aesthetic refinement. The giant of this late Renaissance style, Giovanni Bologna, worked in Florence for the Dukes of Tuscany, and there created a series of highly finished, subtle, and sophisticated works [cf. 17]. By the time he was twenty-five Bernini had overthrown this tradition. His revolution was manifold: he tried to tie sculpture to the mass of its architectural surroundings and he began to relate it to the space enclosed by that architecture – the area in which we ourselves live and move. To do this he smashed the proud isolation of art as an object or entity on its own and made it participate in a larger conception, spatial and psychological; Bernini's sculpture charges the atmosphere of the room and even discourses with its inhabitants. The series *Aeneas – Pluto – Daphne* shows his progression from an almost haphazard single view to strong frontality and then to a hallucinatory vision of the group seen as a relief. The *David* takes up a new and fascinating problem that may first have occurred to Bernini while working on the *Neptune*: the communication of the spirit of the subject by including spectators in the action. The *David*'s unification of real and artistic space stands at the core of much Baroque art in succeeding years. In some ways the whole history of Bernini's artistic quest can be seen as the unfolding of this concept, with ever richer meanings and more powerful physical environments. A new unity of the arts ultimately emerged and the *David* stands at the beginning of this stirring adventure.

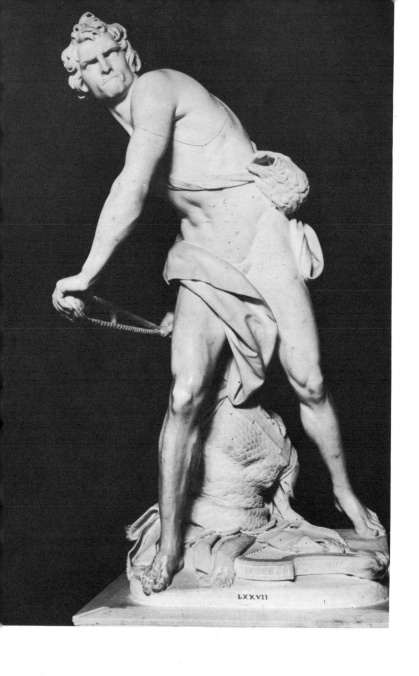

24 *David*. 1623–4. Galleria Borghese

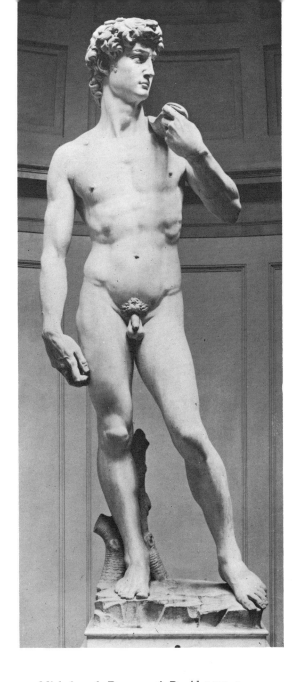

25 Michelangelo Buonarroti, *David*. 1502–4

In addition to all this Bernini also discovered the sensuous and coloristic potentialities of sculpture. We know from statements made late in life that colour was the element of reality he missed most acutely in marble portraiture; an early attempt at colorism can be seen in the face of *Santoni* [5]. His desire for coloristic effects in a monochromatic material is one side of a new sensual awareness of the surfaces of things – the yielding flesh of Persephone

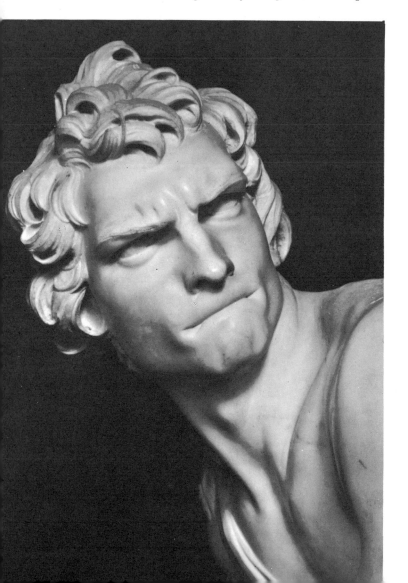

[18–19] and the various surfaces of Daphne [20–21] open up for exploration an area that had never tempted Michelangelo or Giambologna but that was to inspire European sculptors for over one hundred years.

We have traced the evolution of Bernini's groups from the meditative columnar autonomy of the *Aeneas and Anchises* to the extroversion of the *David*. We have noted his sources, which included his father's facility in handling marble, the Mannerist heritage, and antique sculpture. There is no need to indicate the origin of each figure here – the connoisseur of ancient art has no trouble finding the *Borghese Warrior* at the root of the *David*; the *Pluto*, too, has an antique prototype. (Indeed, all of the Borghese works are un-Christian if not wholly pagan; in subject matter they still belong to the Antique-Renaissance tradition, just as their commission for the Cardinal's villa relates them to the art-statuary heritage of Giovanni Bologna.) We are here interested in the formation of Bernini's mind, in the changing artistic aims that kept pace with his rapidly advancing mastery. The answer, so far as we

26 and 27 Details of plate 24, *David*

can know such answers, lies in his education. Bernini was a sculptor, but his vision was permanently influenced by the Renaissance painters who had studied antique statuary and translated it into two-dimensional scenes. So Bernini saw as a sculptor and as a painter. His own development compressed into the space of four years something of the change of taste and of aim that occurred in Greek antiquity between Classic and Hellenistic times. The *Apollo Belvedere*, at the dawn of the Hellenistic era, is itself a work that may approximate painted images in its accommodation to a frontal plane and in its insistence on a single point of view [23]. It and many Hellenistic works that followed culminate a change from the blocky, four-sided figures that had been carved in the Archaic period. The change in seeing of which the *Apollo Belvedere* is symptomatic was based on a pictorial development that can now only be guessed at; Bernini's painted sources are preserved intact. He himself left his opinions on the relative worth of painters and although the statements were made later in life, they seem to reflect his early study.* First he places Raphael, 'who combined in himself what was most beautiful in all others' [cf. 9]. Correggio and Titian rank second and third, showing his interest in the expressive use of colour and atmosphere. Fourth is Annibale Carracci [cf. 28] and among his contemporaries he always singled out Guido Reni [cf. 35]. Reni regularly painted the kind of relief compositions Bernini carved; moreover, Reni's assimilation of such Caravaggesque motifs as the open mouth stands behind Bernini's development of forms like the head of Daphne. It is a truism that painting had advanced far beyond sculpture in the generation before Bernini's activity began. We cannot be surprised that a genius both instinctive and intelligent should turn to the greatest painting of his time rather than to contemporary sculpture, and among modern paintings, surely Annibale Carracci's Farnese Gallery decorations furnished Bernini with the inspiration he could use most effectively [28]. Years later he told Chantelou in Paris that Annibale had fused the grace and drawing of Raphael, the knowledge and anatomy of Michelangelo, the nobility and manner of Correggio, the colour of Titian, and the invention of Giulio Romano and Mantegna

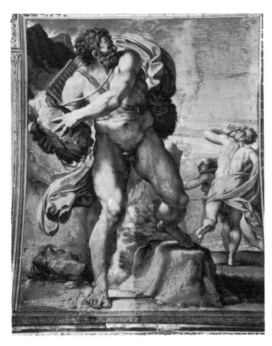

just as a cook blends diverse ingredients. This was conventional praise, but its object was the artist who most clearly achieved the exuberant florid classicism Bernini admired. Annibale used what Bernini called his 'great big brain' to infuse an antique spirit as well as antique proportions into his art. His painting also displays a robust, untrammelled action that belies the painstaking study underlying it. Annibale led Bernini to the interpretation of antique sculpture that bore fruit in the Borghese statues. Bernini himself reports that the older man had urged him to draw from Michelangelo's *Last Judgement* for two years in order to understand the musculature of the bodies. But Annibale's own art provided more of Bernini's inspiration: the *Pluto and Persephone* has an Annibalesque quality unequalled in his *oeuvre*. The gloating god reflects Annibale's vigorous, somewhat ironic interpretaa tion of ancient myth. The *Persephone*, too, can be considered a sculptured Carracci. The action of the *David* reflects the same

28 Annibale Carracci, *Polyphemus Attacking Acis and Galatea*. *c.* 1600. Palazzo Farnese

source [28]. The depiction of a moment of action, or of action about to occur, derives from Bernini's study of the Farnese Gallery.*

Annibale's pictorial classicism and the pictorial aspects of antique statuary were Bernini's school – one reinforced his choice of the other. But there is another source of inspiration that fused his antique sources with the modern painterly vision: the study of nature, of life itself. Keen observation underlies Bernini's method and heightens his results. Hints of this have been noted in details: the *Anima Dannata* and the face of *David* [6; 26]. It was his concern with reality that made it possible for Bernini to use his sources with such electric effect. A return to 'nature' and to 'realism' are classic symptoms of artistic rebirth after years of stagnant formulae. This tendency was noted by Denis Mahon,* who pointed out that

there are recurrent moments in the history of art, not less signifi-cant for being short-lived, when the reaction against a highly 'artificial' style – whether we describe it as Gothic, Mannerist, or Rococo – brings a form of what may by contrast be roughly called 'classicism' and a form of naturalism into brief alliance. The begin-ning of the Seicento is such a moment. Reluctance to accept formu-lae which seemed to have the sanction of convention alone – and a consequent interest in returning to a consultation with nature – pro-vided a common *starting-point* for both Caravaggio and the Carracci.

Bernini's early work exhibits precisely these qualities of classi-cism and naturalism, and the man who led him to this synthesis was not a sculptor but a painter.

In order to assay the quality of Bernini's optical realism we can use his portraits as a control. At about the time of the *Pluto and Persephone* he executed two busts of high quality. The later one, of Cardinal Roberto Bellarmine, seems to have been posthumous, so *Monsignor Pedro de Foix Montoya** serves our purposes better [29]. Now hidden away in the monastery of Santa Maria di Monserrato, it repays a visit by the student seeking to understand the development of Bernini's art. Compared with the Santori bust [5], the most immediately striking change is the increased im-portance of the body, which extends downward to the waist in

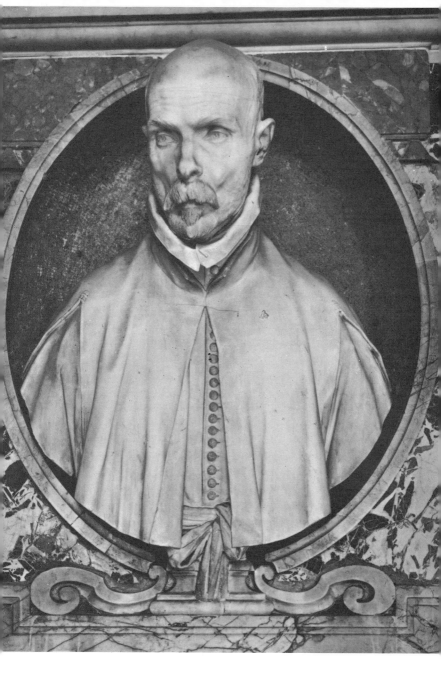

29 *Monsignor Pedro de Foix Montoya.* 1622. Monastery of Santa
Maria di Monserrato

the centre and includes the upper arms at the side. We now have not merely a head but about one third of a man. This puts the head in a more normal environment, predisposing us to expect increased naturalness in its rendering. The head exhibits those qualities of realism noted in the *Santoni* but with a sharpness and accuracy that make the early portrait look coarse and flabby. The bone structure of the head and face serves as an armature for Montoya's tightly drawn features. The textural contrasts of beard, skin, and cloth are more coloristically presented. At the same time Bernini's developed virtuoso technique gives a vivid rendering of the irregular growth of the moustache, the direction of the growth in the brows, the shorter hairs of the cheeks. In these details we already see some of the tendency to caricature that developed in succeeding years. By comparison, a work of high quality by a member of Pietro Bernini's generation lacks the three-dimensional insistence of Bernini's work [30].* Textures are not differentiated, the gaze is remote, and its whole aspect is slightly blurred – a rendering akin to the 'soul portraits' of late antique times. Bernini's *Montoya* is sharp and clear in the whole and in its parts; it was considered the apogee of realistic portraiture. All our sources tell the story of Cardinal Barberini and some friends admiring the newly installed tomb; one exclaimed, 'It is Montoya petrified!', whereupon Montoya himself chanced to come into the church, Cardinal Barberini walked up to the prelate, touched him, and said: 'This is the portrait of Monsignor Montoya,' and then, turning to the bust: ''This is Montoya.'

With the *Montoya* in mind we should now turn back to the Borghese statues. The *David*, modelled on Bernini's own face, is the obvious comparison. We are at once struck by tremendous differences. The textures so noticeable in the *Montoya*, the coloristic contrasts between hair and skin, are drastically reduced. Even allowing for the great disparity in the age of the subjects, we can see a different approach to the head in the *David* – the forms, while individual, are ruthlessly simplified [26]. The surface planes of skin glide swiftly and evenly over the generalized bone structure hidden beneath, without local particularization. The brow, while conveying the concentration of the moment, assumes

an abstract pattern. Even the famous grimacing mouth can now be understood as a greatly transformed version of what was actually reflected in Cardinal Barberini's mirror. Reduction of specific detail, simplification and exaggeration of features and expression – these contrast with the topographic realism of *Montoya* and illuminate the balance between classical inspiration and realistic observation that informs the Borghese statues. Free-standing, life-size, heroic works must perform functions quite different from portrait busts; were the head of *David* as realistic as *Montoya*, the effect of the whole would be damaged. The Borghese statues were primarily conceived for a view from across a room; the larger action, the meaning of the moment depicted, was Bernini's aim.

30 Camillo Mariani (?), *Fabio de Amicis*

2. Bernini in Command

Bernini may well be the first artist who occupied a position truly similar as well as equal to that of the princes and ministers of his day. The opportunity for this achievement came with the election of Maffeo Barberini as Pope Urban VIII [cf. 31]. The two had long been intimate friends, and Barberini had commissioned works by both Pietro and Gian Lorenzo for his chapel in Sant' Andrea della Valle [4]. On the day of his elevation Urban supposedly called in the twenty-three-year-old sculptor and said: 'Your luck is great to see Cardinal Maffeo Barberini Pope, Cavaliere; but ours is much greater to have Cavalier Bernini alive in our pontificate.' This famous statement set the tenor of a long papacy (1623–44) in which the Pope and Bernini enjoyed a relationship unmatched in the history of artistic patronage. The Pope ordered that Bernini be given free access to his own room and urged him to keep their previous friendship unchanged. He liked to talk to Bernini during the dinner hour until he was overcome with sleep; then it was Bernini's task to adjust the window blinds and leave. He was closer to Urban than any relative or adviser: 'Rare man, sublime artificer, born by Divine Disposition and for the glory of Rome to illuminate the century' – so wrote the Pope of his protégé.*

Urban VIII wanted a Michelangelo of his own. He urged Bernini to study painting and architecture, and commissions were waiting. Above the entrance portico of the new façade of St Peter's is an immense corridor running the width of the church [cf. 80]; from a central window in this loggia the Pope still gives his Benediction at Easter. This enormous hall, comparable to the Sistine Chapel in size, needed a fresco cycle, and Urban hoped

31 *Urban VIII* (detail). *c.* 1637–8

32 Santa Bibiana, façade. 1624–6

Bernini would decorate it – although this never came to pass.* Bernini studied painting, no longer as a sculptor, but as a professional. According to the biographers he devoted himself to painting for two years; it would be hard to say which two they were since all of them from this time on are crammed with activity. We are told that he did over 150 paintings; and although most are lost, what is left makes us agree that he could indeed do anything [Frontispiece].* We see the same interest in a momentary vision that he had expressed in sculpture, with an additional informality and a bravura touch appropriate to the medium. There is a Venetian freedom in these paintings and a chiefly black and white tonality that once led connoisseurs to confuse them with early works by the great Spanish painter Velázquez. Bernini's paintings deserve attention, and repay it, but they play a small part in his life work. He knew that his fate was sculpture and so, although very much attracted to painting, he never wanted to take it up seriously – it was always a *divertimento*.

Bernini's first architectural efforts also begin at this time. In accord with the Pope's ambition, he was charged to design a new entrance portico for the little church of Santa Bibiana on the outskirts of Rome [32]. Bernini's simple solution is notable for its focus and clarity. Its importance has been exaggerated, however, perhaps because of the significance of the works commissioned for its decoration inside.* Bibiana (Vivian) was persecuted under Julian the Apostate and finally was tied to a column and whipped with leaded cords. A small church was immediately raised on the site of her father's palace and there she was buried with her martyred mother and sister. In the course of a routine restoration her remains came to light, apparently prompting a poem by Urban VIII as well as Bernini's statue, which is in a niche above the high altar, framed by an impressive columnar aedicula [33]. *Bibiana* stands at the moment of her martyrdom, her right arm supported by the column. Her head and eyes are cast upward to receive the vision of heavenly glory, which is painted on the vault above her. *Bibiana* is obviously a variant on the frontal figures with spatial involvement we have just discussed. The psychological extension of the sculptured figure into the world inhabited by living people,

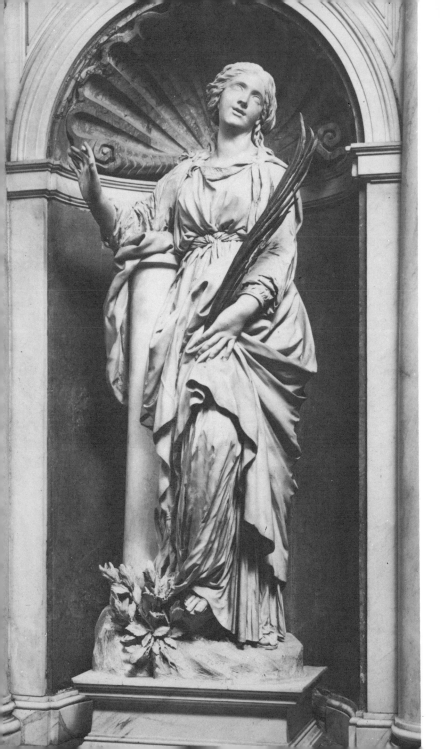

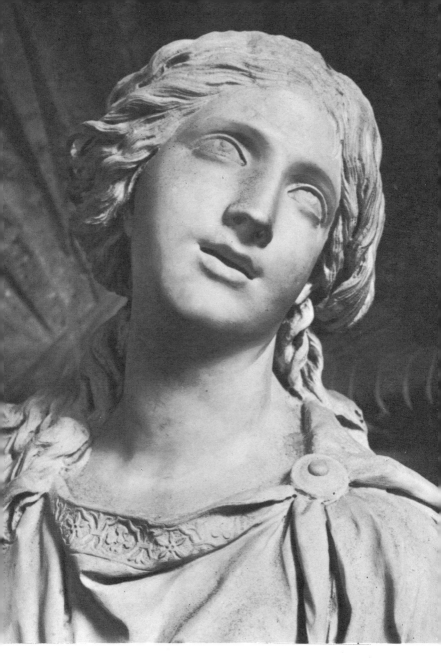

←— 33 *Santa Bibiana*. 1624–6. Santa Bibiana
34 (*above*) Detail of plate 33

which we first saw in the *David*, is here adapted to a new, specifically Catholic, context. The contrast of mood and meaning in these two figures is as great as their similarity of means, and it is symptomatic of Bernini's virtuosity that the determined Hebrew warrior and this trusting martyr are only a year or two apart in time.

The *Bibiana* was Bernini's first official religious commission and his first draped figure. We are consequently transported from the Antique-Renaissance tradition to a more decidedly contemporary, and specifically Counter-Reformatory, world. Resurgent Roman Catholicism placed great emphasis on its ties with the historical Christian community of Rome in the early years – the restoration of the church dedicated to Santa Bibiana is just one symptom. For religious figures, particularly of this early era, artists of the seventeenth century created an unmistakable feminine type –

35 Guido Reni, *Massacre of the Innocents* (detail). 1611

yielding, yet inspired with resolution through spiritual communion. It is to the art of Guido Reni that the *Bibiana* should be compared [34-5]. The form of her body is revealed in only the most general way by the bulky folds of drapery, in which we find the variation of texture and the lively movement we have come to expect. The comely neck and head of the virgin have a quality not wholly ascetic: a spiritualized sensuality typical of the seventeenth century. In this and other aspects the *Bibiana* is a close relative of the women painted by Pietro da Cortona, the great painter and decorator of the Roman seicento. As it happens, Pietro executed his first public commission on the nave walls of the same church at this time and the contact between Bernini and his older but less precocious contemporary must have been fruitful for both.

The decoration of St Peter's provided Urban VIII with his greatest artistic challenge. This huge basilica, begun more than a century earlier by Bramante for Pope Julius II, had only recently been completed with nave and façade. The architect of this addition, Carlo Maderno, was still alive, but the decoration of the church demanded the genius of Bernini. From 1623 until his death fifty-seven years later he was rarely without some project for the embellishment of that mammoth organism. Our sources tend to quote Annibale Carracci much as New Testament writers recall the Prophets and in his decoration of St Peter's, Bernini supposedly fulfilled a significant prophecy by Annibale which, though suspect, is worth quoting. One day the great painter was watching the construction of St Peter's in the presence of Gian Lorenzo *bambino*. 'Believe me,' said Annibale, 'he is still to come, some prodigious artisan who must make two great monuments proportioned to the vastness of this temple – one in the centre, and one in the end.' 'Oh, if it could only be me!' the child genius supposedly cried.

The most pressing need was a canopy, or baldachin, over the site of St Peter's grave under the dome – the monument in the centre. The stupendous size of the church required no ordinary decoration. A number of more or less prosaic designs had been considered when Cardinal Barberini's election made Bernini the chosen executant. Our knowledge of the commission and its

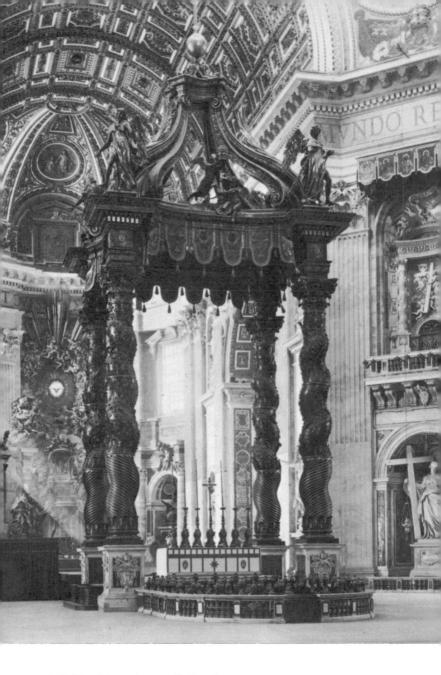

36 Baldacchino. 1624–33. St Peter's

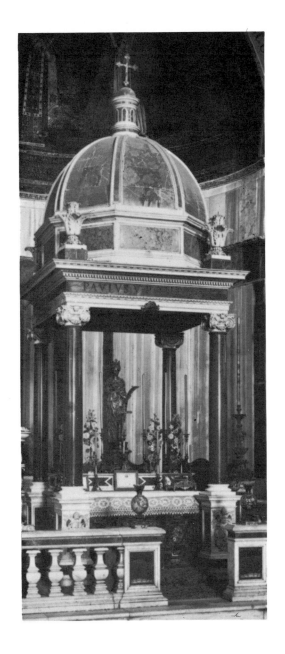

37 Ciborium. 1614–15. Sant'Agnese fuori le mura

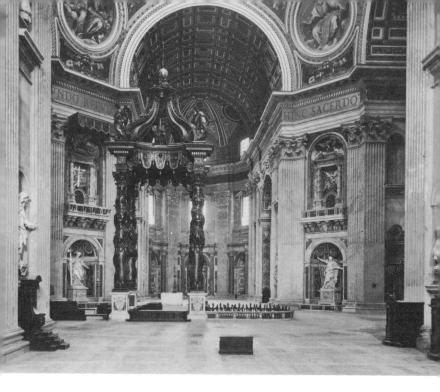

progress is still incomplete.* The decision to make giant bronze versions of the twisted Early Christian columns that had served Old St Peter's was not Bernini's, so some of the credit for the brilliant conception must be taken away from him [36]. The commission, nevertheless, occupied most of his energy from its beginning in 1624 until its completion almost ten years later. It more than taxed his personal forces, and his father and numerous assistants were pressed into service. Not the least of their problems was the acquisition of so vast an amount of metal; even the ancient bronze revetment within the portico of the Pantheon was robbed, giving rise to the famous Pasquinade:*

> *Quod non fecerunt barbari*
> *Fecerunt Barberini*

– what wasn't done by the barbarians was done by the Barberini. But even more perplexing than the technical problems were those

38 St Peter's, crossing with baldacchino, *St Helena* by Andrea Bolgi, and *St Longinus* by Bernini

of design. These can be realized only by turning to a contemporary, conventional solution [37]. Substitution of the twisted vine-covered columns for traditional ones was merely a first step in the design; once it had been taken, the crowning feature still remained a problem, and one that Bernini could not solve immediately. A print purporting to show his design in 1626 shows a figure of the risen Christ standing above the twisted columns on crossed metal bands. In 1628 Bernini may have settled temporarily on the traditional dome [cf. 37]. The ultimate triumph of four great volutes joining over the centre to support the symbolic orb and cross was the product of much thought and experimentation. The change from a more mechanical solution with a traditional figure to an organic, lively crown embodying fantastic architecture and decorative forms as well as figures is a characteristic of Bernini's evolution in the years before and after 1630 and can be found in his fountains and other decorative works of this period.

The original meaning of 'baldachin' is a silk cloth from Baghdad (*Baldacco* in Italian) and, by extension, a rich fabric of silk and gold. In the Middle Ages a canopy of rich material was called a baldachin and ceremonial canopies were used by medieval artists to indicate a person or spot of special importance. Bernini's bronze monument consequently displays gilt bronze hangings between the entablatures of the columns. Above, putti exhibit the papal regalia and hauntingly beautiful bronze angels seem to hold the volute crown in place. The Baldacchino of St Peter's is the tomb-marker of Christ's earthly successor, the symbolic foundation stone of the Church. It thus stands as a triumphant symbol of the resurgent strength of Roman Catholicism and is at once a memorial, tied to Early Christian antiquity in form (the twisted columns) and reference, and a brilliantly successful decoration [38]. It is also a very personal monument to Pope Urban VIII; bees and suns, the heraldic symbols of the Barberini family, are spotted all over the Baldacchino, and the vine on the twisted columns is the Barberini laurel.

The Baldacchino is the first Baroque monument of world significance. It freely combines natural, architectural, and decorative forms and fuses them into an amazing whole that functions

not only as a symbol and as a tomb marker but also as a mediator between us and the irrelevantly large dimensions of St Peter's. This act of mediation is performed by the perfect proportional integration of the Baldacchino into its setting and, more significantly, by its own intermediate status as a hybrid of sculpture and architecture. Its lively, active outline, moving upward to the triumphant crown of volutes, its dark colour heightened with burning gold, make it more like a living organism than any previous monument. The Baldacchino is an unusually effective reference between the visitor and the architecture because its magnificent variety encompasses both the human and the abstract.

Bernini may well have been relieved when the gigantic monument was finally finished – despite his own contributions and the help of assistants, it cannot have been mere modesty that led him to comment in later years that 'the work came out well by luck'. The Baldacchino is the first work to demonstrate Bernini's unparalleled executive talents, and it is therefore at the Baldacchino that we first meet a recurrent problem connected with almost all of his later work: to what extent is it actually by Bernini? Many of these questions are still far from solution – part of the continuing fascination of Bernini studies.

While work on the Baldacchino was under way, Bernini was put in charge of the decoration of the four great piers that support the dome [38]. The basilica of St Peter's houses a number of hallowed Early Christian relics, four of which are of great importance. Bernini projected four colossal statues, each almost three times life-size, relating to these relics: St Helena with the True Cross, St Veronica with the Sudarium, St Andrew's Crucifixion, and St Longinus, the Roman Centurion, with the spear. The actual relics were housed above the figures in shallow niches decorated with reliefs and framed by the original Early Christian twisted columns. The entire design was Bernini's; his own share of the execution was the *Longinus*, begun in 1628 or 1629 [39]. Like so many other large projects from this time on, work progressed haltingly and many commissions overlapped – an absolutely chronological approach cannot be maintained.

Although the marble statue of *Longinus* was executed between

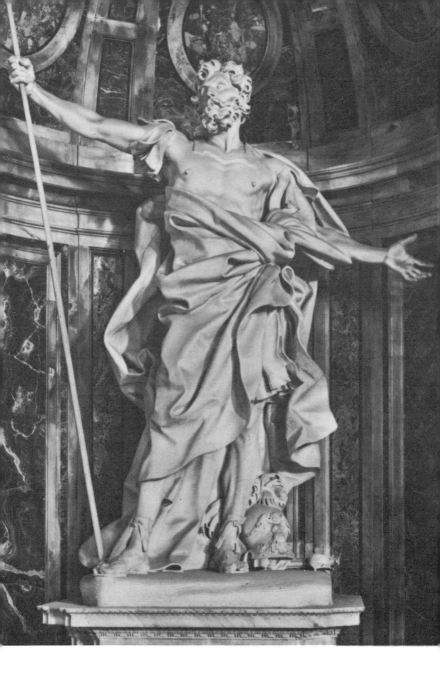

39 *St Longinus*. 1629–38. St Peter's

1635 and 1638, its conception apparently belongs to the years around 1630. Bernini had never done so large a figure and he prepared it carefully. A contemporary, Joachim von Sandrart, reports that he saw almost two dozen small clay models of the figure; at least one survives [40]. This *bozzetto*, as such models are called, shows Bernini's ideas in the course of development. The body has a graceful sway that was later given up and the drapery is as yet uninteresting – it follows the lines of the body with a perfunctory classicism. Such a small model was created in the process of working out the general pose and stance of the figure. In company with the three artists he had chosen to carve the other statues, Bernini also made a full-size stucco model, finished in mid 1631, which was set up in the niche in order to judge its effect. Bernini arrived at his final solutions only after thought and work on many different levels.

40 (*above*) *Bozzetto* for *Longinus* 41 Detail of plate 39 →

Longinus, like *Bibiana* [33], is in a niche; there is no doubt what view is emphasized. The firmly grasped spear (the relic preserved above) and the outstretched arms describe a triangle framing the sturdy figure. Despite the implications of space, the movements of the *Longinus* are essentially two-dimensional. The soldier who pierced Christ's side looks up at the crucified man and exclaims: 'Truly, he was the son of God.' Helmet and sword are at his feet; his armour is all but covered by the dramatic drapery, tied under one arm, that billows around his back and falls down behind. The excited play of folds reinforces the emotion expressed by the figure, whose emphatic pose and gesture conjure up a vision of Calvary within the light-filled dome and include us among the witnesses.

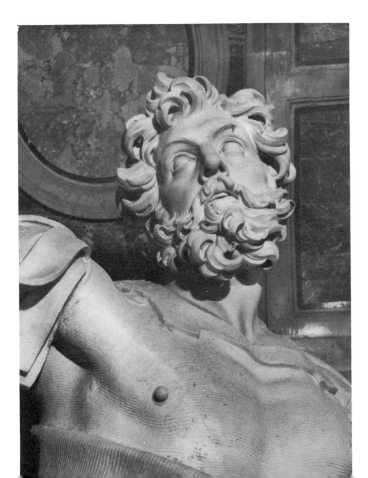

Bernini's conception of *Longinus* was based on a distant view. The statue base alone is higher than a man and the figure had to be meaningful across a great space [38]. The gesture is clear and dramatic; the drapery is notable for its strong play of light and dark. In such a work Bernini could not fuss with niceties of local textures – he needed broad contrasts and large, striking forms. For this reason the entire surface of the statue was left with a ridged or striated finish – fine and shallow for the skin, coarser and deeper for the drapery, which is carved broadly, with bulky folds and deep cavities. These grooves, created by the toothed chisel, are noticeable only nearby [41]; the effect from a distance is one of unusual richness: the ridged surfaces catch the light, giving a subtle inner modulation to the large forms that create so dramatic a pattern of highlight and shadow. The grooving adds a velvety texture, a series of vibrant transitions from dark to light. This coloristic *chiaroscuro* is to be compared with contemporary paintings by Lanfranco and Guercino, where just such light-dark effects were exploited for dramatic and emotional purposes.* A non-imitative textural colorism is achieved through careful attention to the optical effect *in situ*.

The other three statues, finished to a conventional polish, are far less impressive. From a distance their inner subtleties are lost; transitional forms and shadows tend to flatten out. If we compare the *Longinus* with Mochi's *St Veronica*, which is the most venturesome of the others, we can immediately see the difference; from afar the fine folds of *Veronica*'s dress become mere hairlines [42]. The polished marble surfaces break up into a torrential linear flow and the whole figure, despite its alarming (and unmotivated) activity, is less effective than Bernini's and far less successfully composed within its niche. The comparison is telling, but it contains a note of sadness: Mochi had been the first to break with the formulas that had stultified late sixteenth-century Roman sculpture; although his influence on Bernini was probably slight, he is one of the real heroes of early seventeenth-century art. Mochi's activity continued for years, but we can see how readily Bernini outdistanced him. The other sculptors of the crossing statues may be quickly mentioned: Andrea Bolgi (*St Helena*,

[36]), a favourite assistant of Bernini's during the 1630s, was a pedantic practitioner of his master's idiom. Francesco Duquesnoy (*St Andrew*) was, after Bernini, the finest sculptor in Rome, but his strength is best exhibited in intimate works.

We have analysed Bernini's pictorialism, his desire to create a three-dimensional picture which contrasts so strongly with Giovanni Bologna's style of complete autonomy and multiple views. Bernini rejected this aspect of late sixteenth-century style but his sculpture does not return to the simple statuary ideal of the Renaissance. The *Longinus* is the best possible example of his new concept of statuary. Although made for a single point of view, it does not reflect the shape of an original block of stone. An open, broken profile is Bernini's greatest point of contrast with

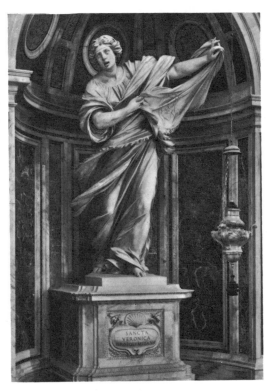

42 Francesco Mochi, *St Veronica*. 1629–40. St Peter's

Michelangelo [39; cf. 43/25], who had an almost mystical idea that every block of marble enclosed an ideal figure that the sculptor was duty-bound to release. The finished statue consequently had the contained, blocky aspect of its original home (or prison as Michelangelo thought of it). This theory gave rise to the idea that a good piece of sculpture could be rolled down hill without harm: its form was true to the original block [cf. 43]. Later sixteenth-century sculpture tended to abandon this approach: the statue no longer reveals the shape of its block [17]; indeed, much of the

43 Michelangelo Buonarroti, unfinished '*Slave*' for Tomb of Julius II. *c.* 1519

best late sixteenth-century sculpture is bronze, worked up from little models. Bernini took what he wanted from both styles. The *Longinus* is frontal, but it contains no clue to the form of an original block – in fact, it is made up of several pieces of marble. The arms of *Longinus*, flung out in the air, project far beyond the plinth on which he stands. His form penetrates the space around him in an irregular and dynamic way – or, conversely, the surrounding air moves deeply into the area occupied by the figure. We can no longer speak of the boundary of the statue nor define its area: solid and space commune actively, in detail as well as in the whole. The drapery of the *Longinus* is spatially alive, and the colorism of which we spoke is a function of this movement. These stylistic features begin with the *Neptune* and *Pluto and Persephone* [15; 16], but they reach a climax of dramatic emotion in the *Longinus*. The form, strictly speaking, is following the meaning or function of the statue. As Bernini's works become more and more related to the space around them psychologically, so do they physically.

Longinus is the most significant statue Bernini had executed up to this time; it culminates the artistic revolution initiated by the Borghese sculptures. Unlike those early works it is religious, and specifically Catholic, in subject. With the *Bibiana*, and then more impressively with *Longinus*, Bernini began to use his dramatic, spatially active, psychologically intense style in the service of his Church. This is perhaps the most important fact about the statue. Bernini's early virtuoso pieces were Ovidian in subject and prodigious in technique. His growth from prodigy to mature mastery coincides with a change of patron and the change from pagan to Christian subject matter. *Longinus* represents a forward step in Bernini's art and adapts this style to religious imagery appropriate to the *Ecclesia Triumphans*. The *Longinus* makes rhetorical and dramatic a conversion that must necessarily have been private and internal. It aims at emphatic participation in an experience that, in fact, could not have taken place so openly. There is nothing cheap or 'theatrical' in this process. All visual art communicates by making thought and emotion external. Bernini did this with more dramatic force than any of his predecessors but he belongs in the great tradition of Italian rhetorical art that goes back to

Giotto and to antiquity. In the *Longinus* Bernini first discovered the 'objective correlative' of religious emotion. He expressed the immediacy prescribed by St Ignatius in his *Spiritual Exercises*, not by naturalistic dissection or surface realism but by an empathy that for the first time identified the personal religious aspirations of the Catholic worshipper with a spiritual hero of Early Christian times. *Longinus* is merely the first of the great succession of sinners whose life was illuminated by the revelation of Christ's divinity and the relevance of his sacrifice.

Previous to the *Longinus* Bernini had gone little further than his painted and sculptured prototypes. His contribution in those years lay in his translation of the dramatic imagery of painters like Annibale, Caravaggio, and Rubens into three dimensions [cf. 7; 28]. His transformation of the Hellenistic heritage and his ability to rival painting are the main keys to Bernini's art in the 1620s. The whole process must have seemed easy and logical to him, just as it did to his followers once he had shown them the way. He simply had a broader conception of sculpture than that of his predecessors: with a technical virtuosity that allowed him to paint in marble, he was free to open a new era.

In portraiture we can follow a parallel development. In the years after Urban VIII's coronation Bernini was far too involved with the Baldacchino and other large commissions to accept many sitters. Such a bust as the *Francesco Barberini*, done before 1628, can stand for a few other examples [44]. It is a posthumous portrait of the man who was Maffeo Barberini's first protector and must have been worked up from drawn and painted records. It is one of a series of busts of the Pope's family and ancestors, doubtless executed in part by assistants. We notice some of the reticence of the *Montoya* [29], although the *Barberini* lacks its high finish and acuteness of observation. The worthy man stares out at us from blank eyeballs. The head is clear and forceful in its plasticity but the individual forms are not delineated with great attention to detail: it is conceived for a general impression. Some changes in format from the *Montoya* may be remarked: the shoulders and upper arms now jut out forcefully, the line of the bottom cuts in at an acute angle toward the base. Compared with the roughly segmental outline of the *Montoya* this is a less ornamental, more virile and immediate depiction of the upper body.

The first bust to achieve the quality of the *Montoya* and to supersede it in style was, appropriately, a portrait of Bernini's first great patron, Cardinal Scipione Borghese [d. 8 October 1633; 45].* The press of Barberini commissions had put Bernini out of even Borghese's reach and we are fortunate that the sculptor found time for this final tribute. One source claims that the Pope himself ordered Bernini to do the portrait. Perhaps Borghese, who had been instrumental in Barberini's election, called upon Urban's friendship in order to have his favourite released to do this bust, which dates from 1632. The result is not only a precious document of a great patron portrayed by a great artist; it is also a milestone in the history of sculpture and one of the finest portraits of all time. Under the circumstances one might call it a labour of love; we are also told that Bernini was very richly paid.

In the course of completing the bust Bernini executed a legendary *tour de force*. The story is told most convincingly by Baldinucci, who relates that when the bust was almost completed Bernini discovered a flaw in the marble that ran across the forehead,

disfiguring the work [48]. In order to fulfil his commission the virtuoso made a copy in secret – according to Baldinucci, in fifteen nights; according to Domenico Bernini, the job took only three days and nights. Baldinucci goes on to tell how Bernini showed the defective bust to Cardinal Borghese, who tried nobly to hide his disappointment. When the sculptor produced the second version, the patron's immense delight indicated how unhappy he had actually been with the first. The copy is almost as good as the original, and even if it took double Baldinucci's fifteen nights it is a remarkable achievement. Many years later (according to Baldinucci it was forty) Bernini toured the villa Borghese with Cardinal Antonio Barberini; upon seeing the two busts of Cardinal Borghese, he is reported to have said: 'How little progress I have made in the art of sculpture in so long a stretch of years, when I realize that as a boy I worked marble in this way.' Bernini seems to have given the impression that the bust of Scipione Borghese was done in his extreme youth; but he was right in calling attention to the virtuoso treatment of the marble. The extroversion and immediacy of the groups done some ten years before for the same patron are transposed for the first time into the realm of serious portraiture. The Cardinal is shown in the act of speaking and moving; the action is caught on the wing, at a moment that seems to reveal all the characteristic qualities of the subject through typical unconscious action.

The Cardinal appears to react as a conversationalist to some unseen companion. His extraordinarily impressive gaze glints in the light – the product of pupils carved like inverted gunsights. Since we have before us only a single bust, we are invited, even forced, to include ourselves in the group. In this it is like the *David*; both seem to demand an actively participating audience to complete the action. *Borghese*'s involvement with the living world gives the stone bust a new dimension of reality that can tell more of value about the inner qualities of a sitter than does either tactile naturalism or its opposite, allusive blurring and incompleteness of form.

In order to achieve the immediacy that makes us feel the Borghese bust is actually alive and breathing (as Bernini's friend

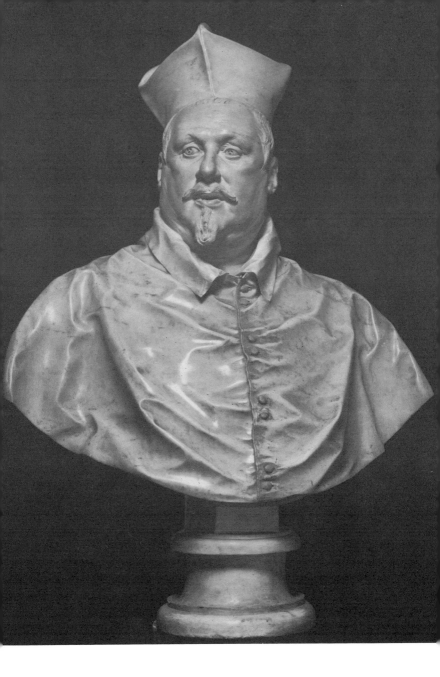

45 *Cardinal Scipione Borghese*. 1632. Galleria Borghese

46 *Cardinal Scipione Borghese*

the poet Fulvio Testi remarked), Bernini relied on a novel preparatory device. Instead of taking a likeness from a formal sitting he watched and sketched his subject in the act of carrying on his daily affairs, trying to record the liveliness of the sitter as well as the likeness. For this purpose he made rapid sketches of the Cardinal in action. The process was fully explained by Bernini over thirty years later when he worked on the bust of Louis XIV. He was then quick to say that he did not rely on sketches when carving but rather used them as a means of steeping himself in the features of the King. (For the general composition we have seen that he relied on another kind of sketch: the clay model. Since there are no surviving models for the Borghese bust we can only imagine that he must have used this means too in preparation for the final marble.) Luckily, the only preserved example of these lively sketches from life illuminates the creation of this most lifelike of all portraits, a magnificent profile in chalks now in the Pierpont Morgan Library in New York [46]. It seems fitting that the first of Bernini's 'speaking likenesses' should be documented by this mercurial sketch. Bernini himself prized drawings highly and once said that artists' drawings were often better than their finished works. Bernini's sketches were essentially preparation for his revolutionary statuary: thanks to them he was able to preserve an improvisory impression in the completed marble, even when it was highly finished. This is very 'modern' of Bernini and helps to explain why his works are enjoying renewed popularity with contemporary sculptors.

We do not have to look far to find the roots of Bernini's new portrait formula. The Morgan drawing is itself the key, for it was surely the tradition of drawn and painted likenesses that produced Bernini's pictorial portrait busts. Bernini himself practised such painted portraiture. The turn of the head, the parted lips, the expressive gaze, all are found in Bernini's paintings of the period of the Borghese bust and earlier [Frontispiece]. If we then ask ourselves where else in contemporary painting such faces are to be found, one's first answer would be in the productions of the Caravaggisti [cf. 7] and particularly the Northern followers of that revolutionary Italian master. The transient pose, sparkling eyes,

and speaking, singing, or laughing mouth are all trademarks of the genre scenes and anonymous portraits of lower-class people that were so loved by the Northerners. We have noticed relationships between Bernini and Caravaggio in those early self-portraits, the *Anima Dannata* and the *David* [6; 26]. The *Scipione Borghese* in no sense falls into the category of frozen grimace although it may owe something to the liberating experience of such experiments. We come closer to this kind of portrait in some of the faces in Caravaggio's own paintings, and Annibale Carracci had pioneered an informal portraiture in which a momentary pose is caught with sympathy and virtuosity. The tendency was in the air early in the seventeenth century; Bernini grew up with informal portraiture around him and this is the way he saw himself and his friends. Domenichino's '*Sibyl*' in the Borghese Gallery is an example of this style in its idealized form [47]; the girl's attention seems just to have been called: her head lifts and twists, her eyes turn in anticipation or alarm, her lips part as if to speak. Here, perhaps more than in the work of the boisterous Caravaggisti, we have the kind of antecedent we seek. But the painted prototypes of the *Borghese* are phlegmatic, dispirited creatures compared to those created by Bernini's electrifying imagination, which approach

47 Domenichino, '*Sibyl*' (detail). 1618

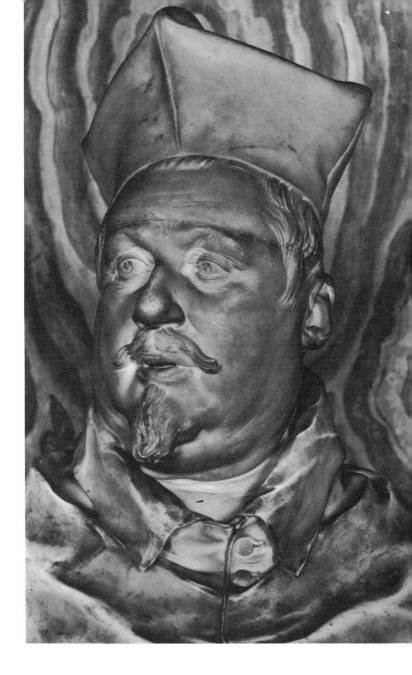

48 Detail of plate 45

reincarnation. And so sculptured portraiture, which had lagged behind the painted in psychological interest and emotional communication, with this single work leaps far ahead.

In the *Borghese*, Bernini gathered up the lessons learned from his predecessors and contemporaries and with characteristic ease rendered them obsolete. This holds true for his own works as well. Despite its realism, the *Montoya* [29] lacks animation. Compared with the over life-size bust of Cardinal Borghese the little *Montoya* head resembles a death mask. Standing before the Cardinal's portrait in the Galleria Borghese, we seem to be in the breathing presence of the sybaritic prelate [48]. Bernini's *Borghese* is the first example of serious sculptured portraiture done in the new informal fashion. The formal portrait is the last category of representational art to succumb to new trends – the same slowness has always been remarked in the persistence of the profile portrait in quattrocento Florence. Only an artist of Bernini's standing and familiarity with the great could dare to institute this mode of informal portraiture in stone, just as only he could bring it off.

The Borghese bust, then, realized in portraiture what Bernini had already achieved in his large statues, but with the more realistic surface and subtler attention to psychological niceties appropriate to a portrait. Once achieved, it too entered into the common repertory. Apart from the immediate influence of the *Borghese* on sculptural portraiture by other artists, a subject outside the scope of this book, it is instructive to turn to two related portraits more or less by Bernini: the busts of Thomas Baker and Paolo Giordano Orsini [49–50]. Both of them may be considered marginal in a book concerned with only the highest achievements of Bernini's career but a brief discussion will at least illustrate the range of quality and the varying degrees of personal execution possible in works of the same type that are still 'by' the master, and will also hint at some of the problems of attribution that beset the specialist when he is dealing with works that are not obviously, or entirely, autograph.

In 1635 Bernini received a commission for a marble portrait of King Charles I of England that was executed the following year

49 *Thomas Baker* (detail). *c.* 1638

with the help of Van Dyck's famous triple portrait. The bust, destroyed in the Whitehall Palace fire of 1698, was politically significant since Urban VIII made it a gift to the Catholic Queen. The bearer of the triple portrait from England to Rome was apparently a Mr Thomas Baker, and all the sources testify to the persistence of a certain Englishman who demanded a bust by Bernini. Despite his other obligations Bernini finally acceded to the importunate young man in order to demonstrate to the English the quality he could achieve when working from life. There was another reason too: the Englishman was rich and offered Bernini a highly inflated price, six times the payment he had received for the *Scipione Borghese*. Bernini seems to have blocked out the entire bust and finished the face and some of the hair when orders from the Pope commanded him to stop: the

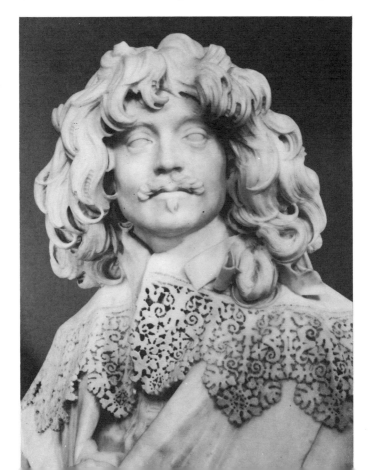

English sculptor Nicholas Stone entered into his diary in October 1638 that

... it fell out that his patrone the Pope came to here of itt who sent Cardinal Barberini to forbid him ... for the Pope would have no other picture sent into England from this hand but his Mai[es]ty.

In this way Urban VIII was able to heighten the diplomatic importance of his gift; but Bernini was unwilling to give up the work – or the money – and so, while claiming to abandon the bust he actually handed it over to an assistant, probably Bolgi, for completion. The portrait, now in the Victoria and Albert Museum, is consequently only partly executed by Bernini [49].* The stiff lace, done with boring precision, the drapery, and some of the great mane of hair are not his. But *Mr Baker*'s handsome face is a work by Bernini of high quality, though less vibrantly alive than the miraculous *Borghese*.

51 Caricature of a cardinal ('Scipione Borghese')

In a bust of the Duke of Bracciano, Paolo Giordano Orsini [50], Bernini pushed the new portrait method initiated in the *Borghese* across the borderline of characterization into caricature – reminding us that Bernini was a brilliant caricaturist with the pen as well, one of the earliest and best exponents of the genre [51]. The *Orsini* offers still another example of variation in quality. The conception, which pillories the Duke for all time, is clearly Bernini's. When compared with the *Borghese*, however, it looks distinctly unfinished; we can almost consider the bust a marble sketch. Forms are generalized; the wonderfully tousled hair is given a generic treatment that bespeaks haste on the part of the master rather than careful execution by a pupil. The broadly executed head is supported by a draped body *all'antica* that actually was left unfinished – but in this section we are surely dealing with the work of an assistant.

The scope of Bernini's female portraiture was equally wide, but he had fewer opportunities to display it. One side of his style at this time is represented by the tomb monument to Countess Matilda of Tuscany in St Peter's, which was executed between 1633 and 1637 [52]. Its interest is chiefly symbolic, for Matilda, an eleventh-century ruler who ceded her territory to the Holy See, had significantly bolstered the temporal authority of the popes. Urban VIII, like his predecessors a century before, was a vigorous, if unsuccessful, secular prince as well as the spiritual head of the Church. The Matilda monument offers a revealing insight into Urban's thoughts at this time: the relief on the Countess's tomb represents the Emperor Henry IV at Canossa, kneeling before Pope Gregory VII. Execution of the monument was done in large part by assistants after Bernini's designs and models, and the results show it. The contrast with the Borghese bust is striking. The idealized image of this historical benefactress failed to arouse in Bernini his customary imaginative response; various reasons have been suggested, including an illness in 1635 mentioned by his son Domenico. But if the statue is disappointing as a 'portrait' it is fascinating as an early indication of Bernini's interest in amalgamating sculpture with its architectural setting (cf. pp. 130 ff.).

The best antidote to the chilly *Matilda* is the famous portrait of Costanza Bonarelli [53–4]. This feral creature was the wife of an assistant; she became Bernini's model and his mistress. The bust is a unique private record, a petrified fragment of passion – 'more a piece of life lived than a work of art'. References to the body are abbreviated: a carelessly open chemise begins to reveal a breast, but the bust is rounded off at this point in order to concentrate on the features of the fiercely voluptuous face. Her lips are parted; the hair has been swept back loosely in a bun and falls in easy loops and, possibly, rather dirty strands. As in the face of *Scipione Borghese* we seem to see the pulsating life beneath the skin, are made to feel the different qualities of flesh, now taut, now soft. The averted eyes, carved like bullseyes, give diffused focus to her gaze. In this intimate bust Bernini cast aside all the rhetorical elements of public portraiture. We may here speak of a 'naturalistic' portrait as we can of no other marble bust of the seventeenth century:

52 Tomb of Countess Matilda of Tuscany. 1633–7. St Peter's

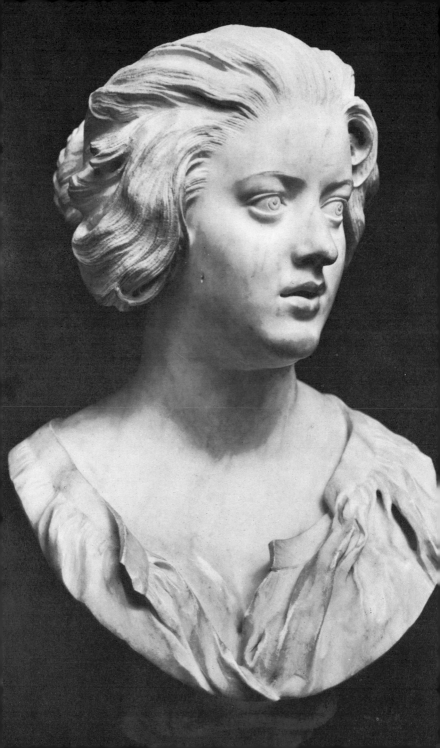

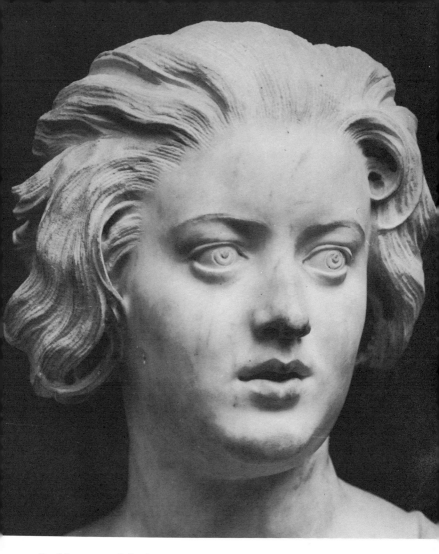

for his own satisfaction Bernini created a style that was not to exist otherwise for another century or so. The *Costanza Bonarelli* is a false dawn of the unvarnished naturalism we associate with the later eighteenth century and, in marble portraiture, specifically with Houdon. Its antecedents are painted portraits of the most informal type and ancient Roman portrait busts.

← 53 *Costanza Bonarelli. c.* 1635 54 (*above*) Detail of plate 53

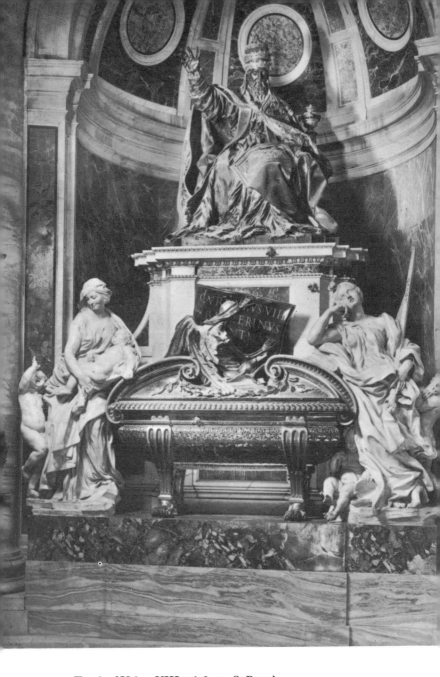

55 Tomb of Urban VIII. 1628–47. St Peter's

Such is the gallery of Bernini's portraits of the 1630s. They alone would establish a reputation. We have, however, deliberately omitted one important genre, the portraits of the Pope. It was inevitable that Bernini should carve a great series of images of his friend and protector; we can here single out only two. The first, surmounting his magnificent tomb in St Peter's, is much more than a portrait and demands detailed discussion. The second, perhaps Bernini's finest papal bust, needs no special pleading [31]. The ageing Pope seems to be in a reverie; his hooded eyes are sunk into sockets creased with worry. Years of responsibility have saddened the poet's face. Here is a man, disastrously unsuccessful in affairs of state, humiliated by nepotism, who was an artistic patron of imagination and insight, a great humanist, a dear friend.

Although the tomb was finished only after the Pope's death in 1644, the sober and vigorous image on it is several years younger than that of the bust [55]. Planning for the monument probably began as early as 1627, twenty years before it was unveiled. When the decision was made to use the niches in the crossing of St Peter's for *Longinus* and the other statues, the mid sixteenth-century tomb of Pope Paul III had to be placed elsewhere. This was the opportunity to plan a pendant memorial to Urban VIII; the older tomb was placed in a new niche left of the high altar and a similar niche was made for Bernini's monument. It was thus fore-ordained that Bernini should provide a variant of the tomb of Paul III [56] and so break with the more recent vogue for wall tombs with carved reliefs, such as the one of Clement VIII in Santa Maria Maggiore on which his father had worked. The sculptor of the tomb of Paul III, Guglielmo della Porta, had modelled the general scheme of his memorial and the form of the reclining figures on Michelangelo's Medici tombs in Florence.* Bernini's solution is a much more imaginative interpretation of this exemplar. The seated Pope, in gilt bronze, gives a commanding sign of benediction. His throne rests on a high base rising behind the ornate sarcophagus of marble and bronze. To left and right stand marble Virtues. A number of Barberini bees have alighted capriciously on the sarcophagus and statue base – Bernini liberated heraldry as he did everything else. The agglomeration is fused by a brilliant conceit:

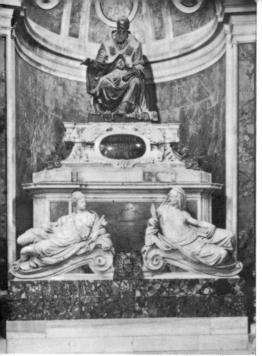
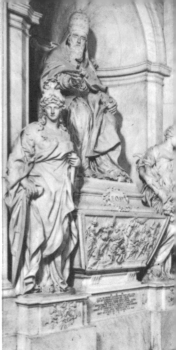

a skeletal *Death* above the coffin inscribes the name of Urban VIII in gold letters on the bronze tablet that will serve as the epitaph. Compared with the earlier tomb, Bernini's is more vertical, with greater emphasis on the figures. The entire composition builds up pyramidally to the summit; its triumphal reference outward to the spectator is aided by the imperial gesture of the Pope and by the very human personifications who lead us in. By contrast the *Paul III* is an elegant exercise, the figures are recessive, and even the architecture of the base is confusing. Bernini concentrated the specifically funereal elements in the centre of his composition: they are essentially in bronze and allow the marble statues at the sides to assume an unwonted lifelikeness. Unlike those on the earlier tomb, they stand and react.

The Pope's regal salutation of blessing breaks decisively with the spirit of the tomb of Paul III, where the gesture is gentle, almost private. Bernini's Pope is swathed in robes full of complex movement and texture. Only his mitred head and upraised hand

<table>
<tr><td>56</td><td>Guglielmo della Porta
Tomb of Paul III Farnese
1549–75. St Peter's</td><td>57</td><td>Alessandro Algardi
Tomb of Leo XI Medici
1634–52. St Peter's</td></tr>
</table>

project significantly – a ceremonial, official dress and benediction that engage our attention from afar. The same change from contemplative introversion to dramatic engagement is found in the allegories. Della Porta's personifications recline elegantly and look meaninglessly into each other's eyes. Even the sex of the *Prudence* is unclear. Bernini's marble personifications, executed in the 1640s, represent *Love (Caritas)*, the greatest of the Christian virtues according to Paul, and *Justice*, chief of the Cardinal virtues. *Love* is a marble Rubens, who holds one child to her breast (covered out of respect for the place) and turns to comfort the other, who squalls uncontrollably. *Justice*, refined and womanly, sinks back on the sarcophagus 'in an ecstasy of sadness'. Although these figures are personifications of Urban's virtues, they also serve as mediators in our own grief over his loss. Bernini's personifications are not bloodless anagrams but lifelike actors who participate in our world while belonging to another. These dual roles are Bernini's characteristic contribution: they form part of a *concetto* or, as the word was used in seventeenth-century English, a conceit. Like the other works of Bernini's maturity, these figures create their own theatre. Instead of decorating a passive memorial they enact a dramatic spectacle. The skeletal *Death* carries the drama and movement of the marble figures into the realm of the memorial *per se* and demonstrates the meaning of the sarcophagus below.

Bernini's dramatic clarity gave ideal expression to the religious attitudes of his age, and the contrast of gilt bronze and milky marble was exploited with a richness that had never been seen before. Baldinucci said that this 'great miracle of art' was itself worth the trip to Rome (he himself had only to travel from Florence), and the monument was one of Bernini's greatest triumphs; at the unveiling in 1647 even the unsympathetic Innocent X was forced to exclaim: 'They say bad things about Bernini, but he is a great and rare man.'

The tomb of Urban VIII was of great importance as a model for later Baroque tombs. Its most immediate influence was on the tomb of Leo XI by Alessandro Algardi (1598–1654), which took over the form but discarded the drama [57]. The contrast between the two artists is nowhere clearer: Algardi avoided the

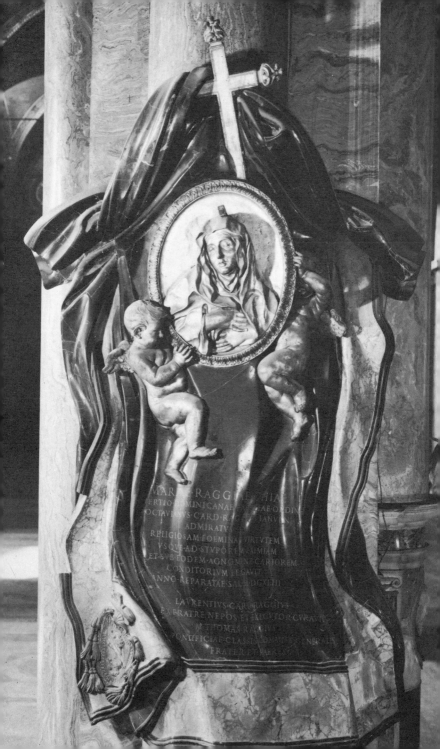

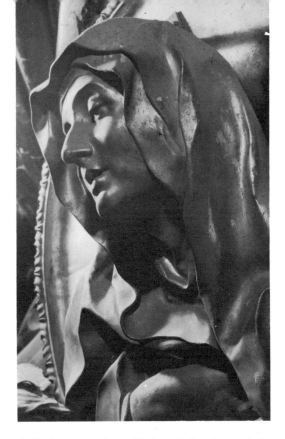

coloristic play of gilt bronze and marble just as he shunned the transitory *concetto* embodied in Bernini's writing skeleton. Algardi's tomb, restricted in size because of the site, is in numberless ways a representative work of the mid seventeenth century, a work of high quality; comparison with the tomb of Urban VIII illuminates Bernini's radical position among Roman artists of the time.

With the versatility we begin to take for granted, Bernini turned from the formal grandeur of the papal tomb to create a completely new kind of memorial. The tomb of the nun Maria Raggi (1643) culminates a little series of small but novel designs [58]. Varicoloured marble relief is carved to depict blowing drapery; before it, two flying putti carry a gilt-bronze portrait medallion [59].

← 58 Tomb of Maria Raggi. *c.* 1648. Santa Maria sopra Minerva
59 (*above*) Detail of plate 58

The whole is surmounted by a cross that seems also to act as a large stick-pin fastening the cloth to the pillar. Perhaps the most remarkable aspect of the whole is its colour. We have noted Bernini's interest in colorism, even when he was working mono-chromatic materials. In the 1630s and 40s he grew fond of the actual play of rich colours and textures, probably because of his work on the tomb of Urban VIII. Bronze and marble fascinated him in combination; here the result is a *tour de force*. It is above all the idea – the *concetto* – that is brilliant and novel. The Raggi tomb presents a many-layered tissue of meaning. The drapery seems to blow aside to reveal a portrait of the dead woman. But the portrait is also an apparition, carried upward by the putti as her soul must have been wafted to heaven. Bernini conjured up a visionary likeness and petrified the evanescent. He created such iconoclastic images not to shock, but to attract the observer to the inner meaning of the work. Portrait, memorial, devotional image, heavenly revelation: Bernini fused these disparate genres into one. Approach the tomb in any mood we will, we end by experiencing them all.

Bernini's fountains are one of the glories of art, his most obvious contribution to the Roman scene, and the Triton fountain in the Piazza Barberini is as hauntingly evocative an image as his restless mind ever created [60–1].* Rome is rich with fountains, but before Bernini they had been essentially architectonic – geometric forms, often stacked one above another [cf. 82]. The Triton is a typical Roman fountain come alive. As if by magic, the anthropomorphic bent of the sculptor's imagination has transmuted the familiar into pure poetry. Four dolphins rear up from the pool, a huge shell opens wide, and from it emerges the sea god. The generic quality of fountains was never so brilliantly epitomized – the Triton is an apotheosis of moving water, myth come to life. Ovid, in the *Metamorphoses*, relates how after the flood

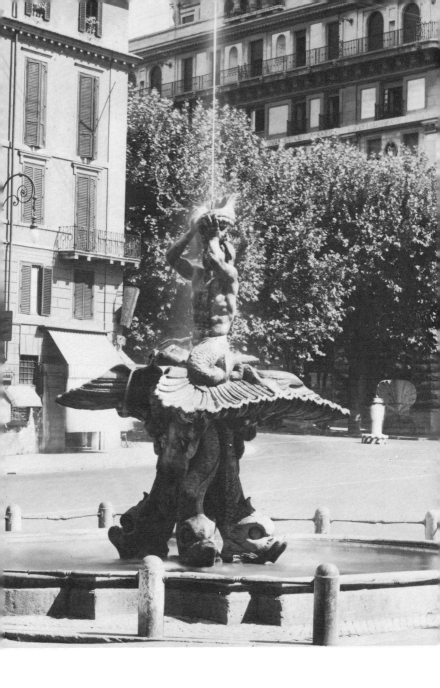

60 Triton fountain. 1642–3. Piazza Barberini

King Neptune
Put down his trident, calmed the waves, and Triton,
Summoned from far down under, with his shoulders
Barnacle-strewn, loomed up above the waters,
The blue-green sea-god, whose resounding horn
Is heard from shore to shore. Wet-bearded Triton
Set lip to that great shell, as Neptune ordered,
Sounding retreat, and all the lands and waters
Heard and obeyed. The sea has shores; the rivers,
Still running high, have channels; the floods dwindle,
Hill-tops are seen again; the trees, long buried,
Rise with their leaves still muddy. The world returns.

The *Neptune* [14] was Bernini's earliest fountain figure but despite *Neptune*'s association with the pond below, the statue can never really have fused with its watery environment. Here, with no impediments, Bernini made the now familiar jump from a decorative figure to a meaningful *concetto*, employing forms that become more deeply significant in combination than alone.

The Triton epitomizes Bernini's city fountain designs and we may pause to consider just what ingredients went into it. Tritons blowing water from conch shells were common tableau figures in rural grotto fountains; Bernini's originality lies, on its simplest level, in transplanting this familiar sea god into a Roman piazza and setting him up in a free version of the typical geometric piazza fountain [cf. 82]. The Triton was, however, also an emblem signifying 'Immortality Acquired by Literary Study'. This esoteric symbolism is probably linked with the massive papal arms entwined in the dolphins' tails. Everyone knew that Urban VIII was a Latin poet of some skill and so the Triton seems to proclaim Urban's literary immortality. The image may be even more complex since dolphins symbolized princely benefaction and the bees on the Barberini arms were recognized emblems of divine providence. The Triton thus emerges not only as a personal allusion but also as a symbol of enlightened papal government under divine guidance. The complex iconography has, however, been completely digested into the image; the Triton retains its magic whether or not we choose to see it as a meaningful *concetto* as well as an inspired civic monument.

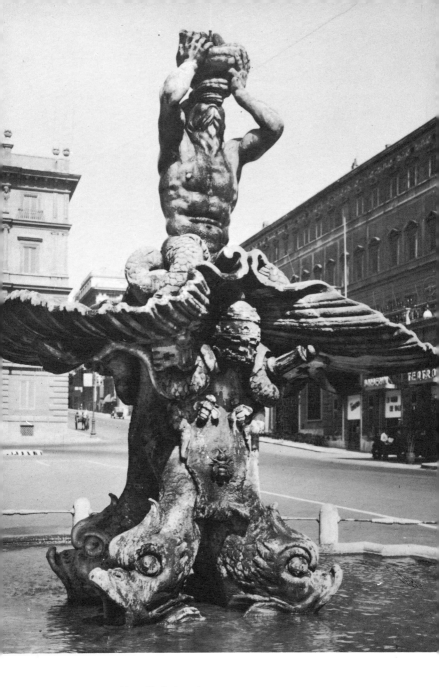

61 Detail of plate 60

In his preparatory drawings Bernini paid careful attention to the water and it is ultimately the jet rising high in the air, falling down over the sea creature, splashing noisily into his shell, and finally dripping into the pool below, that transforms the image into one of the most sublime creations in all art. There are other distinguished fountains in Rome, but for anyone who has stood in the Piazza Barberini and watched the virile sea god blow the glistening stream high from his wreathèd horn, Bernini's Triton will always be *the* fountain.

Bernini's career blossomed and came to fruition in the pontificate of his great friend and benefactor. During these twenty years his sculptural projects grew more varied, richer in content, more fertile in imagination. At the beginning of the pontificate he was producing marble versions of the most progressive kind of contemporary painting. Bernini's energetic vision infused new elements of imagination into the linear, classicizing styles of Domenichino and Reni; he was also attracted to the colour of Lanfranco and the Venetians. And despite the tendencies toward classicism that we noted cropping up in the 1630s, he emerged in the 1640s with an even more vigorous, inventive, and liberated vision.

We have mentioned that Bernini was ill in the mid thirties and for some time had to rest at home. The Pope visited him one day, a unique demonstration of affection and concern, and seems to have urged Bernini to marry and have children. (Whether or not this prescription reflects on the nature of Bernini's illness is conjectural, but we may recall that Poussin was constrained to marry because of his experience with venereal disease: to remove himself from further exposure he took a wife.) Bernini made the time-honoured reply to the Pope that his statues were his children and that for centuries they would keep his memory alive – but eventually he did marry, in May of 1639. The girl, half his age, was a Caterina Tezio, the daughter of a lawyer who could not afford a dowry. Bernini, the story goes, secretly furnished the large sum of 2,000 scudi. It has been surmised that the dowry explains his eagerness to continue the Baker bust but Bernini, already rich, was always

acquisitive. One sacrifice clearly had to be made: the bust of Costanza Bonarelli [53], which he had kept at home, was given to a friend. By this time Bernini had moved to a palazzo near the Piazza di Spagna where he lived until his death. His marriage seems to have been one of genuine affection. Caterina bore him eleven children – a Bernini would have to be prolific in life as well as art – of whom nine reached maturity.

At this time Bernini's personal religious convictions seem to have strengthened and deepened. He consorted with Jesuits and Oratorians and devotions became an important feature of each day. For years he walked to the church of the Gesù every evening for vespers; we are told that he always had a keen awareness of death. Despite his association with the nobility of Europe, he lived a simple life. His diet was largely fruit, and we see him in his self-portraits and through descriptions as a small, thin, fiery man, 'terrible in wrath'.

Shortly before the death of Urban VIII the famous Cardinal Mazarin, who was Italian and very friendly with Bernini, tried to lure him to France with the promise of an annual salary of 12,000 scudi. The Pope would not hear of it: 'Projects in France are begun in heat,' he advised, 'but end in nothing.' Besides, and this was surely the truth, Bernini 'was made for Rome, and Rome for him'. After Urban's death in July of 1644 Mazarin tried again, to no avail. Twenty years later a new king and a new minister persuaded him to go.

Bernini was more than a great artist, he was virtual artistic dictator of Rome during the second half of Urban's pontificate.* No Italian artist since Giotto had been so completely triumphant and Bernini's position naturally earned him the envy and enmity of all those who sought preferment in vain. A hostile biographer wrote of him: 'That dragon who ceaselessly guarded the Orchards of the Hesperides made sure that no one else should snatch the golden apples of Papal favour. He spat poison everywhere, and was always planting ferocious spikes along the path that led to rich rewards.' As long as Urban was alive Bernini was unassailable; after his death Bernini's fortunes took an almost fatal turn for the worse.

3. Disaster and Triumph

Urban VIII was the last pope to take a significant part in European politics. Long before he died it was clear to everyone that the papacy was no longer a power of European significance and after his death this change of status was given formal recognition by the Treaty of Westphalia (1648). Urban's successor, Innocent X Pamphilj (1644–55), inherited a far more restricted political and economic situation than Urban's had been only twenty years before. Although large-scale papal patronage at home continued for a few more years, it had ceased to be the chief magnet for European artists long before Bernini's death in 1680. In fact, Urban VIII was the last pope to have adequate funds for art; he raided the papal treasury so systematically – in part to maintain his brothers and nephews in the manner to which they rapidly became accustomed – that upon his death the papacy was very nearly bankrupt. Innocent X became the implacable enemy of the Barberini family and feeling ran so high that Urban VIII's closer relatives found it prudent to go into exile. Since the Barberini were by far the most lavish patrons of art in Rome, their departure meant further restriction of artistic opportunity. Bernini, the Barberini favourite, also suffered: the Pope was eager to hear the worst of him. Alessandro Algardi (1598–1654) became the favoured sculptor, and the architect Borromini was for the first time able to exercise his great talents on a large and official scale. Bernini remained Architect of St Peter's but even this post became a liability because of the *débâcle* of his campanili (bell towers). The façade of St Peter's, as left by Maderno, was flanked by two gigantic foundations that were meant as supports for towers. They are still in much the same state Maderno left them and give the

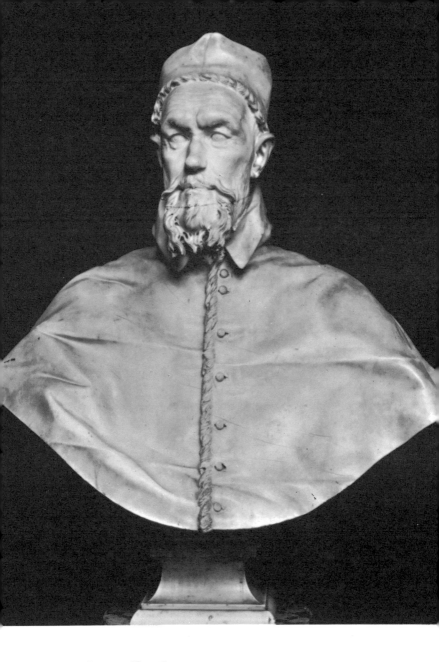

62 *Innocent X. c.*1647

façade an appearance of excessive width that was never planned or desired [81]. In order to complete the façade, Bernini made drawings and a model of bell towers to surmount these end sections; his project was accepted in 1637. Since the façade had been built over underground springs, he made technical inquiries about the state of the foundations. Perhaps his information was faulty; perhaps he did not understand its implications. After the left (south) tower was begun, cracks began to appear in the structure below. In 1641 work was stopped and Bernini was attacked from all sides, but while Urban VIII was alive he was invulnerable. As soon as Innocent X became Pope, however, Bernini's critics, hungry for commissions and recognition after his near monopoly, found ready ears. New projects were presented; Borromini and others criticized Bernini's work. In 1646 Bernini's tower was pulled down and the architect was in disgrace.

As Architect of St Peter's Bernini was also in charge of the sculptural decorations in the nave of the church, which were executed by his assistants according to Bernini's designs. These consisted of relief decorations on the piers of the nave and giant personifications of virtues in the spandrels above the arches. Most of the work was carried out in time for the Jubilee of 1650. An army of sculptors executed this gigantic decoration and each of them retained something of Bernini's style forever after.

Bernini's reputation was so great that he continued to receive magnificent private commissions despite papal disgrace. And even Innocent gradually came to see that Bernini was 'born to deal with great princes'. The means by which Bernini recovered his lost prestige are worth recounting. The Pamphilj built a large family palace on the famous oblong piazza that had served in antiquity as the field of Domitian's stadium for Greek foot-races or *agones*. (Over the centuries the name *platea in agone* gradually evolved into *Piazza Navona*.) This piazza served as the site of many Renaissance and Baroque spectacles, most notably when it was flooded. The new Pamphilj palace was, characteristically, entrusted to a conservative architect of an older generation and eventually completed by Borromini. The building stands next to a new church memorializing the martyrdom of St Agnes: Sant'

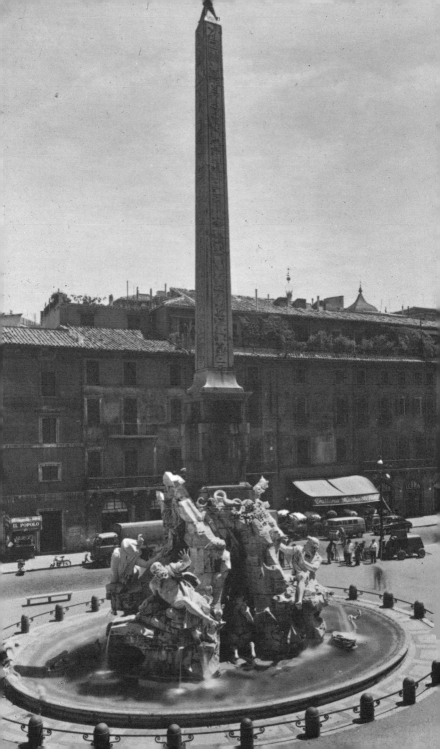

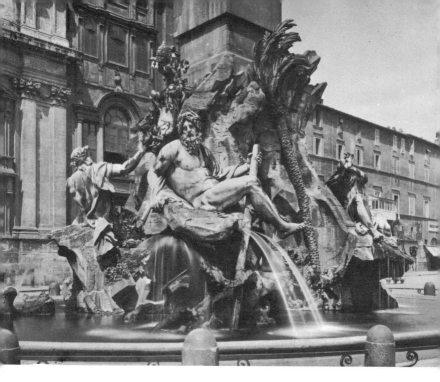

Agnese in Piazza Navona, which was also designed in part by
Borromini. Thus the piazza became a kind of Pamphilj showcase.
A giant fountain was to rise in the middle and the Pope wanted as
the central feature an Egyptian obelisk that then lay in pieces in
the Circus of Maxentius on the Appian Way. Every artist worthy
of the name was invited to submit designs for this great decoration,
with the exception of Bernini. Early in 1647 the victor seemed to
be Borromini, who had developed the idea of having the fountain
represent four rivers, and who was also responsible for bringing an
increased supply of water to feed the fountain. But Bernini's
friend Prince Niccolò Ludovisi, who had married a niece of the
Pope's, insisted that Bernini make a model too. This was secretly
placed in a room where the Pope would see it, and when he did he
was ecstatic.* Bernini envisioned a great island rock, a sort of
Ultima Thule, from which the Four Rivers of the World spring.
Each of these is personified by a statue and the whole is surmount-
ed by the obelisk topped by the Pamphilj dove – a fitting symbol

for the Church Triumphant ever expanding on the four continents [63]. After admiring the work, the Pope exclaimed: 'This is a trick of Prince Ludovisi's; we must indeed employ Bernini. . . . The only way to resist executing his works is not to see them.' The construction and carving, a work of many hands, occupied the years between 1648 and 1651. The fountain is made of travertine, the chief Roman building stone which, although not suited to the finest sculptural effects, is much quicker to work than marble. Bernini himself is traditionally held responsible for finishing the rock, palm tree, lion, and horse, all of which had to be worked *in situ* [64–5]. The marble figures of the four rivers, executed during 1650–1, were done after Bernini's designs by assistants: Antonio Raggi (*Danube* – arms up), Jacopo Antonio Fancelli (*Nile* – head covered because, according to Baldinucci, its source was long undiscovered), Francesco Baratta (*Rio della Plata* – negro with coins symbolizing the riches of the Americas), and Claude Poussin (*Ganges* – with oar). The Pope wanted to inspect the fountain prior to its unveiling in mid 1651. Bernini said he was sorry that the conduits were not ready; the Pope gave his blessing and turned to go when, with a great roar, water began to flow from all sides. Innocent declared that this surprise added ten years to

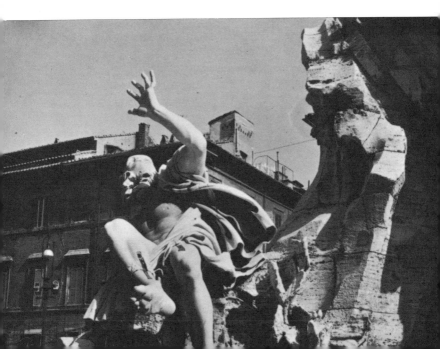

his life and although he lived less than five years more, his delight may well be imagined.

We can understand that Bernini's engineering triumph almost completely erased the wound inflicted by the failure of his campanili. And the technical difficulties were matched by aesthetic problems inherent in the site. The imposing façade of Sant'Agnese, with a dome and towers planned, lay alongside the fountain but not on axis with it. The fountain had to enhance the centre of the piazza and also maintain a satisfactory relationship with the great church. Bernini's design has much in common with the temporary festival and triumphal decorations that were then so much in vogue. These fugitive displays of extravagant pomp were a glory of the age and the Four Rivers Fountain is one of the chief relics of this festive life. More than any other work by Bernini, it seems like a gigantic papier-mâché confection, an exuberant piece of stagecraft. Bernini probably got the idea of a rustic fountain from the grotto nymphaea that were popular in country settings, transforming them into a free-standing city monument rising from an oval lake. He combined it with the evocative image of the Four Rivers and surmounted the whole with the obelisk – an awe-inspiring fusion of conceits made miraculous by the hollowed-out rock that allows us to look right through the space underneath the obelisk, which seems to hover in mid-air. The resurrected pagan obelisk, originally in a temple dedicated to Isis, rises in obeisance to the Pamphilj church, which itself commands the site of pagan festivities. It has been suggested that the four rivers can be interpreted on another level as the Rivers of Paradise, a symbol of the ancient world. A re-awakened Rome again dominates the earth, not through arms, but by faith. And so the fountain symbolizes the triumph of the papacy and of the reigning papal family. Nevertheless, it is as pure scenography that the fountain stands supreme. The great machine never fails to rouse the spirits of visitors entering the piazza; it reigns superb over that resonant space, pouring out its cascades below, rising high and triumphant above – Bernini's most purely spectacular work. Yet for all its magnificence we can also sympathize with Bernini in later years when, passing by, he closed the shutters of his carriage and said:

66 Moro Fountain (detail), executed by G. A. Mari. 1653–5.
Piazza Navona

'How ashamed I am to have done so poorly!' There are aspects of the fountain that belong more to the circus than to serious art. Bernini's vision became increasingly fervent and exalted in his last years; in that world such a fountain plays no part.

After the centre fountain was finished Bernini had to refurbish an older fountain at one end of the piazza. The original fountain had been built by Giacomo della Porta (d. 1602), the chief Roman fountain designer of the late sixteenth century. In the centre Bernini placed a Moor with a spouting fish standing on a great conch [66]. The figure was executed by Giovan Antonio Mari after Bernini's spirited model. The Moor is truly free-standing and has many possible points of view. Basically, he is to be seen from the centre of the piazza, but his vigorously twisting body, the sharply turned head, and the writhing fish show how capable Bernini was of executing true sculpture in the round with many views. In this respect the *Moro* contrasts with the *Triton* of some ten years

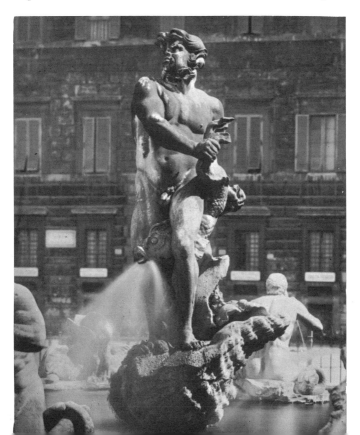

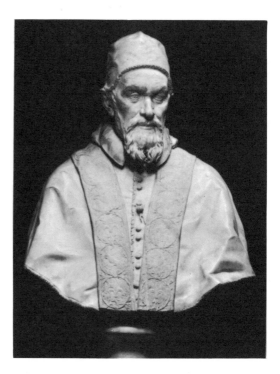

earlier, where an even more evocative series of views is obtained from a figure that has absolutely no torsion at all [60].

The fountains in the Piazza Navona were largely executed by assistants after Bernini's designs and it is in this period that Bernini's studio began to absorb most of the talented sculptors in Rome. Because of the increasing scope of Bernini's ambition, individual busts and statues naturally take on less important roles in his career. He could execute only the most important commissions personally and Innocent X was the last Pope to be portrayed by Bernini's own hand: two busts of high quality survive. Since Algardi was the preferred sculptor of the Pope in these years, we have the opportunity to compare Bernini's work with that of his rival. Bernini's bust (both this and the other one, not illustrated, are damaged) presents him as a resolute man of character and determination, his unattractive features generalized and enobled

67 Alessandro Algardi, *Innocent X* . *c.* 1646

[62].* The bust extends downward to give a slight impression of the arms beneath the cope; a swirling fold at the left begins to give a movement to the lower part of the bust – a major motif in Bernini's secular portraits of these years. By contrast, Algardi's portraits are human and realistic. Algardi, who was a member of the 'classicist' wing of Roman artistic society, always strove to portray an ideal rather than a transitory vision, but he was at the same time a more prosaic observer than Bernini: he showed his subjects less as they ought to look than as they were, with honest directness and attention to detail. At his worst Algardi loses the forest for the trees; at best his reserve and sincerity communicate a sense of homely virtue. The bust reproduced in 67 is such a work, showing the human, pensive Pope with quiet dignity. Algardi typically gives more of the body than does Bernini, with a squarer, less ornamental cut on the bottom; he took time to fuss with buttons and decorations, and his surface realism is especially noteworthy in the face around the eyes. Bernini's treatment is generic, reminding us of one of those illuminating comments related by Baldinucci: Bernini supposedly said that realistic portraiture consists wholly in perceiving a unique quality in each person – but one must choose a beautiful and not an ugly feature. This theory lies behind Bernini's idealization; in this instance it has produced an impressive if hardly fascinating portrait. Bernini's bust is noble and striking; Algardi's loving portrayal tempts the observer to read the features like a book and arouses a sympathy for the man that Bernini probably did not feel and does not convey. Bernini's aim was not for a likeness touching on our common human condition but for an image worthy of the man's great office.

The pontificate of Innocent X also produced one of Bernini's greatest portraits. The bust of Francesco d'Este, Duke of Modena, was done from paintings and drawings but Bernini seems to have been not at all hampered by his distance from the sitter: the Este bust embodies Bernini's mature vision of the absolute ruler [68]. Along with the *Louis XIV* of a decade later, it culminates his revolution in portraiture. Much of the freedom and spontaneity that he achieved in the *Borghese* is kept [45], but it is united with heroic pomp and grandiose movement that portrayed the age at

least as much as the man. The *Duke* is not dressed in the actual clothes of his time but in something more suitable and appropriate by seventeenth-century standards: the parade armour and flowing robes that established his state and dignity more truly than realistic dress. Decorum demanded a 'truth' that goes beyond mere optical reality.

Early in his career Bernini began to show his lifelong concern for the purely formal problem presented by the portrait bust. His impatience with a mere head is evident in the series *Santoni – Paul V – Montoya* [5, 1, 29]. In these works he was clearly searching for a more natural solution to the truncated chest of the traditional bust – an artistic genre that had been of great importance in ancient Rome and that Bernini again raised to prominence. His first resolution of this rather ticklish problem can be exemplified by the *Borghese* [45], which allows the drapery to define the underlying body only dimly and thus makes the truncation less arbitrary and surgical. The austere elegance of Bernini's mature papal busts [cf. 31; 62] contrasts with Algardi's more naturalistic rendering which, however, gives the impression of a stuffed garment surmounted by a marble head [67]. Bernini's definitive solution to this ageless problem first appears in the *Este* [68]. A noble flow of drapery, unrelated to any particular fashion or usage, moves grandly up and out from below the Duke's left arm; his armour is partly revealed by a swirl of drapery behind. The head turns to one side while the shoulders move in the other direction, instituting a dramatic torsion reflected in the drapery. The sharp folds of the mantle catch the light; deeply undercut areas throw these brilliant edges into contrast with shadows falling into the hollows and recesses, giving a highly polished, jagged topography. These meaningful diversions utterly distract our attention from the problems of the truncated chest. The Duke's fleshy face looks out with impassive confidence beneath the mop of ringlets flowing in rivulets down the chest. The image is grand and imposing – we can imagine the energetic young Duke vainly trying to live up to it. In contrast to the dignified papal memorials as well as to intimate portraits like the *Borghese*, the Este bust creates a new type of heroic portraiture eminently

68 *Francesco I d'Este, Duke of Modena.* 1650–1

suited to great princes and kings in the age of absolutism. This bust and the *Louis XIV* [87] set the standard for monarchical portraiture up to the time of the French Revolution.

Despite the set-back caused by the failure of his campanili, and in the face of papal displeasure, Bernini created some of his most imaginative works under Innocent X. His new, liberated style begins even earlier, in the last years of Urban VIII's reign: the Triton fountain and the Raggi tomb mark the beginning of a newly dynamic phase* of Bernini's career in which traditional forms and modes were imaginatively combined and transcended in the service of Church and State [58; 60]. The decade of the 1640s was decisive for Bernini's art, and the most important creation of this period remains to be discussed. It is poetic justice that the one work known to everyone as 'Bernini' was commissioned at precisely the time of his disgrace: the Cornaro Chapel in Santa Maria della Vittoria with its *Ecstasy of St Teresa*. Bernini often said it was the most beautiful thing he had ever done; and we may ponder the thought that, had Innocent X been as enthusiastic a patron as Urban VIII, it would never have been done at all.

The man whose famous name the chapel bears was the Patriarch of Venice, Cardinal Federigo Cornaro (in Venetian dialect Corner) who decided to make his sepulchral chapel in the left transept of the small Carmelite church and commissioned Bernini to decorate the shallow space [cf. Fig. 2]. The architectural framework was begun *c*. 1647, and work on the sculptural decoration continued into the 1650s. The whole complex is best understood by consulting an eighteenth-century painting that shows the whole in a way no photograph can rival [69]. The group of St Teresa and the Angel is revealed in celestial light within a richly articulated niche over the altar. The same heavenly light seems to flood the vault of the chapel, where angels among the clouds adore the Holy Spirit. At left and right, in spaces resembling opera boxes, numerous members of the Cornaro family – the donor, his father the Doge Giovanni, and six Cornaro Cardinals of the preceding century – are found in animated postures of conversation, reading, or prayer [70]. The visitor does not see the whole chapel until he stands directly before the St Teresa group, which is set back

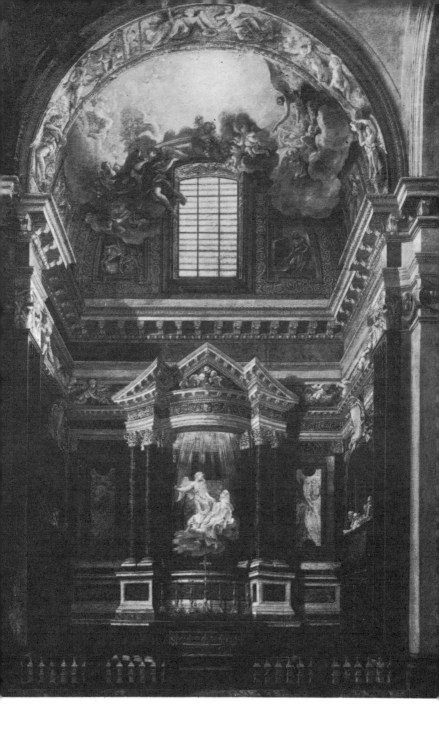

behind a proscenium-like opening. Once there, he sees the saint's ecstasy as if by revelation and looks up to see a heavenly glory. The Cornaro Cardinals at the sides appear in architectural settings that seem to stretch back left and right like transepts so that the shallow chapel is transformed spatially into something like a church. We, in the space of the chapel defined by Bernini's architecture, are in the same world as the members of the Cornaro family who, left and right behind their *prie-dieux*, discuss or meditate on the vision they cannot actually see. In these lively studies Bernini created the first sculptural group portraits of the Baroque. Their dramatic interplay of look and gesture extend the psychological insights of the Borghese bust [48] into actual group discourse that rivals contemporary paintings by Hals and Rembrandt. Unlike such paintings, Bernini's Cornaro portraits are posthumous recreations who not only act and react among themselves but also – like us – are concerned with the *Ecstasy*. Moreover, they are found in a sepulchral chapel of one of their family, as we are reminded by two dramatically agitated marble skeletons inlaid into the floor. Since Bernini was at great pains to unify this complex of images it is not easy to separate the different levels of illusion. It seems that the members of the family are discussing the miracle before us – we may even assume that their study and devotion have conjured up the vision. If this is so, the *Ecstasy of St Teresa* is an artistic re-evocation of an actual event as it is imagined by the Cornaro Cardinals who, though all but one were dead, appear before us in the vigour and animation of life.

Once again Bernini created a spectacle that takes the beholder by surprise. We have noticed that he constantly presents his works from one point of view in order to achieve the full impact of momentary action, but he seems to have become increasingly dissatisfied with the limited power of single statues or groups to create their own environment. In our discussion of the *Longinus* (pp. 83f. above) we saw how he tried to solve the problem within a conventional niche. The tomb of Countess Matilda [52] rises within a modestly illusionistic space that transforms the shallow niche into something that begins to resemble a little chapel. In the Cornaro Chapel Bernini reached out beyond the focal group in

order to control and direct the eyes and mind of the visitor. The architecture contains us and directs our vision to the framed revelation; it, too, plays an active part in the experience. The walls are encrusted with coloured marble in subdued shades of yellow, grey, and green with the most impressive effects concentrated around the *Ecstasy* [71]. There the wall opens up to reveal an unnatural space framed by pairs of columns set ajar, as if some gigantic force had heaved open the curtain of wall and bent it toward us. The broken pediment above bends with it, creating movement of great richness and complexity in little space [Fig. 2].

70 Cornaro Chapel, Santa Maria della Vittoria. Detail of Cornaro Cardinals

71 Cornaro Chapel, Santa Maria della Vittoria

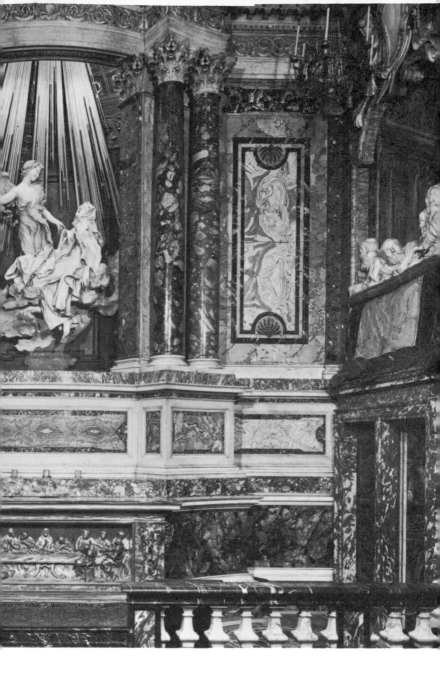

The Ecstasy of St Teresa. 1645–52

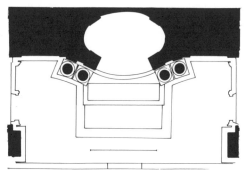

Fig. 2 Rome, Cornaro Chapel, Santa Maria della Vittoria Plan

Within this fanfare of architecture the hovering group of white marble seems truly visionary.

The Cornaro Chapel carries Bernini's ideal of a three-dimensional picture to a new level. The group of *St Teresa and the Angel* is sculpture in white marble but it is so situated that we can receive only one view of it, and since it is within a space separate from ours, we cannot tell whether it is precisely in the round or merely a very high relief. Moreover, the natural daylight that falls on the figures from a hidden source above and behind is *part of* the group as are the gilded rays behind; the whole miraculous vision is produced by a light we do not understand. 'The group', in the sense of the marble figures, has been superseded by a variety of effects, including sunlight and gilt wood rays, all of which belong to the statuary group. So we are no longer speaking of sculpture in the conventional sense but of a pictorial scene framed by architecture that includes us as worshippers in a religious drama that is not so much acted as revealed. Bernini used painting, sculpture, architecture, and added the natural resource of light to create a hallucinatory revelation. The mystery has its origin above us on the painted vault where we can seek out the heavenly source of the vision [69]. The heavens actually seem to be blowing into the church since Bernini made clouds of stucco that really cover part of the architecture and decoration of the vault. It is on this realistic stucco empyrean that the host of angels appears.* The cherub piercing Teresa's heart has seemingly descended from the painted

group above; he has materialized out of the hot sun that 'must have shone very brightly here, to leave the soul thus melted away' – as Teresa said of another experience. Bernini shows us Teresa's vision and its source as if by divine revelation. Architecture, sculpture, and painting all lose their traditional independence in favour of new roles in a single religious experience. This achievement led Domenico Bernini to say that here his father outdid himself and conquered art.

What Domenico admired in the Cornaro Chapel is just this breaking down of traditional and familiar boundaries. The sunlight streaming in from a hidden source to illuminate a marble statue of a saint, the simulated encroachment of clouds and a heavenly host upon the architecture of the vault – all of this denies the Renaissance concept of a building as an independent and unbroken enclosing shell in favour of a new artistic goal that does not respect the hegemony of architecture. There had been illusionistic paintings in antique and Renaissance buildings but their modest trickery left the actual walls as they were. Bernini calls upon this tradition, and other such illusionistic attempts, but so deploys his resources that the various media are fused just as the various levels of reality – psychological, chronological, and tangible – melt into one.

We have mentioned that Bernini was a man of the theatre (see p. 19) and such works as the Cornaro Chapel have been dubbed 'theatrical' by unfriendly critics of a later period. There is, however, nothing inherently wrong with theatrical art; anything that exceeds the boundaries of what we consider decorous may be damned as theatrical, but we have not made a useful judgement. On the other hand, we have seen that Bernini's artistic flexibility and vision led him to borrow techniques from other arts, and he must have been influenced by theatrical practice early in his career. In his actual works for the theatre he tried to make stage effects as 'real' as possible in order to intensify the dramatic impact. We read of an actual fire on stage, of a realistic sunrise, and of a staged flood seeming to threaten the audience. These devices tended to break down the psychic as well as physical barriers between staged drama and human spectators. This kind

of heightened emotional appeal is found in many contemporary arts. St Philip Neri (1515–95) and his followers encouraged popular devotion by means of religious songs and dramas set to music – the oratorio, which evolved in Rome during the early seventeenth century, takes its name from Philip's Oratory. There are similarities between Bernini's art and that of the leading composer of oratorios, Giacomo Carissimi (1605–74). Like Bernini, Carissimi tried to appeal to a vast audience through the emotions. He set lively stories to music and employed impressive choruses to further his religious dramas. Opera, the secular counterpart to oratorio, had a brilliant early development in Rome under Barberini patronage. Bernini quite possibly designed settings for some of the productions in their huge theatre, built in the early 1630s. Opera and oratorio, like poetry and drama, followed roughly parallel courses in Rome at this time. Bernini, however, was uniquely successful in making art and life merge into one exalted experience – this was surely his aim, and his approach to theatrical, artistic, and even urban problems was all of a piece.

In 1628 Bernini introduced dramatic devices from the theatrical repertory into a solemn papal function. For the Forty Hours' Devotions he created an illusion of heaven in the Pauline chapel of the Vatican: the vault was invaded by artificial clouds and hidden lamps cast a heavenly light.* This spectacle is an early example of the dramatic impulse that led Bernini to cover the vault of the Cornaro Chapel with a realistic vision of heaven. Such scenic effects, like the use of sunlight as a component of a work of art, made the Cornaro Chapel an unparalleled religious experience. In the midst of this impressive ensemble Bernini gave Teresa's 'Ecstasy' its definitive representation.

The Ecstasy was a mystical experience of the great Spanish Carmelite reformer, Teresa of Avila, a 'transverberation' that pierced her heart with the fiery arrow of Divine Love [72]. This vision was cited in the Bull of her canonization in 1622; from that time on the Ecstasy of St Teresa was a common artistic subject in churches of her order, the Discalced Carmelites. The style of Bernini's group cannot be dissociated from its religious significance. St Teresa (1515–77) was a straightforward but by no means

ordinary girl who, through a series of physical and mental experiences, became a mystic. She was at the same time a very practical reformer who founded a number of monastic establishments; she was also the teacher of St John of the Cross. Teresa's practical nature allowed her to describe and analyse her religious experiences with unparalleled concreteness in her famous *Life* and other books that followed. She described her Ecstasy in these words:*

... Beside me, on the left hand, appeared an angel in bodily form, such as I am not in the habit of seeing except very rarely. Though I often have visions of angels, I do not see them. . . . But it was our Lord's will that I should see this angel in the following way. He was not tall but short, and very beautiful; and his face was so aflame that he appeared to be one of the highest rank of angels, who seem to be all on fire. They must be of the kind called cherubim, but they do not tell me their names. I know very well that there is a great difference between some angels and others, and between these and others still, but I could not possibly explain it. In his hands I saw a great golden spear, and at the iron tip there appeared to be a point of fire. This he plunged into my heart several times so that it penetrated to my entrails. When he pulled it out, I felt that he took them with it, and left me utterly consumed by the great love of God. The pain was so severe that it made me utter several moans. The sweetness caused by this intense pain is so extreme that one cannot possibly wish it to cease, nor is one's soul then content with anything but God. This is not a physical, but a spiritual pain, though the body has some share in it – even a considerable share. So gentle is this wooing which takes place between God and the soul that if anyone thinks I am lying, I pray God in His goodness, to grant him some experience of it.

Bernini was a profoundly devout Catholic, strongly influenced by Jesuit teaching. We are told that for the last forty years of his life he went to church every day and took Communion twice a week. For him, the *Ecstasy of St Teresa* was not merely a problem in sculpture but an exercise of devotion, an opportunity to enlighten and inspire. He took Teresa's text in the spirit in which it was written and made the hallucinatory event appear as real and as concrete as possible. The experience was divine; Teresa was a saint; the sculptured marble group hovers behind the architecture on a fluffy cloud, bathed in light, as if in all its reality it were our

own beatific vision. Bernini has created an image that can serve as the means to inspired religious communion. The vision is the kind we are enjoined to summon up for contemplation by St Ignatius in his *Spiritual Exercises*, which Bernini practiced. St Ignatius urges us to picture each religious event in its setting and to conjure up the image of the holy person in order to converse with it. This desire for a visual, even tactile, reality lies behind Teresa's vision and Bernini's representation. Teresa recommends the soul, for example, to 'picture itself in the presence of Christ. . .'. When she herself saw Jesus, he appeared to her as he looked in the paintings she knew. She tells us how to proceed, by four stages of prayer, to the divine rapture of pure enjoyment in which the soul and God are one. 'While seeking God in this way, the soul is conscious that it is fainting away almost completely in a kind of swoon, with very great calm and joy . . . once the . . . faculties have begun to grow drunk on the taste of this wine, they are very ready to give themselves up again in order to enjoy some more.' Bernini created a sculptured picture of Teresa's Ecstasy, which was itself originally a mental picture as well as a powerful physical phenomenon. The 'truth' of the vision is consequently conveyed on more than one level: ideally we enter the chapel, observe the *Ecstasy* – removed, white, mysteriously illuminated, but also very solid and realistic – and ultimately participate in a religious experience of our own, aided by the mystic concretion hovering before our eyes.

Once we understand that it is only the smouldering core of a larger, unified whole, this work can be examined as a great piece of sculpture in its own right [72]. The saint in ecstasy was a favourite subject in the seventeenth century and Bernini's group has painted precedents, notably Lanfranco's *St Margaret of Cortona* [73]. *St Teresa* has been literally transported. She was often the victim of that disconcerting levitation that plagued certain mystics, and we see her here, appropriately, in the void, on a fluffy but reassuringly solid marble cloud. She swoons back and at the same time seems to strain forward and upward, as if in the grip of a superhuman force. Her sightless eyeballs are revealed below heavy lids, her lips are parted in that involuntary moan she herself mentioned [125]. It seems quite clear that the angel has

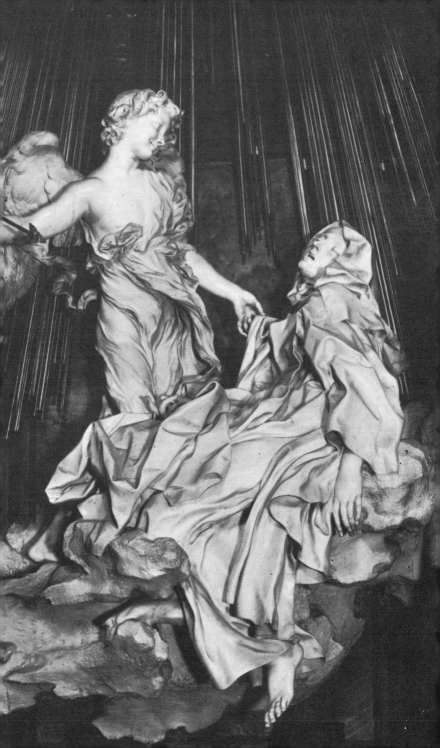

already pierced her heart with his fiery arrow. The left hand dangles senseless while her feet abandon themselves to the air. Between head, hand, and feet is seen not so much a body as a mass of cascading drapery that neither clothes nor reveals her. It has an abstract sculptural life of its own, carrying on the emotional patterning we saw developing in the *Longinus* [39]. In both these works Bernini had to reveal an inner state by external means – a goal rarely approached in antiquity but one with which Bernini was occupied all his life. The tender angel contrasts with the reclining saint in every way. Upright to her diagonal, his cherubic, smiling face beams down as his hand touches her garment to implant the arrow once again in her breast [74]. The angel's sexless body is partly bare; a clinging, flame-like drapery wholly different from the coarse cloth of Teresa's garment seems to lick and consume its lower parts in accord with the saint's description – poignant contrast between spirit made flesh and flesh made spirit. Teresa on her cloud seems almost earthbound, as if dragged down by the weight of material that seems to suffocate her [72] while

73 Giovanni Lanfranco, *The Ecstasy of St Margaret of Cortona.* 1621.

74 Detail of plate 71

the buoyant wraith rises up like a djinn to inflict that sweet torment of divine fire she so clearly describes.

The Cornaro Chapel is the crowning synthesis of Bernini's earlier development. In some respects it represents the highest achievement of his sculptural art. In later years, the aims that culminate in the Cornaro Chapel led him to concentrate more and more on architecture: Bernini's late achievement was not primarily sculptural but spiritual, and to realize this mission his art ultimately became one of environmental influence: buildings and city-planning took up more and more of his energy in the period after 1650. So the Cornaro Chapel is in many ways the pinnacle of Bernini's sculptural career, summing up the revolutionary experiments of the Borghese period and drawing upon the maturity that the variety of Barberini commissions had fostered. But the work that epitomizes Bernini's artistic development in the first half of the century can also be seen as the matrix from which much of his later work drew its life.

4. Two Churches and St Peter's

At this point the loose chronological sequence that shaped the first half of our story has to become much freer. The pontificate of the Chigi Pope, Alexander VII (1655–67), was rich with architectural and decorative works. Alexander's pontificate was like Urban VIII's all over again – he deliberately reversed the policies of Innocent X; but there was no hiding the gradual impoverishment of Rome, which was exacerbated by a disastrous plague in 1656 and by rapidly worsening political relations with Louis XIV. Alexander's reign included Bernini's epoch-making trip to France in 1665 – his influential designs for the Louvre and the magnificent bust of Louis XIV. Bernini began to develop what can be called his late style in these years. It continued to ripen in the following decade, but Bernini was close to seventy when Alexander VII died and his last manner was already adumbrated in the Chigi pontificate. It will therefore be most convenient to divide the last twenty-five years of Bernini's career according to different criteria. A separate chapter is given to the trip to Paris and the works connected with it; another discusses the purely sculptural enterprises of the last years. This chapter is accordingly concerned with his architecture: his monumental decorations for St Peter's and the churches designed in the years around 1660. Bernini also built two palaces of some importance. The first, the Palazzo Montecitorio, was completed by other hands and is now remodelled as the Chamber of Deputies. The other, the façade of the Palazzo Chigi-Odescalchi, was also changed in later years; but since it is one of the glories of Italian architecture it will be discussed in the context of the Louvre façades, to which it is closely related.*

Our analysis of the Cornaro Chapel attempted to show that the

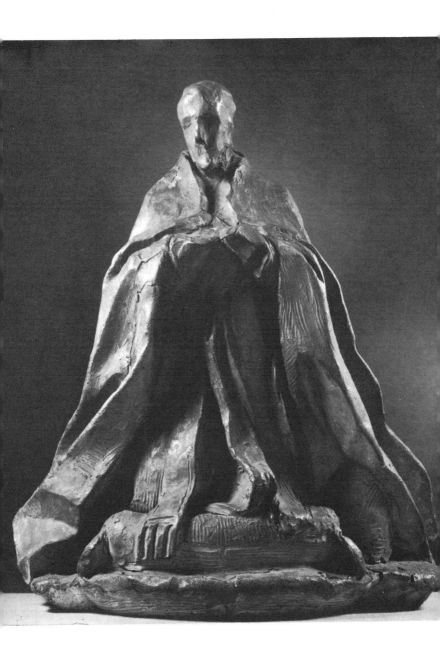

75 *Alexander VII. Bozzetto* for plate 118. 1669–70.

architectural framework was an extension of Bernini's sculptural ideal – a single view of a climactic religious moment with active communication between spectator and statue. These principles predisposed Bernini to pay extraordinary attention to the environment of his works, and ultimately his desire for controlled submission to a spiritual experience forced him to subordinate sculpture to higher things. After the Cornaro Chapel – which is, in spite of its brilliant success, a decoration superposed on a pre-existing space – Bernini seems to have been challenged by the desire to shape a complete religious experience in the form of a church. Several opportunities arose almost at once.

The richest of Bernini's churches is Sant'Andrea al Quirinale, begun in 1658. Funds were provided by Cardinal Camillo Pamphilj for a new church to serve the Jesuit novices living on the Quirinal hill. The site did not afford space for a large building, and Bernini solved some of the inherent problems by planning an oval with the main entrance and high altar on the short axis [Fig. 3].

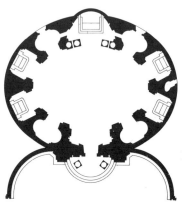

Fig. 3 Rome, Sant'Andrea al Quirinale. Plan.

The visitor approaching on the street is attracted by an exedra that leads to a series of segmental steps and a high, narrow façade [76]. This façade is unusual since it is more specifically a monumental entrance or gateway than the traditional mask before the west wall of a church. Indeed, the sides of the church can be seen curving back above the quadrant walls of the entrance area. These

76 Sant'Andrea al Quirinale, façade. 1658–70

two opposed curves meet and are joined by the large portico. Within its austere framework, a segment of the wall seems to have swung out and down to be supported by two columns, forming an entrance porch for the doorway within. The walls of the entrance area draw the visitor to the stairs, which reflect the shape of the roof above.

Once through the door, we are immediately confronted by the high altar [77]. The distance from entrance to altar is the shortest in the church and this direct confrontation must have recommended the unusual orientation of the oval. Only after our initial vision of the main altar area do our eyes wander around the sides of the space, where the dark chapels and a negative articulation of the long axis soon send them back. The altar space is screened off from the main church by two pairs of fluted columns of richly veined red marble, reminiscent of the Cornaro Chapel but more monumental and sober [cf. 71]. Within, a small altar chapel

77 Sant'Andrea al Quirinale, interior

receives light from an invisible source. A richly coloured painting by Guglielmo Cortese (Guillaume Courtois) representing the *Martyrdom of St Andrew* seems to be carried by a host of angels, who appear to fly down on glinting beams of light to place the picture on the altar. The whole chapel partakes of another level of existence from our own and since we cannot enter, it has the quality of an apparition. Our eyes then rise to the pediment of the framing aedicula to see a marble *St Andrew* floating on a cloud. He appears to have risen from the altar chapel through the pediment, which curves around him accommodatingly, and now flies into the 'dome of heaven' above us. The tactile reality of the white statue flying above is the clue to the meaning of the event. The ascension to heaven is the important fact, the crucifixion only a mundane prelude. To reinforce this, the lower part of the church in which we find ourselves is dark, but the richly stuccoed and gilt dome above is brightly lighted by windows over the cornice, with more light streaming in from the lantern at the summit. Andrew looks upward to the symbol of the Holy Spirit stuccoed in the lantern.

In this way Bernini shaped an entire religious experience. The church is the framework and in a sense the theatre of action. The painting, the statue, and the relief decorations are the means by which the religious drama unfolds. Pilgrims to this shrine witness a divine event and are encouraged to experience it with all their senses, to use it as a touchstone for meditation and prayer. With this introduction it will not come as a shock to learn that the sculpture of *St Andrew* is not by Bernini at all; it was carved after his designs by his most gifted follower, Antonio Raggi (1624–86). There was no particular incentive for Bernini to do more than plan the decoration; it was subordinate to the whole conception and could safely be entrusted to his studio.

Sant'Andrea al Quirinale is the logical consummation of the principles Bernini had been evolving for decades and that he so brilliantly illuminated in the Cornaro Chapel. The extension of his aims to embrace architecture does not mean that this church can be judged fruitfully as part of a previous architectural evolution. Nor can Sant'Andrea al Quirinale be compared with such works of pure architecture as the contemporary churches of

Borromini. Bernini was not working as a traditional architect but rather used the resources of architecture for special purposes; the architecture should no more be discussed on a purely formal basis than the decorations – all play their parts in a coordinated spiritual whole. Like his sculpture, Bernini's architecture is based on a broader conception of art than had previously existed. Bernini himself valued this church above all his other works of this kind. One day Domenico Bernini came into the church to pray and came upon his father, who was off to one side, looking around the little interior with evident pleasure. Domenico asked: 'What are you doing here, all alone and silent?' Bernini replied: 'Son, I feel a special satisfaction at the bottom of my heart for this one work of architecture, and I often come here as a relief from my duties to console myself with my work.' Domenico found this a novel attitude since his father had never shown signs that he was pleased with any of his works, 'all of which he considered far inferior to the Beauty that he knew, and conceived in his mind'.*

Another church, at Ariccia, a Chigi stronghold just beyond Castel Gandolfo, exhibits some of the same characteristics. Like Sant'Andrea, it is based on a central plan, in this case the purest and simplest of all [Fig. 4].

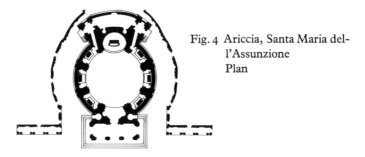

Fig. 4 Ariccia, Santa Maria dell'Assunzione
Plan

There is no doubt that Bernini's inspiration was derived from the Pantheon, which had occupied his attention for several years before the church was begun in 1662. He remarked in Paris a few years later that the most perfect forms were the circle, the square, and other simple geometric shapes. Bernini admitted that the

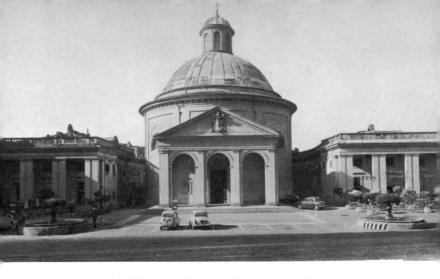

78 Ariccia, Santa Maria dell' Assunzione, façade. 1662–4

dome of St Peter's was beautiful, and unparalleled in antiquity, but he added that there were a hundred faults in St Peter's and none in the Pantheon. The church at Ariccia deserves special attention because it represents Bernini's adaptation of the building he considered to be the greatest in the world to the service of Christianity [78]. Bernini's studies of the Pantheon show that he thought its essential character was expressed in the contrast between temple-like portico and domed cylinder behind. He reduced the importance of the portico but at the same time framed the building between two harmonious palace elements that curve back round the church. Surviving drawings show how carefully the exterior – portico and dome – was planned in order to be seen entirely from the opposite side of the road; again we see the artist's desire to control the experience of his work. Such a desire led to his study of the Pantheon; Bernini wanted to reconstruct the area around the ancient building in order to exhibit it to best advantage. It is probably correct to say that the Ariccia scheme illustrates his Pantheon project on a small scale and, further, that it represents his idea of how such a building would have been seen in antique times. The interior, on the other hand, has a new and specifically Catholic meaning [79]. The dome is supported by a

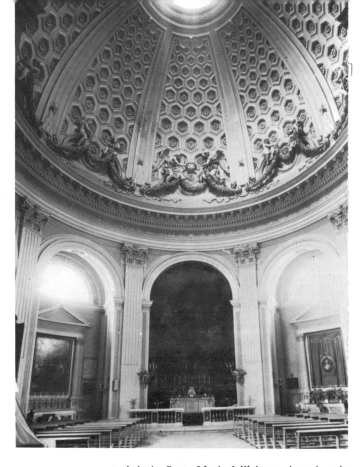

79 Ariccia, Santa Maria dell' Assunzione, interior

simple ring of walls and chapels; the necessary space for sacristy
and passages is hidden in the rear. Stucco putti and angels sit in
the lower reaches of the dome, holding garlands that swing from
rib to rib. The meaning of these figures has recently been ex-
plained by Wittkower :*

The church is dedicated to the Virgin (S. Maria dell' Assunzione)
and, according to the legend, rejoicing angels strew flowers on the
day of her Assumption. The celestial messengers are seated under
the 'dome of heaven' into which the ascending Virgin will be re-
ceived; the mystery is adumbrated in the *Assumption* painted on the

wall behind the altar. Since the jubilant angels, superior beings who dwell in a zone inaccessible to the faithful, are treated with extreme realism, they conjure up full and breathing life. Thus whenever he enters the church the worshipper participates in the 'mystery in action' . . . the entire church is submitted to, and dominated by, this particular event, and the whole interior has become its stage.

By and large, the Renaissance church had been conceived as a monumental shrine, where man, separated from everyday life, was able to communicate with God. In Bernini's churches, by contrast, the architecture is no more and no less than the setting for a stirring mystery revealed to the faithful by sculptural decoration. In spite of their close formal links with Renaissance and ancient architecture, these churches have been given an entirely non-classical meaning. Obviously, Bernini saw no contradiction between classical architecture and Baroque sculpture – a contradiction usually emphasized by modern critics who fail to understand the subjective and particular quality with which seemingly objective and timeless forms have been endowed.

Even before the first of these church designs was formulated, Bernini embarked upon two of his most ambitious projects – the Piazza before St Peter's and the *Cathedra Petri* in its apse. These two works, fragments of his larger conception if you will, show his approach to Catholic religious experience on an unrivalled scale. The Chigi Pope, Alexander VII, relied on Bernini as firmly as had Urban VIII. According to the well-informed Baldinucci, the sun had not set on the first day of his papacy before he sent for the artist. Alexander kept Bernini as Architect of St Peter's and made him his own architect and Architect of the Camera as well – an unprecedented occurrence. It is therefore under Alexander VII that Bernini first came into his own as an architect of international importance. Like Michelangelo, Bernini considered architecture a sideline, but again like Michelangelo, he brought to architectural design what his contemporaries could explain only as a divine gift.

The Piazza before St Peter's, begun in 1656, posed a series of complex problems [80–1]. The chief function of the large space was to hold the crowds that gathered for the papal benediction given *Urbi et Orbi* on Easter Sunday and other special occasions. Bernini needed to enclose a space as large as possible to accommodate the natives and visitors to the *urbs* and to give them a view of the pope

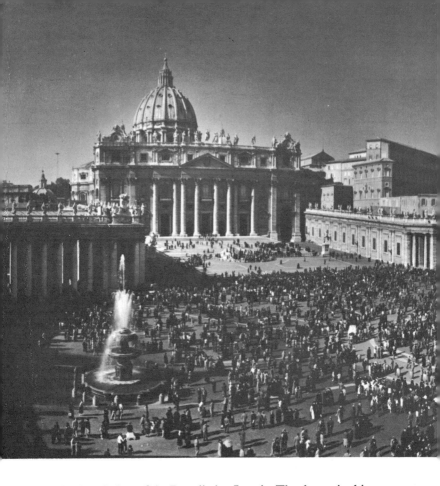

in the window of the Benediction Loggia. The throng in this space symbolizes the rest of the world – *orbis* – receiving the blessing. At the same time Bernini needed to provide for a different group of occasions: the pope gives his more usual blessings from his private papal apartment in the Vatican palace and Bernini's piazza enclosure had to take this different focus into account [82]. His ultimate solution comprised a trapezoidal space before the church,

80 Piazza before St Peter's. 1656–67

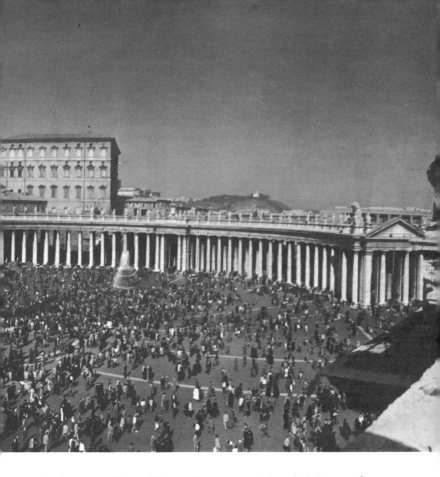

in large part dictated by previous construction; bulging out from
this forecourt, a huge oval piazza is held between the pincers of two
free-standing colonnades. Bernini also planned a third section of
colonnade to block the axial entrance to the piazza, further enclos-
ing the space and providing still more contrast with the approach,
which led through the narrow streets of the Borgo, as the district
around St Peter's is called. This part of his plan was never executed

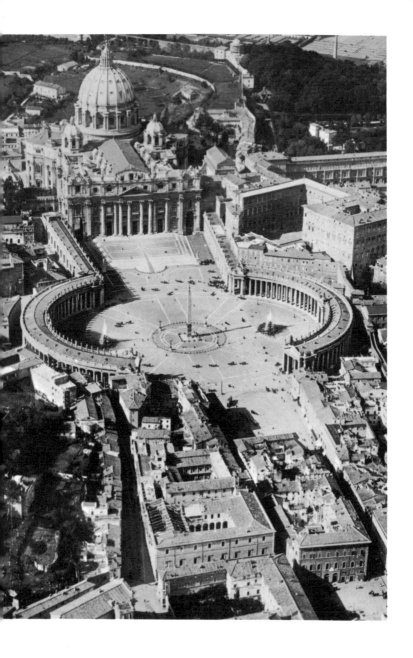

81 St Peter's and the Vatican. Air view with Bernini's piazza

and today the whole approach has been altered to provide a vast vista before the church down to the river – an effect Bernini did not want. The image of the piazza was likened by Bernini to the outstretched arms of the Church welcoming the faithful, so that even this seemingly pure architectural creation has an anthropomorphic, and even quite sculptural, connotation and function. (We know from Bernini's statements in Paris that he subscribed to the ancient theory that the classical orders were based on human proportions – Doric and Tuscan were masculine, Ionic feminine. He argued that since this was so, painters and sculptors made the best architects because of their constant study of the body. In this he was in accord with Michelangelo, who had gone even further to say that sculptors made better architects than painters because sculptors worked in relief. Bernini, who told this story, obviously agreed – and he revered Michelangelo's own architecture above his other creations, saying that since architecture is pure *disegno*, Michelangelo was a divine architect.) Bernini's piazza also afforded a partial solution to a different set of problems. Maderno's façade, with its bell-tower foundations left and right, was too long and low. In addition to the abortive attempt to erect the campanili, Bernini had made a number of proposals to rebuild the façade; in the end, he solved the difficulty by optical means. The low arms of his piazza tend to squeeze the façade in and at the same time to emphasize its height. Such a 'solution' is naturally far from the ideal Bernini sought, but it is typical of him that, when direct intervention failed, he did his best to resolve the problem by changing the environment.

The free-standing colonnades were a novel solution to the various needs of the piazza: enclosing arms, directional guides, and finally, counter-balances to the wide façade of the church. Direct sources of inspiration are hard to find; there are some antique parallels, and Palladio had been fond of quadrant colonnades although his were always on a smaller scale. Perhaps the most important source for Bernini's curved colonnade with its interior vault was the similar hemicycle on the upper level of the Sanctuary of Fortuna Primigenia at Palastrina, the great Republican Roman monument of the late second century B.C. that had been studied,

drawn, and reconstructed with enthusiasm in this period. As architecture, Bernini's colonnade succeeds because of its own self-effacement. The simple Tuscan order, crowned by a continuous Ionic frieze, is repeated in two pairs of colonnades framing a central walk. The sculptural travertine columns do not call attention to themselves but stand, sober and monumental, a penetrable passage as well as a guiding and moulding wall. In planning the piazza Bernini had to take account of the Vatican obelisk that had been moved to the entrance axis of St Peter's under Sixtus V (1585–90). The obelisk now stands as the central focus of the oval and is flanked left and right by two magnificent fountains. The one on the right, designed by Carlo Maderno, was rebuilt on the long axis of the oval [82]; a matching fountain by Bernini balances the composition at the other side. This long axis is further emphasized by special porticos on the colonnades that echo the great entrance aedicula of the church façade. Above the colonnades stand numberless statues of gesticulating saints carved in travertine by Bernini's followers, in large part after his designs.

Once again, as at Sant'Andrea al Quirinale, Bernini found the oval to be the best form for his purposes – and once more it was an oval whose short axis is the one of greatest importance. To simplify the design and construction of four concentric colonnades in each arm, Bernini designed them as segments of a circle, pulled apart to enclose an oval space. The focal point is clear, and the outer reaches of the arms are subordinate, as at Sant'Andrea. But at St Peter's the south curve of the piazza also serves to contain the crowds participating in the papal blessing from the Vatican palace: on the other side, the colonnades themselves partially hide the view of his window, and thus the bulging south colonnade also serves to accommodate the throngs whose primary goal is not the church but the pope in his window. Nothing but actual experience of the powerful space created by Bernini's chaste colonnades can do it justice. As Domenico Bernini wrote, the piazza has few equals in antiquity and none in modern times. It is, however, its role in the religious life of the *Urbs* and its active part in the drama of papal benediction that show the piazza in its true grandeur.

The Piazza is such an unequivocal success that we tend to forget

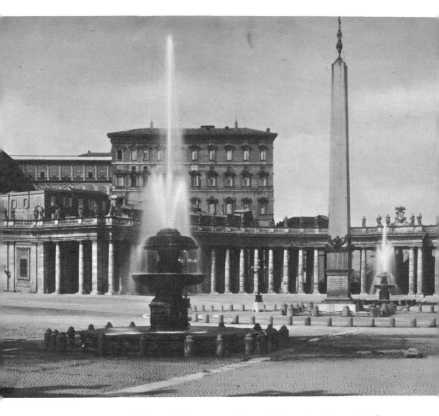

contemporary criticisms. These were in part the natural result of jealousy, fired by want: Bernini's artistic monopoly was a continuing disaster to his rivals. Criticisms based on extravagance were more to the point: in 1661 the Venetian Ambassador reported that

The Pope has long paid particular attention to beautifying the city and repairing the roads, and truly in this labour he has far surpassed his predecessors The building of the colonnades which encircle the piazza di S. Pietro will be an achievement to recall the greatness of ancient Rome. It is estimated that the work is about half way through and that in three years it will be complete. I am not going to discuss whether such efforts are advisable at the present moment and will leave that to those who understand these things

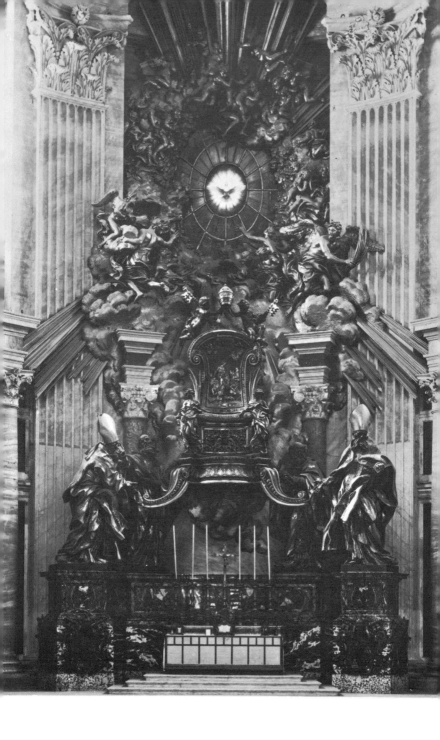

better than I do. It is true that Rome is getting more and more buildings and fewer and fewer inhabitants. This decrease is very striking and obvious to everyone, and in the Corso and the busiest streets one sees nothing but empty houses and the sign 'To Let'.

A few years later his successor stated that 'over a million scudi have been spent on a series of catastrophic mistakes'.*

Bernini's sonorous prelude to the first apostle's church is matched in the apse by a magnificent finale, the *Cathedra Petri*, the throne of St Peter as Christ's vicar [83]. Bishops always have their seats in a chief church of their ecclesiastical district (*cathedra* →cathedral) and early medieval artists used the vacant throne to symbolize the lordship of Christ, just as the artists of antiquity had used it to indicate the ideal presence of their secular ruler. The pope is Bishop of Rome and his cathedral is St John's in the Lateran, but the traditional throne of St Peter, the first Bishop, is kept in the church memorializing his grave, St Peter's in the Vatican. So St Peter's, one of the great Roman basilicas and originally a Constantinian foundation, is not a normal cathedral but occupies an ambiguous first place among Roman churches – part public chapel of the pope, part mausoleum of St Peter and, most important, symbol of the legitimate succession and primacy of Roman bishops from Peter to the present. The monument exhibiting St Peter's chair has, therefore, a far-reaching significance. It now seems inevitable that the earlier projects for displaying the chair in a minor chapel were superseded by the decision to display the throne of Peter in the main apse, between the tombs of the two popes whose pontificates frame the active period of Catholic Counter-Reformation. Nothing symbolizes the new *Ecclesia Triumphans* more clearly than Bernini's Cathedra.*

Bernini needed to make a decorative frame for the chair and at the same time create a goal for the pilgrim's journey through St Peter's. Various solutions were tried and discarded. Finally, a large-scale construction of many materials was erected to exhibit the great relic. The 'real' (medieval) chair of wood was wholly encased in a magnificent gilt bronze throne, which is, therefore, primarily a reliquary. On the back, Christ's command to Peter,

'Feed my sheep' (*Pasce oves meas*) is illustrated in relief [cf. 102]; above, putti hold the papal keys and tiara; beside the empty seat stand two angelic creatures, clad in flame-like drapery. The seat itself hovers in the air, seemingly supported by four imposing figures of gilt bronze – Sts Ambrose, Athanasius, John Chrysostom, and Augustine (more will be said about these figures in the last chapter). These men of East and West, by work and faith, sustained the papacy in historical times and here symbolically support the throne of Peter which, however, does not rest on their arms but hovers by Divine Will – the seat is apparently maintained by direct intervention from on high. This power is manifested by the golden glory of angels on clouds and rays of light emanating from the dove of the Holy Spirit and flowing down on to the darker bronze of the chair and figures below. The dove, painted on a glass window, appears as the source of the real light flowing in. We may recall that the eagle of Jupiter was represented above Caesar's throne in ancient Rome; here these timeless symbols have been transformed. The light on which the dove is borne is the visible symbol of the stream of God's grace flowing over the world through the agency of his only legitimately founded church. At the head of this church is Peter, buried under the Baldacchino, and symbolically present on the empty throne in the apse. The divine will was done by the agency of its great preachers, represented here by the four Doctors who also stand for the Catholic hierarchy in its broadest sense [83;103]. The whole vision – for vision it surely is – enframes the papal altar below, officiated by Peter's legitimate successor. The entire Cathedra is in turn framed by the Baldacchino under the dome, and in his final studies Bernini took great pains to adjust the size of the Cathedra to the view through the Baldacchino [84]. This sketch reminds us of Bernini's constant awareness of the many roles played by the Cathedra. Seen through the Baldacchino from the nave it is like a tremendous picture come alive in the apse. On closer inspection it seems to be a relief decoration of unusual extension, and finally it reveals itself as a composite of free-standing sculpture, relief, painting, and coloured light, all held together by Bernini's *concetto*.

Bernini reached his solution in answer to a number of

84 Drawing of Cathedra seen through Baldacchino

practical problems. The surrounding architecture of the church apse had to be incorporated into the composition. The enframing columns of the niches containing the ⁻papal tombs at left and right were repeated behind the Cathedra in a rich Composite order that carries on the sequence but differentiates the apse from the rest of the church. The window above posed the greatest problem and became the basis for the ultimate meaning of the *concetto*. Unwilling to do without the window, but unhappy with its glare of light above the Cathedra, Bernini resolved both difficulties by giving the opening an oval form and by painting a dove on the window as the source and centre of a heavenly emanation. The walls of the church appear to have been penetrated by the celestial glory: clouds and light carrying the heavenly host pour in between the giant pilasters of Michelangelo's apse to confirm the legitimacy of Christ's vicar on earth. The succession of popes is based on Christ's command 'Feed My Sheep', represented on the back of the throne [102], and by his statement, '*Tu es Petrus, et super hanc petram aedificabo Ecclesiam meam . . .*', which is inscribed inside the ring of the great dome above; it finds divine confirmation in the presence of the martyred Peter under Bernini's Baldacchino and from his symbolic chair in Bernini's Cathedra.

The execution of the Cathedra was the work of many hands but of only one mind. No other sculpture by Bernini so perfectly exemplifies his executive powers – he delegated most of the execution to his collaborators but remained in complete control. An entire book has been written on the Cathedra, and it would take an inordinate space even to outline the history of the conception, the changes and enlargements, the models, and the execution through its various phases. Work began in 1657 and was finished nine years later for the unveiling in January of 1666. It is almost exactly contemporary with the Piazza and the contrast between these two works of Bernini's middle age demonstrates once again his unparalleled versatility. The Cathedra seems to have been especially dear to Bernini; far away in Paris the summer before its completion, the thought of his creation taking final form in his absence brought tears to his eyes.

After the projects for the Piazza and the Cathedra were finally set and in the process of execution, Bernini was called upon to solve still another problem. The pope in the Vatican palace had to descend to St Peter's by a dark and narrow stair that led from the Cappella Paolina above, past the walls of the Sistine Chapel, and down to the portico before the church. The pope, always old and often infirm, was frequently carried down these rickety stairs in terror of his life. Alexander VII, who commissioned the Piazza and the Cathedra, determined to end this miserable situation and had Bernini rebuild the stair. The difficulties were considerable; the site did not allow a wide passage at all points and yet the pope needed a monumental, safe, and adequately lighted passage. Bernini took advantage of the space at his disposal; where the stair was narrowest, he made it look wider than it was by an ingenious device. The whole first flight was framed by columns supporting a barrel vault. Below, where he had more width at his disposal, Bernini set the columns well out from the wall [85]. Higher, where the passage telescopes in, the columns were placed closer to the wall and reduced in height [Fig. 5].

Fig. 5 Vatican, Scala Regia. Plan and Elevation. *163*

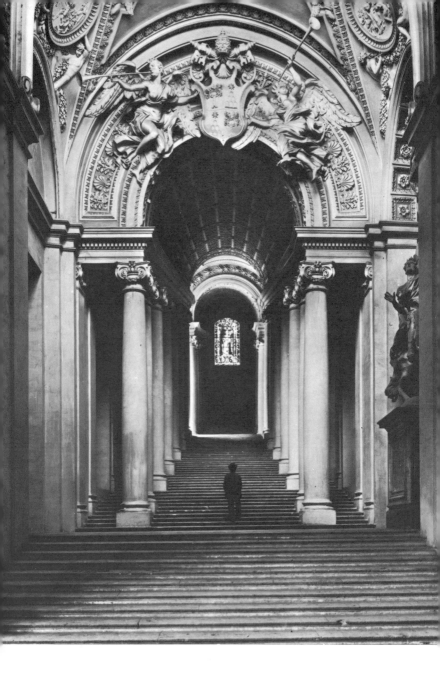

85 Scala Regia, Vatican. 1663–6

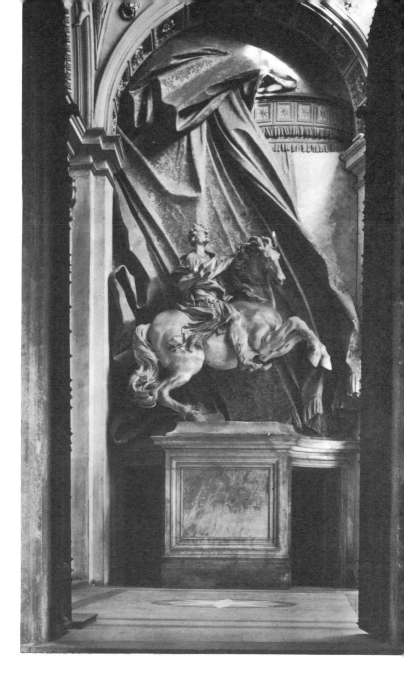

86 *Constantine*. 1654–70. Vatican, Scala Regia

The result was again to regularize an intrinsically irregular space by optical means. Standing below, the observer supposes that the narrowing above is the result of perspective diminution, and he automatically adjusts for this familiar phenomenon by mentally restoring the stair to a standard width and height that it does not really maintain. The unpleasant length of the great flight was broken by a window and a landing at mid-point; another window (originally not the stained glass seen in 85) lights the end. So, in addition to his use of perspective knowledge, Bernini again employs natural light in the service of aesthetic aims – in this case to break in upon the tunnel-like length of the stair, and to relieve the tendency of the architecture to telescope.

The Scala Regia is a continuation of the old entrance corridor to the Vatican that had dictated the shape of the trapezoidal space immediately in front of the church [cf. 81]. But the ceremonial path taken by the pope was normally down the stairs and then right, into the narthex portico of St Peter's. Coming back, he was faced with minor passageways at the point of the turn up to the Scala Regia. To sublimate this awkward turning point Bernini conceived a monumental equestrian *Constantine* in relief [86]. The choice was appropriate since the Emperor Constantine had recognized Christianity and founded the church of St Peter's. He is shown at the moment of his conversion before the Battle of the Milvian Bridge, when the apparition of the cross and the message *In hoc signo vinces* determined his action and secured the future of the church. More will be said about this magnificent sculptural creation; here it must suffice to point out that the excited, symbolic figure performs a function in close rapport with the architecture of the stair by distracting the attention from an awkward change of direction with an electrifying image of the first Christian emperor. In an analogous but wholly different union from that of his churches, Bernini again combined sculpture and architecture in the service of a higher goal.

Technically, Bernini considered the Scala Regia his most difficult challenge, and he was highly pleased with the solution. The Scala Regia and the Piazza determine the approach to St Peter's and the Vatican palace. Just as our basic experience of the

interior of St Peter's is shaped by Bernini's monumental decorations, so the approaches to St Peter's, and even our impression of its façade, have been transformed by his genius.

5. Le Cavalier en France

In March of 1664 Bernini received a flattering letter from Colbert, Louis XIV's first minister, asking him to submit plans for the completion of the Louvre. A long exchange ensued and in the end Bernini emerged victorious from what amounted to a competition since Carlo Rainaldi and Pietro da Cortona had also submitted designs. Bernini's first project was sent off in June. After receiving Colbert's criticisms, he completed a second project by February of 1665. On 10 April Colbert sent a memorandum on the second project and invited him to come to Paris. The 'invitation' was really a command – Louis XIV was determined to humiliate Alexander VII and by taking Bernini away he robbed the Pope of his most valuable asset.* And so, despite his sixty-six years, on 29 April 1665 Bernini set off for Paris. Accompanying him were his son Paolo, who at eighteen was an apprentice sculptor, his architectural executant Mattia de' Rossi, and several others. For reading material Bernini carried the *Spiritual Exercises* of St Ignatius and the *Imitation of Christ* by Thomas à Kempis. The party stopped in Florence, where Bernini was richly honoured by Duke Ferdinando de' Medici; and this set the pattern for the entire trip. All along the way he was received more as a hero or prince than as an artist. The Duke of Savoy entertained him royally, and Baldinucci tells us that in every city crowds lined the road just to see the great man – Bernini remarked that it was like the trip of an elephant (still a rare sight in those days). At the French border he was greeted by an official reception in the King's name, a ceremony that was repeated at every stop on the way to Paris.

Bernini's official career is as well known as that of any artist in history up to this time. Thanks to the early biographers and

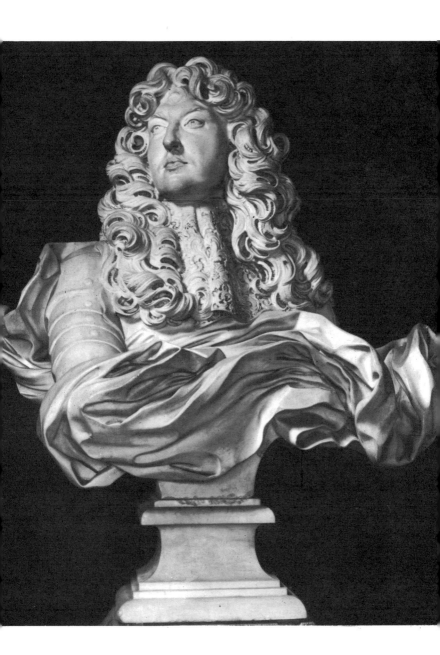

87 *Louis XIV.* 1665

especially to Baldinucci, whose book appeared within two years of Bernini's death, we are able to draw upon fairly reliable stories about his training and personality. In addition, Bernini's trip to Paris is uniquely documented. A diary kept by his constant companion, Paul Fréart, Sieur de Chantelou, was discovered less than 100 years ago. Chantelou, who had been chosen to meet and accompany Bernini during his stay, was himself a highly cultivated man with an important collection of paintings. Having lived in Rome for years, he was perfectly equipped to interpret France for Bernini and *vice versa*. His report of the visit is factual and impartial; its constant fascination is its revelation of the mind of Bernini speaking directly and honestly about what he saw and thought.

Chantelou met Bernini outside Paris on 2 June and reports that the artist's first conversation included a formal statement that he had come to Paris especially in order to see the King and to serve him. The next day Colbert called on the artist after lunch, only to find him taking the usual Italian nap. He insisted that Bernini stay where he was and so this portentous meeting between two of the outstanding men in Europe took place with Bernini stretched out in bed. Bernini made his speech about the King again. The next day Colbert came early to take Bernini to the King, who was then at St Germain-en-Laye. When Louis was dressed, Bernini again made his speech. He then said that the monarch must have a palace greater than any other, and warned the *Roi Soleil*: 'Speak to me of nothing small.' When the interview was over, Bernini went to the chapel and prayed for a long time; after lunch he had another nap and then was taken back to Paris. Since Chantelou's diary of Bernini's stay is very detailed and many times longer than this book, we can hint at its riches only by mentioning a few revealing incidents. Chantelou gives us a precious description of Bernini's appearance that we can compare with an unusually attractive self-portrait that may have been drawn in Paris [91]:

He is of modest height, but well-proportioned, and if anything thin rather than fat, with a temperament that is all fire. His face is eagle-like, especially the eyes. His eyebrows are long, his brow large, with slight projections over the eyes. He is bald, and the hair that

remains is curly and white; by his own admission he is sixty-five. He is vigorous for that age, and always wants to go on foot, almost as if he were thirty or forty. One could say that his mind is one of the most beautiful ever made by nature, since, without having studied, he has most of the advantages that knowledge can give a man. He has, as well, an excellent memory, a quick and lively imagination, and his judgement seems clear and precise. He is a very acute conversationalist, and has a very special gift of expressing things in words, with his face, and by gesture so as to make you see as easily as the greatest painters do with their brushes. This is doubtless why he has been so successful putting on his own plays. . . .

If the force of Bernini's personality impressed this sophisticated gentleman, the Italian's manner was at the same time so imperious that he quickly made enemies. Despite his great success as a papal courtier, Bernini could not bring himself to do obeisance for the sake of French self-esteem. This comes out most clearly in his comments on French art and architecture, which he considered hopelessly inferior. The high pointed roofs of Paris drew his scorn, and he reserved special venom for the now-destroyed Tuileries palace. When the King asked him what he thought of it, he answered 'that it seemed a big little thing' and added that 'it was like a great squadron of tiny children'. The dome of the Val-de-Grâce made him think of a little cap on a big head. On another occasion, while visiting an important dwelling, he volunteered that it was not money but brains that made good houses. Looking down on the city from Meudon, he said he could see nothing but a mass of chimneys, and compared the panorama of Paris to a carding comb. Chancing to see Guido Reni's *Annunciation*, he said it was worth half the city, then reconsidered and said it was worth more than Paris. François Mansart, France's outstanding architect, found some favour with Bernini, who said that had Mansart gone to Rome he would have been a great man. And so it went.

Bernini's opinion of French painting was low. The French style was '*petite triste et menue*', and his universal recommendation was that they send their painters to Rome before it was too late. But Bernini did prize the paintings of France's greatest painter, Nicolas Poussin, who had lived almost uninterruptedly in Rome for forty years. Bernini was apparently not very familiar with

Poussin's works before coming to Paris. Certainly Poussin's circle in Rome – Duquesnoy, Algardi, Sacchi, Bellori – were not Bernini's friends and held theoretical beliefs about the nature and aim of art that seemed to conflict with Bernini's practice. Poussin himself had painted only one picture for a Roman church, early in his career, and since much of his later production was sent straight to France, Bernini had had little opportunity to become acquainted with his mature style. Chantelou was one of Poussin's most faithful patrons, and Bernini's visit to Chantelou's collection makes one of the most fascinating and moving impressions in the diary. Bernini recognized Poussin from a *Self-Portrait* and spent a long time looking at the other Poussins his host had collected. He looked at a *Bacchanale* for fifteen minutes in silence and then said: 'Truly, that man was a great history painter and a great painter of mythology' (*favoleggiatore*). A *Triumph of Bacchus* again elicited '*O il grande favoleggiatore!*' Chantelou then showed him his proudest possession, Poussin's second series of *The Seven Sacraments*. *Confirmation* was the first one Bernini saw; after examining it silently, he remarked on the Raphaelesque inspiration. 'What devotion! What silence!' he exclaimed. He looked at the series of paintings for an hour without tiring. Finally he turned to Chantelou and said: 'Today you have given me great displeasure by showing me the worth of a man who makes me realize that I know nothing.' Later he came back to the *Sacraments* and said, 'I value these pictures as highly as those by any painter who ever lived He is a great genius, and with all that, he based himself chiefly on the antique Your Excellency must realize that you have a treasure in these paintings that must on no account ever be given up.' The next evening he remarked that he couldn't get Chantelou's paintings out of his mind. (Colbert remarked acidly that he was pleased Bernini had at last liked something in France.) Bernini's most revealing remark about Poussin was made on another occasion. He saw one of Poussin's greatest paintings, *The Ashes of Phocion*, which was then in Paris. After looking at it for a long time he put a finger to his forehead and said: 'Signor Poussin is a painter who works up here.' We may recall that he had made a similar reference to Annibale Carracci (p. 63).

Bernini once stated that all paintings should be judged by Raphael's, and we have mentioned his love for the works of Guido Reni – over and over again in Paris he singled out a painting by Reni for his highest praise. Now Raphael, Annibale Carracci, and Reni are artists who are usually considered 'classical' in the sense that they relied on line before colour, drew from antiquity and, broadly speaking, were cerebral rather than intuitive. Poussin's art embodies all of these qualities – his name is synonymous with seventeenth-century artistic classicism just as Bernini's is with the Baroque. Bernini's consistent and genuine admiration for these painters seems to run counter to his own artistic aims. We might expect that the exuberant, dynamic Bernini, who sometimes valued sketches over paintings and whose own sculpture is the most coloristic ever created, would have prized Titian, Caravaggio, and Rubens over the classicists. In fact, however, Bernini did not think of his own art in just this way. The best evidence we have of Bernini's adherence to traditional artistic theory is Chantelou's record of his advice to the French Academy of Art.* The remarks were made to men who, Bernini felt, could better study in Rome. For this reason he began by saying that they should have casts of all the great pieces of antique sculpture for the instruction of the young, who should be required to draw from them in order to form a first idea of Beauty that would serve them all their lives. If set to draw first from nature they would be ruined, for nature is almost always weak and insignificant. This advice could as easily have come from Giovanni Pietro Bellori, the spokesman for the classical, anti-Bernini faction in Rome, and it has even been suggested that Bernini was speaking tongue-in-cheek. Nothing could be further from the truth. His education and his own practice confirm his faith in this method. Drawing and the study of the antique were for Bernini the basis of art: from first to last he relied on ancient examples as the source of his inspiration (cf. pp. 61 and 155 above, 191 below). In some works this is apparent, as in the *Apollo* [20] or in the church at Ariccia [78]. In his mature sculpture the antique source can be found only by reconstructing his creative process by means of the preliminary drawings that happen to survive. And although the form of Bernini's architecture

often seems less evolved from its antique prototype than his sculpture, he invariably changed its meaning if not its shape (cf. pp. 148 ff. above).

While at the Academy Bernini asked why some works of art please at first but then pall, while others seem to get better and better. The reason lies in good principles and in having a grounding in *disegno* (not merely drawing but the art of design). Lacking this, there remain only colour and ephemeral effects that please the eye but not the mind. The North Italian painters were great, he said, but lacked *disegno*. (This is an echo of the famous sixteenth-century controversy between the relative worth of Florentine and Roman *disegno* and Venetian *colore*, a controversy that re-erupted in Paris after Bernini's departure when the academic followers of Poussin were challenged by enthusiastic supporters of Rubens.) Bernini insisted that students mix production with imitation so as not to become servile copyists. His three precepts for success were: see the beautiful (antiquity) early and become accustomed to it; work hard; get good criticism. One should correct defects by their opposites, he advised, and we know from his own drawings and clay models that he constantly reversed the poses of his figures so as to expose weaknesses and see the composition afresh (cf. pp. 191 and 202 below). Bernini's artistic theory was based on antique thought. One of his first statements to Chantelou upon arrival was that beauty in the arts, even in architecture, lay in proportion (cf. p. 155 above). This was a divine thing – its origin was in the body of Adam, made by God after his own image. The idea that perfect proportion lay in the shape of man was the basis of Italian Renaissance figural art and differentiates it from the art of Northern Europe. But even in Italy this fundamental belief was weakening in the seventeenth century – Bernini's criticism of Borromini's architecture lay on the grounds that it was based not on the proportions of the human body but on chimeras.

On fundamental principles, then, Bernini was entirely in accord with Raphael and Poussin; in his theory, if not in his actual results, he was still a product of the High Renaissance. We should not take Bernini's theoretical remarks more seriously than we do the evidence of his practice, however; and his works sometimes go

far beyond his theory. Bernini did draw from the antique, did believe in the universality of human proportions – but these beliefs alone are not sufficient to explain his art. We cannot doubt the sincerity of Bernini's discourse to the Academy but we may suppose that he deliberately stressed his own relationship to tradition while suppressing, consciously or unconsciously, the novel results he drew from traditional sources. Bernini's theoretical statements are chiefly concerned with methods; here he was at one with the seventeenth-century classicists save for one vital difference: Bernini started with an antique source but so modified its form during the process of preparation that it often became unrecognizable. And the form of the classical source is transformed as much by its new content as by its changed aspect. Poussin, on the other hand, would prepare for a picture by drawing an imaginative composition expressed spatially in broad strokes of light and shade; he then modified it by refining out the accidental and making it planar, concentrated – 'classical'.* But of these differences in approach and in result we hear nothing in Paris; whether by chance or by design, the French Academy – which was to become so influential in succeeding years – heard from Bernini almost exactly what it wanted.

In the course of his talk to the Academy Bernini made a number of interesting if second-hand comments on the relative virtues of the arts, the old *paragone* that had so interested Alberti and Leonardo. He said, for example, that painting was easier since the sculptor can't add to his statue what he learned while doing it; it represents what he knew when he started while a painting shows what the painter knew when he finished. The sculptor has to fight his material, taking pieces of it away; the luckier painter *adds*. He would rather have been born a painter because paintings are easier to produce. Nevertheless, sculpture is a truth; a blind man can judge it. Painting is a trick, a lie, and the work of the devil; sculpture is the work of God who was himself a sculptor, having made man of earth, not in an instant but in the manner of sculptors. On other occasions, however, Bernini used different arguments. Baldinucci reports that he considered painting superior to sculpture because it shows what is in relief without having any and

makes things seem distant that are not. Painting is particularly superior for portraits, and Bernini had a lot to say on this subject in Paris while he was working on his bust of the King. One day he discoursed on the difficulty of portrait sculpture, particularly in marble, and reminded his listeners that the great Michelangelo would never do a portrait bust. If a man were to become all white, Bernini pointed out, he would hardly be recognized, even by his friends. When someone is ill and pale, we say 'he doesn't look himself'. So in a marble portrait, in order to imitate the natural, the sculptor has to make something unnatural; for example, to represent the livid area around an eye with realism he must incise the spot to give an effect of colour in the white material by creating a shadow.

Thanks to Chantelou, Bernini's bust of Louis XIV is better documented than any of his other works.* Shortly after his arrival in Paris the idea was broached and on 20 June he was officially commissioned; the bust was finished on 5 October [87]. After choosing the marble (which never pleased him because it was too friable – '*cotto*') he first set about sketching the King as he moved about in his natural occupations. This process has already been discussed in connexion with the Borghese bust (p. 93), but our knowledge of the technique and its purpose is chiefly based on Chantelou's record. Bernini expressly wanted the King to speak and move normally. He once said he wanted to steep himself in the likeness of the King. He said that the best moment to catch a likeness is that instant when the subject has just finished speaking or is about to speak, a principle that can first be deduced from the Borghese bust of 1632 [46]. Bernini began to make small clay models the day after he began his sketching. These two activities had a different purpose. The drawings were made to capture the likeness and liveliness of the man; the *bozzetti*, as the models are called, were done to work out the broader form, the composition of the whole. On 6 July his favourite pupil, Giulio Cartari, began the rough blocking-out of the marble. On 14 July Bernini himself began working the marble and spent a total of forty working days on it. When chiselling the stone, he did not make reference to the drawings and models but worked from his idea of the King.

(Otherwise, he explained, he would be making only a copy and not an original.) A suit of armour was brought as a model and a piece of taffeta was used for studying the drapery, which was chiefly executed by Cartari. Bernini had said he needed twenty sittings but in the end got only thirteen, each lasting about an hour. The first of these was on 11 August. During the sittings Bernini worked directly on the marble, a practice that few sculptors would dare imitate. The last things he carved were the pupils of the eyes. When the bust was finished he marked the blank eyeballs with charcoal to achieve the effect of light reflecting from the centre of the pupil. He then chiselled out the places he had marked so that the darkness of the charcoal was replaced by shadow.

When he had finished, Bernini said that what he had achieved was beyond the natural. His bust is a symbolic portrait of a great leader rather than an intimate likeness. Several of the courtiers commented on Bernini's freedom in interpreting the monarch's features. Louis had, in fact, small eyes and a low brow but Bernini gave him large, noble features and a high forehead. 'My king will last longer than yours,' he once said to the courtiers watching him work, and this remark is the key to the meaning of the bust. The armour, the flowing drapery, the *contrapposto* of the head and shoulders all announce an imperial image. The *Louis XIV* is full of references to portraits of Alexander the Great; Louis' own features had to be modified accordingly. The basis for these liberties is the Platonic theory that inward virtue must be reflected in external form – that Beauty is the outward face of the Good. Apart from conventions, Bernini seems to have had a genuine admiration for the King. For Bernini, he was indeed a divinely guided monarch; and long after he had anything to gain from it he remarked that the King's understanding of art was greater than that of anyone he had ever met. Bernini's evident desire to see in the King the characteristics he ought to have had is paralleled in the bust. The base for the portrait occupied him a long time; it was to be a gilded copper globe of the world with the seas coloured blue and the inscription '*Picciola Basa*' – the idea being that the world was a small thing to support such a monarch.

The *Louis XIV* is superficially similar to the Este bust of fifteen

years before; in it Bernini had first achieved his dynastic portrait style [68]. In the long stretch of years lying between these two works he had been too busy with great commissions to carve another bust. The *Louis XIV* is, therefore, an isolated work, and makes an interesting contrast to the *Este*. The earlier bust seems more massive and pictorial. It flares out to left and right from a somewhat precarious perch on its base and then diminishes again above to form a diamond shape, more horizontal than vertical but with emphasis on the diagonals. The *Louis XIV* is far more linear and more stable. The sweep of drapery from left to right covering the truncated arms and chest forms, by comparison, an almost horizontal plinth upon which the shoulders and head rest securely. There is again the *contrapposto* movement of body and head, but in contrast to the human expression of the *Este*, *Louis XIV* gazes out and up with god-like authority. Other portraits of the King show his features with more accuracy but there is no more majestic royal portrait than Bernini's, and the King kept it with him – first in the Louvre, then in Versailles, where it still stands in state, true to Bernini's prediction. The bust is the only tangible achievement of Bernini's portentous visit; the real purpose of the journey, the designs for the Louvre, was never fulfilled.

Bernini's first Louvre project, of mid-1664, comes as a shock [88].* Unlike his classicizing architectural designs for Rome, this has a boldly concave frontispiece with a convex centre section, the whole framed by projecting wings. A colossal order helps unite the scheme vertically. An oval vestibule and, above, a two-storey oval hall lie within the centre projection. Roman church façades like that of Sant'Andrea al Quirinale [76] had already manifested such a bold spatial movement, but it had never before been applied to a city palace. It did not please, but its influence on later Baroque architects was enormous. Guarini in the Piedmont and Fischer von Erlach in Vienna were especially taken with the concept and produced important variations of it.

The second design, also sent from Rome, is a modification of the first, with a second concavity in the centre section in place of the convex projection of the original [89]. The third design, prepared

88 Louvre façade project, first stage. 1664

89 Louvre façade project, second stage. 1665

in Paris, abandons curves in plan in favour of a more typical Roman approach. In this façade Bernini expanded his earlier designs for an actual Roman palace façade, the Palazzo Chigi-Odescalchi, begun in 1664 and under active construction while Bernini was in Paris. The little Palazzo Chigi was built and the Louvre was not; the former is especially worthy of analysis because it represents Bernini's final mastery of pure architectural design in the Renaissance tradition, as opposed to his religious architecture, which was always subordinate to its function.

Since the palace was relatively long, Bernini divided the façade into an ornamented centre section standing out and above the rest [90]. The resulting wings at left and right were given horizontal rustication. The centre section has a columnar portal supporting a balcony and a specially ornamented central window displaying the Chigi coat of arms. The main floor, the *piano nobile*, is dignified by windows whose frames are little columnar tabernacles, terminated above by alternating triangular and segmental gables. The rhythm

90 Palazzo Chigi-Odescalchi as built in 1664

of these pediments, but not the columnar frames, continues with a jump across the wings at either side but with reversed alternation to show that the wings belong to a different order – a second layer lying behind the main block. The second storey windows of the centre section are less important and are given a flat, but fancifully lobed moulding. These two stories are linked by a colossal order of composite pilasters that singles out this section as the noble focal point of the design. These pilasters support a rich entablature; above the cornice, a balustrade with statues was meant to culminate the vertical and horizontal forces below. Here Bernini achieved the final and most harmoniously ordered expression of Italian palace façade design. Its roots go back to the little palace built by Bramante in which Raphael once lived. Bernini's palace still differentiates between the ground floor, literally the base of the design, and the floors inhabited by the nobility above. It organizes the length of the palace by setting out the prominent centre section and giving this part a higher organization on the surface. The whole is a masterpiece of mounting rhythmic forms, of balance and climax, the end-product of over 150 years of Roman façade design. Nowhere else does Bernini so clearly exhibit his community of thought with the High Renaissance, and no other work shows how completely he could resolve the problems of design implicit in the works of Alberti, Bramante, Vignola, and Palladio on their own terms.

The real trouble with Bernini's Louvre was not the façade but the plan of the palace behind. Bernini would not compromise with the parts of the Louvre already built; his grandiose design was typically Italian in its lack of those conveniences and comforts that the more practical French architects had taught their patrons to demand. Bernini's strict sense of decorum required the king's apartment to be in the centre of the complex, despite the noise and confusion that this position happened to imply. For such reasons the project was doomed almost from the beginning and even before Bernini left Paris it must have been clear that his Louvre would never be built. Foundations were begun and his assistant, Mattia de' Rossi, was sent back in 1666 to execute the designs. But the French architects were solidly against him and, despite the

affection that Bernini had aroused in the King, nothing came of the plans. Louis began to play with Versailles, and the Louvre façade was ultimately executed according to French plans. Bernini's project might have been executed but for one damning fact: as Colbert finally remarked, the Italian's symbolic palace, for all its great stairs, halls, and rooms, left the king as cramped and uncomfortable as he had been before.

Bernini left Paris on 20 October, accompanied on the first stage of his journey by Chantelou. When they said goodbye, Bernini's eyes were full of tears. After arriving in Rome early in December he wrote back to Chantelou: 'I returned to Rome to find Signor Poussin dead.' The trip to Paris came to little and it had an unfortunate aftermath. Bernini had agreed to be artistic adviser to the new French Academy in Rome, which was established the following year. As a first project for the students he proposed that they collaborate with him on a giant equestrian statue of Louis XIV that had been discussed in Paris and was finally executed between 1669 and 1677. It was sent to Paris only in 1684, after Bernini's death, but by the time it arrived its exuberant Baroque style was hopelessly out of favour in the French court. The statue was ultimately modified by Girardon into a *Marcus Curtius* and relegated to an unfrequented corner of the garden of Versailles where only the acrid fumes of passing trains and a few devoted students of the Roman sculptor have sought it out.

Bernini's Parisian interlude had little effect on the course of French art and only the bust remains as a relic of the momentous journey. Nevertheless, the trip to Paris in 1665 was an event of great significance. Within a few years Bernini, Borromini, and Pietro da Cortona – the flower of the Italian Baroque – would be gone. Their successors were, by comparison, pygmies and, in any event, the future of artistic patronage lay in France, the France of the *Roi Soleil* and Versailles. Although French art of this period rarely comes up to the quality of the Italian Baroque, the leadership was there. Bellori's *Lives of the Artists*, published in Rome in 1672, was dedicated to Colbert; by that time everyone could see how the wind was blowing. The increasingly enfeebled papacy could no longer support an artistic programme of the sort that

Paul V and Urban VIII had maintained. Bernini's unsuccessful journey represents for us the passing of great artistic patronage from Italy to France.

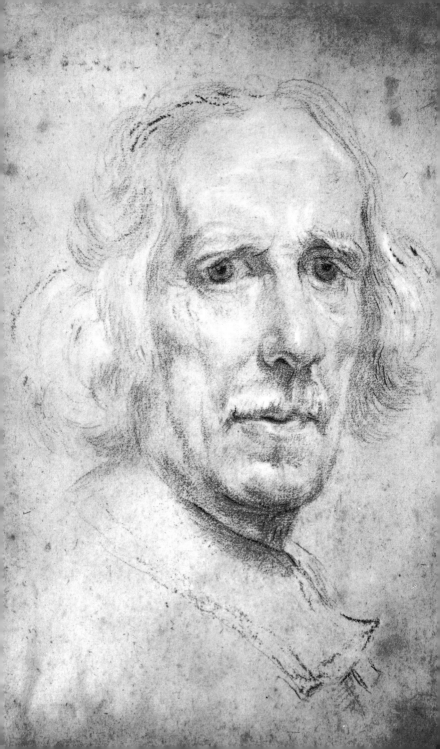

6. The Late Works

Like other great artists who lived long and productive lives, Bernini evolved a very personal late style. It would be a mistake to push the analogy with, say, Rembrandt or Beethoven any further – Bernini's career resists neat division into early, middle, and late. Nevertheless, his later works have a distinctive quality, more spiritual and subjective than the rest. The change begins in the 1650s but is already heralded by the *Truth* begun in 1646 which was, significantly, a private justification for his failure to execute the campanili of St Peter's [92]. The original idea for the composition was *Truth Revealed by Time*. The figure of Time was never carved, and we are faced with a figure left unfinished in 1652 that was never meant to stand alone. Time, with a scythe, was to have flown in over the recumbent figure from our right, revealing her – 'the naked truth' – with her foot on the globe, looking up at him with a smile of ecstasy, and shining the purifying light of the sun in his face. The relic of this conception is unsatisfactory by almost any standard. It is, however, pure Bernini of an unusually private and significant kind, and it has been pointed out correctly that in this work, done only for himself, he first sh ws the signs of what became his late style. The figure is far less classical than any he had previously done. The body and legs are notably elongated, greatly increasing the proportion of these lower extremities to the upper body. The fundamental change of proportion is inspired by a new concept of beauty that is equally unclassical.

The beginnings of Bernini's late style can be traced in individual figures carved for two chapels belonging to the Chigi family, both decorated by Bernini for Alexander VII Chigi (1655–67).

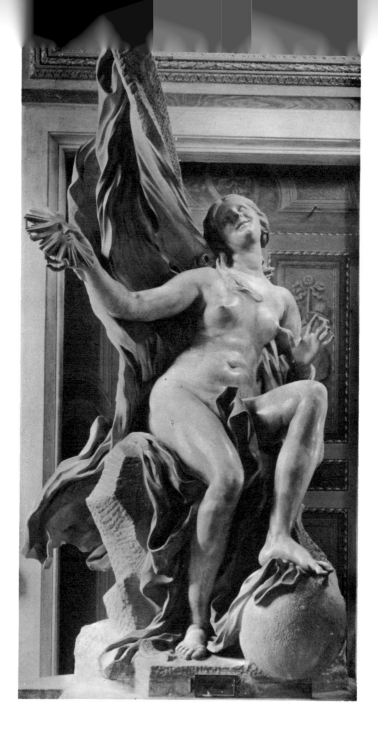

The first of these is the famous chapel in Santa Maria del Popolo designed by Raphael *c.* 1513–15 for Agostino Chigi, the rich Sienese banker who was an ancestor of Alexander VII.* This chapel had already been given two Raphaelesque statues of *Jonah* and *Elijah*. Bernini carved a *Habakkuk* and a *Daniel* for the remaining niches. The story, rather unfamiliar to us, is from the apocryphal legend of Bel and the Dragon, appended to the Book of Daniel in the Catholic Bible, which is read on Tuesday before Palm Sunday in the Catholic service. The text reads in part:

In those days, the Babylonians came to the king and said to him, Deliver us Daniel, who hath destroyed Bel, and slain the dragon; or else we will destroy thee and thy house. And the King saw that they pressed upon him violently; and, being constrained by necessity he delivered Daniel to them; and they cast him into the den of lions, and he was there six days. . . . Now there was in Judaea a prophet called Habakkuk: and he had boiled pottage, and had broken bread in a bowl, and was going into the field to carry it to the reapers. And the angel of the Lord said to Habakkuk, Carry the dinner which thou hast into Babylon to Daniel, who is in the lions' den. And Habakkuk said, Lord, I never saw Babylon, nor do I know the den. And the angel of the Lord took him by the top of his head and carried him by the hair of his head, and set him in Babylon, over the den. . . . And Daniel said, Thou hast remembered me, O God, and thou hast not forsaken them that love thee

Bernini moved the *Jonah* out of its niche flanking the door in order to create a spatial relationship between the *Habakkuk* and the *Daniel* opposite that would enliven the entire chapel. The angel comes to *Habakkuk* but points to *Daniel*, who kneels in fervent prayer [93–4]. By this means Bernini activated the space of the High Renaissance chapel, turning its classical form to a new religious use. The narrow niches afforded little room for the Habakkuk group which, nevertheless, gives a lively dramatic vignette of the comfortably seated figure with his lunch basket, leaning backwards, and pointing in the direction in which he wants to go; the spirited angel leans outward, lifts *Habakkuk*'s head and points toward *Daniel* [95]. It is the *Daniel*, however, that shows the characteristic elongation of which we have been speaking, since the *Habakkuk* had to be compressed in order to make room for a second figure. *Daniel* kneels, his right foot licked

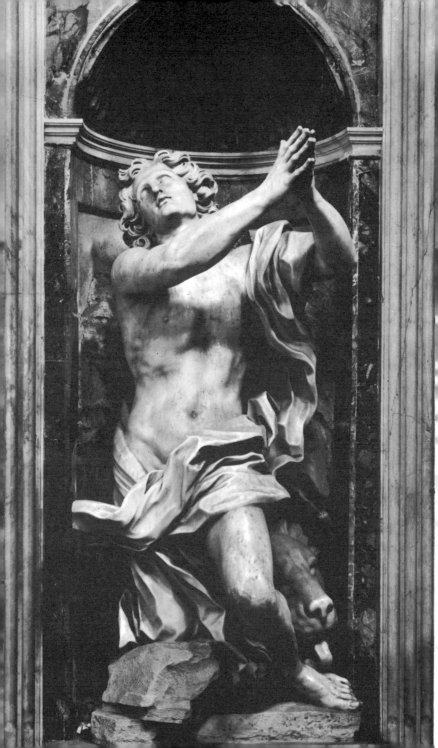

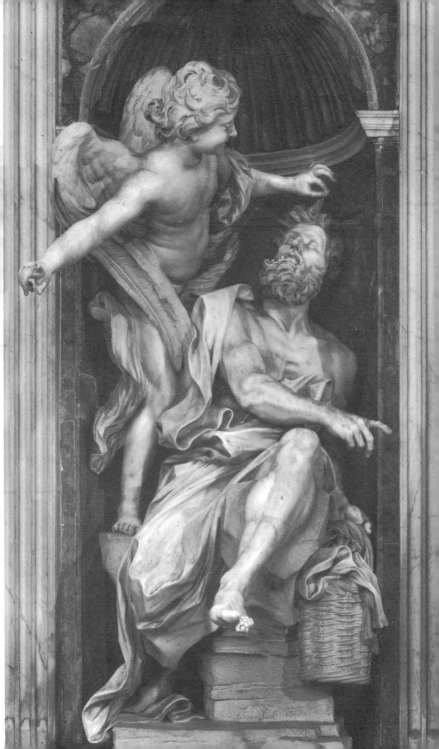

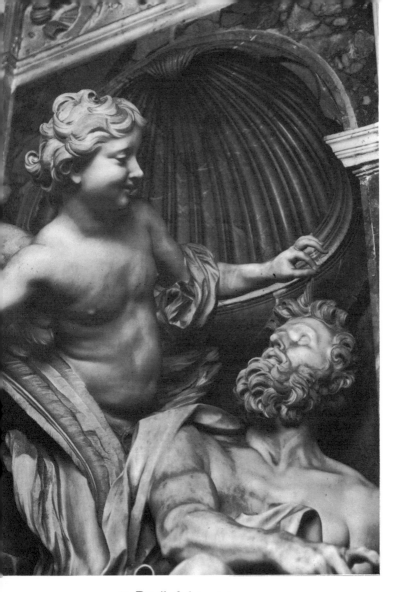

95 Detail of plate 94

← (overleaf)
 93 *Daniel*. 1655–7. Santa Maria del Popolo, Chigi Chapel
 94 *Habakkuk and the Angel*. 1655–61. Santa Maria del Popolo, Chigi Chapel

by the friendly lion; with a bold gesture of prayer he reaches out to his right while his head turns up to the figure of God the Father represented in mosaic in the chapel's lantern. The seeking, longing emotions of the figure seem to stretch his body as he raises his hands and eyes. This upward force is given a counterpoint by drapery flowing in angular folds from the shoulders and across his loins where it intersects more drapery and blows off into the air. The figure's position is extremely complex in its *contrapposto* movement and forms an antithesis to the recumbent *Truth* in its taut, actively beseeching pose. One would never guess that the original inspiration for the figure came from the *Laocoön* [96], but such is the case as a series of surviving drawings proves [97–9]. This is one of the rare instances in which we can follow the process of classical inspiration and subsequent change that Bernini re-commended to the French Academy (cf. p. 173 above). He started with a study from the *Laocoön*, reversed it, and ultimately return-ed to a somewhat similar pose in the *Daniel* that has an utterly different sense. The *Daniel* was finished in 1657, the *Habakkuk* in 1661; at the same time Bernini's pupils redecorated the entire church.

Bernini's figures for another Chigi Chapel, in the Cathedral of Siena, were begun in 1661 and finished two years later. In this commission he had more freedom since he designed the entire chapel. Two other statues were executed by associates. Bernini's saints – *Magdalen* and *Jerome* – flank the entrance to the chapel [100–1]. Each is self-contained, wrapped up in personal religious ex-perience. The *Magdalen* is wholly circumscribed by the architecture of the space and her almost contorted physical state contrasts poignantly with the simple arch above her. *Jerome*, whose experi-ence is inward, meditates with closed eyes on the Crucifix that has miraculously appeared before him. Both the cross and *Jerome*'s drapery overlap the architecture, to insist upon a physical contact with outside space that the rapt *Magdalen* (like *Habakkuk* and *Daniel*) achieves by her gaze. The Chigi figures, in their variety, are continuations, after a long interval, of ideas first evolved for the *Longinus* [39]. All of Bernini's niche figures, beginning with the *Bibiana* of 1624–6, show his compulsion to animate the

96 Agesandros, Polydoros,
 and Athenodoros of Rhodes,
 Laocoön (detail). 150–100 B.C.

97 Drawing after *Laocoön*

98 Drawing for *Daniel* 99 Drawing for *Daniel*

commonplace niche statuary of the past. The sculptured figure in
a niche was a normal architectural decoration in the Renaissance,
but in the earlier period the statue is almost always contained
within it; rarely does it overlap its frame, and almost never does it
attempt to communicate outside itself. Bernini's two figures are
variations on a theme. The *Magdalen* is the traditional penitential
figure of grief and remorse who communicates with her God in an

100 *St Mary Magdalen.* 1661–3. Siena, Cathedral, Chigi Chapel

agony of physical emotion. *Jerome*, whose penance is for intellectu-
al rather than physical sins, turns inward to a mystical experience.
In these figures the fervent qualities of the *Daniel* have been in-
tensified, and the contrast of their complementary emotional
states is expressed through their poses, now mirroring, now echo-
ing each other.

101 *St Jerome.* 1661–3. Siena, Cathedral, Chigi Chapel *195*

102 and 103 Details of plate 83, Cathedra Petri

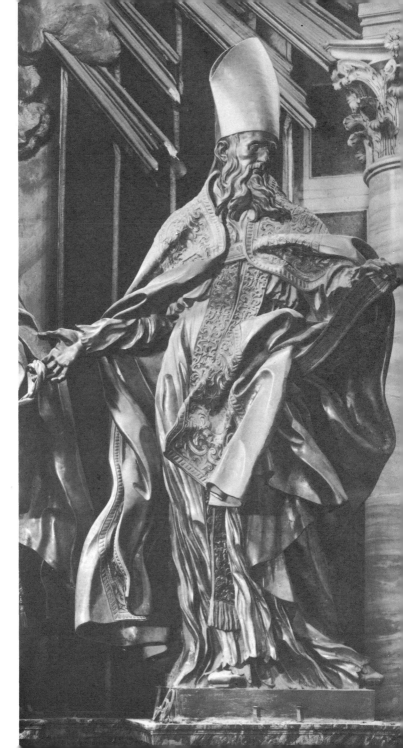

A similar occult balance is found between the bronze angels flanking the Cathedra – notably elongated, ethereal figures with molten drapery [102]. Their poses reflect each other in general but within this mirror symmetry is a subtle echoing seen in the two bare legs, one left, one right, one crossing, one not, while the two left arms are in almost identical positions. In their expressive drapery these two angels go beyond anything we have discussed, but the two figures are also variants of the *Jerome* and *Magdalen*: all of them have one bare leg emerging from the drapery, and all show a pronounced sway or torsion in their poses.

Below the chair, the imaginative portraits of the four Doctors (cf. p. 160 above) are similarly dissimilar [83]. Each is brilliantly characterized [103]. Bernini achieved a sense of expressive, personal emotion through a simplified but exaggerated rendering of form. Extremities are attenuated, facial expressions are pronounced, drapery is agitated. These hallmarks of Bernini's late style are found in much of the sculpture that we label Late Baroque, particularly the figures in many South German churches of the eighteenth century, which depend upon Bernini's inspired late style.

The famous *Angels* commissioned by Clement IX Rospigliosi (1667–9) for the Ponte Sant'Angelo embody Bernini's clearest exposition of complementary figures. Clement and Bernini were fast friends; the Pope, deeply cultivated and a poet and playwright like Bernini, loved the artist's company and they often dined together. Had the Pope lived, he would have given Bernini more important commissions than did his successor, Clement X, but the general economic collapse prevented patronage on the scale of Urban VIII and Alexander VII. Indeed, we hear of a resolution directed against Bernini, 'who was the instigator of the Popes' indulging in useless expenses in such disastrous times'.*
Bernini's *Angels* were carved as part of the modernization of the only bridge giving access to the Vatican from the city across the Tiber [104]. Ten over life-size angels carrying the Instruments of the Passion were carved between 1668 and 1669 under Bernini's direction. His own share of the execution was the *Angel with the Crown of Thorns* and the *Angel Carrying the Superscription 'I.N.R.I.'*

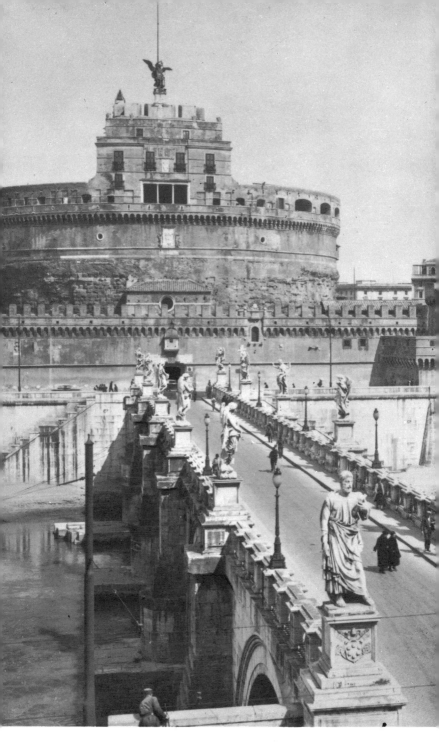

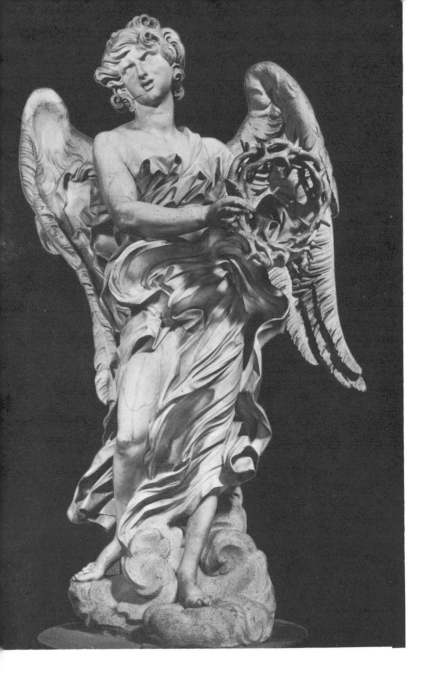

105 *Angel with the Crown of Thorns.* 1668–9

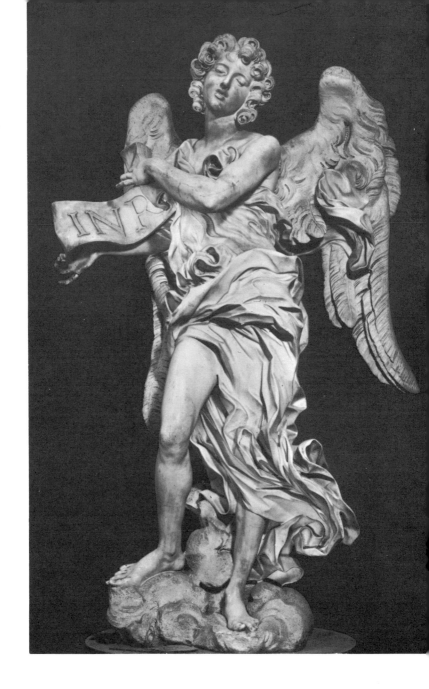

106 *Angel with the Superscription 'I.N.R.I.'* 1668–9

[105–6]. Thanks to a large number of surviving *bozzetti* we can follow Bernini's working process in some detail.* Two facts stand out: first, that he worked on drawings and models simultaneously, as in the past; second, that he studied both angels together, throughout the process of creation, so as always to have a complementary pair. For convenience of illustration we will take the *Angel with the Crown* as a case history. Probably our first piece of evidence is a nude study showing the left leg bent and in front of the right, with an exaggerated *contrapposto* movement in the body above [107]. The purpose of this *bozzetto* was obviously to get the pose and anatomy fixed, and it may well have been modelled from life. At the same time Bernini seems to have worked on an almost

107 and 108 *Bozzetti* for *Angel with the Crown*

exact mirror image for the other angel, but from our knowledge of his other works we can be sure that he never seriously contemplated this for the final solution. A second *bozzetto* shows the same stance, but with a less extreme sway and a far more attenuated body, which is now draped [108]. A drawing records this stage with a different position of the head. Still another *bozzetto* is very close to the final statue and strikingly different from the early studies. As executed [105] it is now the angel's right knee that is bent, the left leg remains in front and is covered by drapery flowing in the opposite direction from that of the *bozzetto*. The position of the upper body is still like that of the earlier studies, but the head looks up and to our left. Although we are surely missing many of the links in this chain, it is clear that Bernini worked separately on anatomy, pose, and drapery, combining and reversing until he got the expressive position he sought. And since the process included not just one, but two angels, and drawings as well as *bozzetti*, it demanded a much more involved and subtle train of thought than can be shown here. All that this discussion can suggest is the almost automatic way Bernini thought with his hands, creating one clay figure after another in his search for solutions.

The *Angel with the Superscription*, as finally finished, has its legs in a similar position [106]; the body leans left rather than right, the sign is held to our left and the angel's head tilts to the right and looks down. Unlike the angels flanking the Cathedra [102], both have the right leg bare, but the drapery swirls in different directions. This complex interplay of heraldic opposition, of similarity and differentiation, is like the fugal development of a theme – the sorrow in heaven over Christ's Crucifixion. The lamenting angels stand sunk into clouds, blown by the wind, holding the signs of Christ's torture. Their drapery makes abstract commentary on the emotional states of the mourners. In these years Bernini increasingly relied on drapery as an agent of his feelings. Instead of wool or linen covering, the drapery becomes a *chiaroscuro* pattern, relating to a highly charged inner feeling whose expression seemingly overpowers the potentialities of the face and body alone. Each of the pairs of figures we have had occasion to discuss – *Jerome* and

Magdalen, the Cathedra angels, and now the *Angels* for the Ponte Sant'Angelo – has had a specific emotion, in no way similar to the others. And yet all of them are variations on one idea. All have in common an emotional fervour that increases and becomes more expressive in each succeeding group.

Bernini's *Angels* were so highly prized that they were never set up on the bridge, and their high polish would seem to indicate

109 *Angel with the Superscription 'I.N.R.I.'* (in part by Giulio Cartari). 1670–1. Ponte Sant'Angelo

that they were not intended to be installed. They were replaced by copies, but the 'copy' of the *Angel with the Superscription* has on good tradition been ascribed to Bernini himself [109]. Perhaps Giulio Cartari, the man who was supposed to do it, had only begun the work, leaving it to be finished by Bernini in secret. It is, in fact, not a copy but a variation, with drapery approximating that of the *Angel with the Crown* rather than its supposed original.

110 Antonio Raggi, *Angel with the Column*. 1668–9. Ponte Sant'Angelo

Their position on the bridge gives the angels three main views since they can be seen from both sides and from straight on. Bernini easily accommodated himself to this situation, as he had in the past with the *Moro* [66], by giving the figures an elaborate *contrapposto* movement in three dimensions that provides a lively silhouette from many angles. These angels are among his most moving works and it is instructive, while crossing the bridge, to compare them with the statues by his followers, which are not of comparable quality or intensity – although Raggi's *Angel with the Column* is a spirited exercise in the externals of Bernini's late style [110].

The Ponte Sant'Angelo – essentially Bernini's even if executed in large part by others – was the gateway to the Vatican and St Peter's, and all along the way the pilgrim was guided and enlightened by Bernini's art: the Piazza, the nave decorations, the Baldacchino, the statues in the crossing, and the Cathedra in the apse. One of Bernini's last masterpieces is also in St Peter's, the altar of the Cappella del SS. Sacramento [111]. His last pair of ecstatic

111 Altar and ciborium, Cappella del SS. Sacramento St Peter's. 1673–4

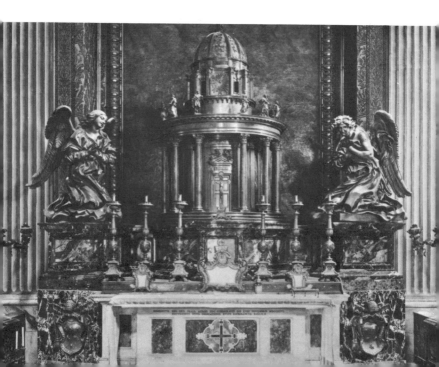

angels was designed for this monument, an old project revived by
Alexander VII and finally realized under Clement X Altieri
(1670–6). During the course of the final planning Bernini tried
out a more elaborate composition in which the tabernacle was
mystically suspended within a ring of angels carrying candlesticks;
the penultimate plan had a circle of angels adoring the tabernacle.
As executed, the ring was reduced to a single pair of angels right and
left of the central building; one adores the holy of holies, the
other turns toward the suppliant at the altar rail. Bernini's final
solution is a Baroque version of a familiar theme; it seems likely
that his source of inspiration was a relief, ostensibly by Sansovino,
in Santa Croce in Gerusalemme, which he would surely have
known [112].* But the earlier composition is on a smaller scale and
is part of a larger monument; photographs do not convey the
scale of Bernini's gilt bronze decoration: his angels are consid-
erably over life-size. Work was begun in 1673 and finished late
the following year. Bernini took personal interest in every stage of
the design, executing a series of drawings and *bozzetti* of which an

112 Follower of Jacopo Tatti Sansovino, tomb of Cardinal Quignone
(detail). *c.* 1536. Santa Croce in Gerusalemme

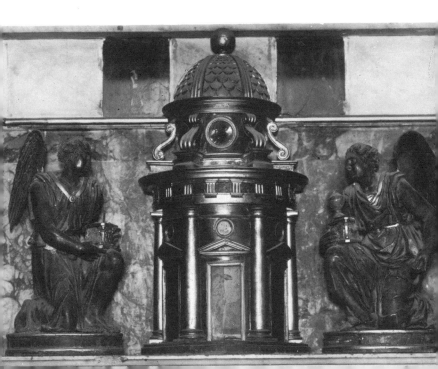

unusual number have survived. One of these, an extraordinarily free drapery study, is shown in 113. Once again Bernini created pendants in heraldic symmetry, full of inner contrast as well as outer harmony. To stand between the angels, he designed a Baroque version of Bramante's famous High Renaissance Tempietto, which was, in turn, an imaginative reconstruction of an antique temple. Bernini's architecture is ornamental, however, with richer details – fluted, unevenly spaced Corinthian columns, statues of twelve Apostles around the cornice, and a high drum and dome, fancifully ribbed and incised. The reference is obviously to the Holy Sepulchre in Jerusalem, the almost mythical structure that exerted so powerful an influence on Western architecture during the Middle Ages and Renaissance. The gilt architecture is studded with lapis lazuli, and the whole is set on a richly

113 *Bozzetto* for *Angel* in Cappella del SS. Sacramento

veined marble base behind the altar, flanked by the Altieri arms. The pliant, human adoration of the angels in contrast to the timeless architecture of the building typifies Bernini's late style. In his last years he seems to have found the inexorable laws of architecture a moving antithesis to our transitory human state.

We have previously mentioned the Scala Regia and the *Constantine* as part of Bernini's contribution to the completion of St Peter's and the Vatican (p. 166 above). *Constantine* is first of all a superb architectural decoration mediating between the two routes meeting at that point [86]. It is also an impressive symbol and, more important to us, a late work of the highest quality. A *Constantine* had been ordered by Innocent X in 1654 to occupy a site within St Peter's. Work began, but when the Pope died it was dropped; when taken up again in 1662 the equestrian monument became the focal point of the Scala Regia as seen from the portico of St Peter's[Fig. 5, p. 163]. Bernini had still not finished it when he went to France; in 1668 it was finally completed and the entire composition was unveiled in 1670 [114].

Constantine's horse rears back in alarm as the Emperor, riding bareback, throws out his arms and gazes up in adoration at the vision of the Cross. The lack of stirrups and reins was conscious; they were probably omitted in conformity with the antique equestrian statue of Marcus Aurelius on the Capitoline, and *Constantine*'s sandals may have been modelled on the same source. (Throughout the Middle Ages the *Marcus Aurelius* was saved from the melting pot only because it was taken for a *Constantine*.) A further piece of historicism was discovered by Wittkower: Bernini copied out for his own use a passage from Nicephorus' *History of the Church* that describes Constantine's appearance. For all that, the result is far from a classicizing reconstruction; it is a typically dynamic transmutation of classical ingredients into an electrifying whole. Bernini again uses a three-dimensional statue as a kind of relief, and the *Constantine* is in fact attached to the wall behind; nevertheless, the approach is hardly different from early statues like the *Apollo and Daphne* [20]. Its attachment to

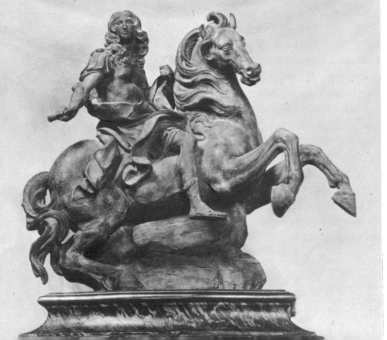

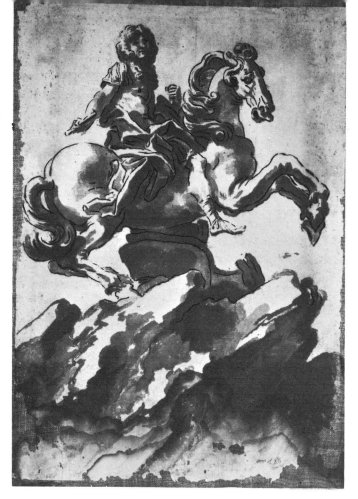

116 Drawing for equestrian *Louis XIV. c.* 1673

the wall allowed Bernini to carve the rearing horse that had so
tantalized previous sculptors of free-standing monuments from
Leonardo da Vinci to his own day. Behind, a great billowing
drapery frames the group, makes it a kind of apparition, and adds
a dramatic directional sweep from upper left to lower right as a
counterpoint to the rearing, neighing horse and the astounded
Emperor.

The *Constantine* is paralleled by the equestrian *Louis XIV*,

←– 114 (*above*) *Constantine* (detail of plate 86)
 115 (*below*) *Bozzetto* for equestrian *Louis XIV. c.* 1670. Galleria Borghese

which is, however, a free-standing monument of very different significance (cf. p. 182 above).* This ill-starred work was executed immediately after completion of the *Constantine*, although it was finished only in 1677. The similarities to the earlier statue are obvious, but there is a significant divergence of meaning. Colbert had asked Bernini to make the statue similar to the *Constantine* but not to copy it. Bernini wrote back late in 1669 that the 'statue will be completely different from that of Constantine, for Constantine is represented in the act of admiring the vision of the Cross and that of the King will be in the attitude of majesty and command'. In fact, Bernini evolved an elaborate *concetto* as the underlying meaning of the monument. Horse and rider were to appear at the top of a high rock, symbolizing the peak of Virtue that Hercules chose when confronted at the crossroads with the choice between the Primrose Path and the steep climb up the rocky mountain. Louis is seen as a second Hercules – an appropriate allusion because of the legendary descent of the French royal family from *Hercules Gallicus*. He has mounted the steep path and looks down as a commander who is both a king and a living counterpart of a mythological hero [cf. 116]. It is amazing to discover the subtlety of Bernini's thought as he shows himself, more than ever before, a master propagandist. As always, it must be insisted that Bernini's idea grew with the form he was modelling and was neither superimposed afterwards nor laid down apodictically from the start. His evolving conception can be seen in a large clay model that probably dates from 1670 [115]. In style it is closer to the *Constantine* than to the final marble, in which the mane and tail curl up and crinkle with an ornamental volition of their own. The *bozzetto* lacks the rock and flags seen in the drawing [116] and originally present in the statue itself (which was re-carved as a *Marcus Curtius* after it arrived in France, with changes in the head and rock). Bernini's *concetto* grew out of a practical demand: the marble horse could not rear back on its hind legs without some support below. The decision to make this support the rock of Virtue climbed by Hercules illuminated the entire image with a higher significance. It may seem far-fetched today, but the Choice of Hercules, and the idea of the rocky ascent to a temple of Virtue

or Glory, was familiar to every cultivated European of the seventeenth century. It should have been an especially appealing idea to Louis XIV: the quest for 'glory' was the mainspring of his existence.

In addition to the two equestrian monarchs, Bernini also conceived something like an equestrian obelisk which, however, rides an elephant rather than a horse [117]. The small obelisk that inspired the monument was found in the monastery garden of Santa Maria sopra Minerva; Bernini got the job of setting it up in the piazza before the church soon after his return from Paris. The idea goes back to a woodcut of 1499; Bernini had planned a similar monument for the garden of the Palazzo Barberini, but the idea remained on paper. Alexander VII was particularly interested in the meaning of the hieroglyphic inscriptions on the needle and had them interpreted by a learned Egyptologist, Athanasius Kircher, who published a book on the subject in 1666. The scholarly Pope was pleased to consider the re-erected obelisk a special glorification of his reign. It was interpreted as a symbol of sunlight, and a series of explanatory inscriptions on the base below the elephant elucidate the *concetto*. The kernel of the arcane meaning was expressed in a contemporary poem: 'The Egyptian obelisk, symbol of the rays of *Sol*, is brought by the elephant to the Seventh Alexander as a gift. Is not the animal wise? Wisdom hath given to the World *sol*ely thee, O Seventh Alexander, consequently thou hast the gift of *Sol*.'* The charm of the work for us is the more literal joke of the baby elephant carrying a high obelisk on its back; it is interesting to compare this conceit with Bernini's other obelisk-monument, the Four Rivers Fountain [63–5], where the obelisk is held in the air by a kind of four-footed mountain. Elephants, in any event, were a great curiosity in the seventeenth century (cf. p. 168 above), and many artists drew them, including Rembrandt, even though not all of them had actually seen the fabulous animal. And of all the elephants in art Bernini's humorous beast is surely the most engaging.

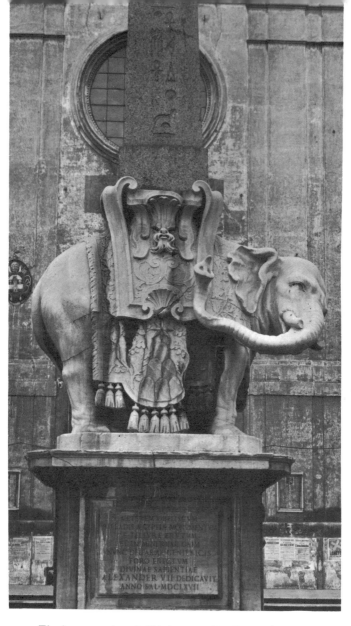

117 Elephant carrying obelisk (executed by Ercole Ferrata)
1666–7. Piazza Santa Maria sopra Minerva

Shortly before he died Alexander VII commissioned a tomb monument. In the early phase of planning Bernini seems to have decided on an image of the Pope praying above his own tomb chamber, with four allegories below him. In the end, the site chosen was a large niche containing a door. Bernini brought the door forward and distributed the figures above and to the sides [118]. The physical problem posed by the door was the catalyst for a conceit that lifts the group out of the ordinary into a realm of typically Berninesque dramatic tension. A marble shroud covers the supposed tomb chamber; out from the door to the 'tomb' flies the skeletal figure of Death holding an hour glass as he raises the shroud to show us the Pope's final resting place. The Pope above is on his knees in eternal adoration. The four Virtues – *Caritas*, *Prudence*, *Justice*, and *Truth* – have varying reactions. The *Caritas* at left yearns forward toward the praying figure. The *Truth*, right, modestly covers her nakedness – but since nudity in St Peter's was soon frowned upon, both she and the *Caritas* were covered with added folds of drapery, which conflict with the original meaning of the pose of *Truth*.

The tomb of Alexander VII is another of Bernini's group projects but here, unlike the Cathedra, his control seems to have relaxed. The reason may simply be that the Pope was dead. It was carved between 1671 and 1678 by a large number of assistants working from Bernini's models and drawings. Yet the whole, despite the inspired conception, does not entirely come off. The two half-hidden Virtues are only mediocre in quality and look like uncomfortable afterthoughts – which they are not. The *Caritas*, by Giuseppe Mazzuoli, is a robust creation reminiscent of the earlier figure carved for the tomb of Urban VIII [55]. *Truth*, finished by Giulio Cartari, is a hauntingly attractive figure of willowy grace and Botticellian sweetness. All four Virtues are, in fact, carefully differentiated according to type. The statue of the Pope was carved by Michele Maglia; an impressive compositional study by Bernini survives [75]. The executed marble is wholly in Bernini's late manner, and in the exaggeratedly ornamental treatment of hands and face it borders on caricature, as does Bernini's only portrait bust of this period [119]. The tomb

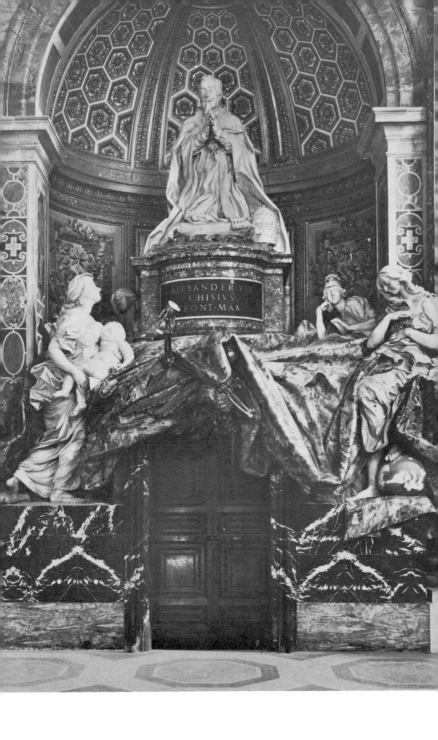

ALEXANDER VII
CHISIVS
PONT·MAX

is a *tour-de-force*, far more successful *in situ* than in photographs. The rather narrow passage in which the tomb is situated forces the spectator to see it from close by and from below. One needs to walk past the tomb, and back and forth, in order to see all of the figures, understand the action of the skeleton, and grasp the idea as a whole. The haggard, suppliant Pope kneels in prayer – taking up a long tradition beginning in the Middle Ages – a striking contrast to the Urban VIII across the church [55]. The triumphal qualities of the tomb of Urban VIII are entirely lacking; the macabre skeleton on the later tomb sets the mood, wholly dedicated to the next world.

Bernini's last portrait bust is also seen in eternal adoration [119].* The *Gabriele Fonseca* is the only piece of sculpture by Bernini in the family chapel he designed in S. Lorenzo in Lucina early in the 1660s [120]. The bust seems considerably later and in execution probably dates from the 1670s although Fonseca died in 1668; life-studies, *bozzetti*, or even a beginning on the marble during Fonseca's lifetime may account for the apparent verisimilitude of the portrait. The subject, a Portuguese doctor, had been Innocent X's personal physician. He is seen leaning out of his square niche, clutching his rosary with one hand and his chest with the other as he gazes raptly at the mystery on the altar (which has, significantly, a copy of an *Annunciation* by Guido Reni). Perhaps in no other work did Bernini so successfully externalize an interior state. The hands seem to clench and press with spastic intensity as the beseeching eyes and mouth form a silent prayer. The fur-trimmed cloak falls into an immaterial pattern of chasms and ridges – Bernini differentiates brilliantly between cloth and fur, skin and hair, but the purpose is no longer naturalistic. The *Fonseca*, like so many of the late works, exploits an emotional vehemence that can be called caricature in its emphasis on expressive detail. This tendency, already noticed in some of his early works (pp. 66, 99 above), is here pushed very far. Great art and caricature may at first glance seem opposed although no less a master than Dickens has been accused of the same 'fault'; but there can be no caricature without character.*

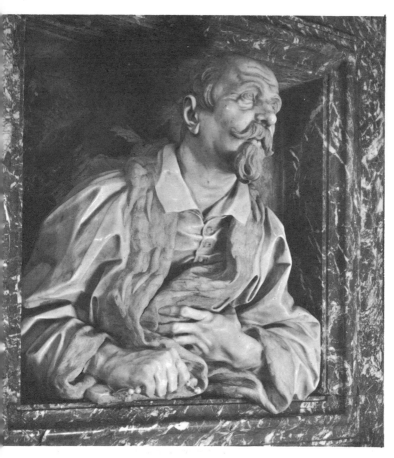

Turning back to the *Santoni* and *Montoya* we enter a different world [5; 29]; perhaps no other comparison shows so forcefully the long road Bernini travelled in the more than fifty years separating his earliest and latest works. Even the Borghese bust [45] seems calm by comparison with the fervent emotion of the *Fonseca*, which is one of Bernini's most memorable and deeply-felt portraits. This kind of fervour may not be to everyone's taste, but Bernini, the greatest Catholic sculptor in an age of increasing doubt, was perhaps destined to create a work of blind adoration as one of his final gestures.

119 *Gabriele Fonseca.* 1668–75 (?). San Lorenzo in Lucina, Fonseca Chapel

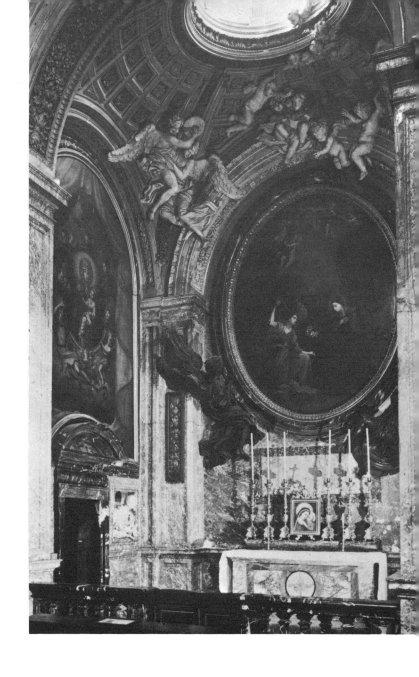

120 Fonseca Chapel, San Lorenzo in Lucina. Begun 1663–4

The *Fonseca* is paralleled emotionally and stylistically by *The Death of the Blessed Ludovica Albertoni* of 1674 [123].* The statue is again part of a larger whole designed by Bernini. The patron, Cardinal Paluzzi degli Albertoni, was related by marriage to Pope Clement X Altieri (1670–6), and took the name Altieri as the result. The chapel in San Francesco a Ripa is dedicated to one of his own family, however, the Blessed Ludovica (d. 1533), whose cult was sanctioned in 1671. One of Bernini's brothers was in trouble at this time and Bernini may even have done his work for nothing to hush up a sordid scandal. It is nonetheless one of his major achievements, proving again that in his seventies he was still in command of his almost magical powers.

The chapel itself is a domed space that Bernini opened up in the back, above the altar, to reveal a vision of Ludovica's death [121]. She lies in her final agony on a marble bed, below a large painting of the *Holy Family* [122]. The illusory effect of the scene is achieved by hidden illumination from windows at left and right; winged cherub heads appear to float down on the light to alleviate the final suffering of the Blessed, while the dove of the Holy Spirit hovers above to receive her devout soul. The contrast with the Cornaro Chapel is striking. Here, the actual depth of chapel and recess is relatively great; the vision appears at the end of a perspective view that is increased by the telescoped arch over the altar but joined to our world by the coloured drapery falling down in waves from her couch. A traditional architectural decoration behind the dying woman frames the painting by Giovan Battista Gaulli ('Baciccio'), a painter of high quality who collaborated with Bernini in this period. This painting does not create an imaginary extension of the space – as, for example, a view seen through an open window – but functions simply as a devotional image, although it was carefully and beautifully composed to fit into the larger composition.

The whole is considerably simpler than the Cornaro Chapel – it was obviously a much cheaper job – but apart from this there is an important stylistic difference between the two works. The fundamental fact that we stand in a normal chapel and look at a scene that partakes of an hallucinatory experience is common to both.

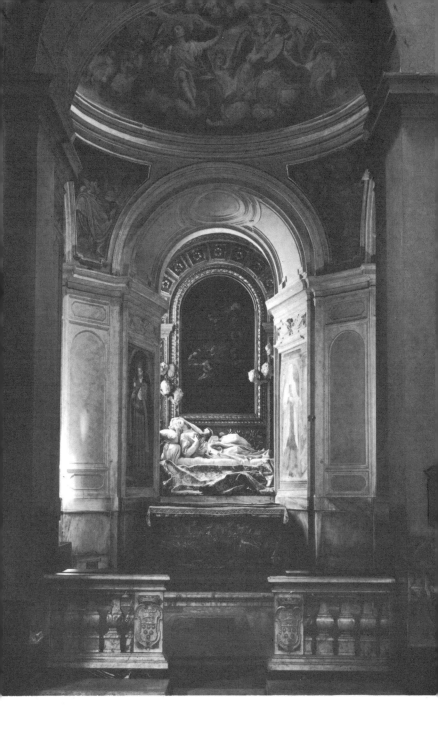

But the rich Baroque marble architecture of the Cornaro Chapel, with its broken pediments and curves in plan, makes a strong contrast to the simplicity of the Altieri Chapel, where chaste arches lead from aisle to chapel, from chapel to picture frame. Instead of filling up the aedicula, as does the *Ecstasy of St Teresa*, the *Ludovica Albertoni* lies at the bottom of a large volume of space, illuminated in her death by a heavenly light, maintained in her faith by the devotional image, watched over by the Holy Spirit. Even slight deviations from the vertical or horizontal become notable within this tectonic framework – the two groups of floating cherubs point like arrows at her convulsed figure. A slight inclination of the upper body and the counter curve of her arched neck are in poignant contrast to the hard horizontals of the picture frame and pallet. The waves of drapery in front echo her position, their heaving billows reflect her agony, their colour accentuates her pallor. The focal point of suffering is indicated by the lines of angels, by Ludovica's clutching hands, and by an unusual turbulence of drapery that loops above and bunches below her vitals. The deeply excavated undulations of stone express a specific emotion in the drapery language that Bernini had evolved in the preceding decade. The *chiaroscuro* of this drapery and the diagonal of Ludovica's arms, broken by her hands, create an almost symphonic treatment of physical suffering and death [123]. Her swollen throat, sightless eyes, and gasping mouth complete the delineation of an expiring body; the frieze of bursting pomegranates below the painting signifies the immortality to which her soul is passing.

The face of *Ludovica* has a superficial similarity to the *Teresa*, but the *Ludovica* is more insistently feminine with an undulating outline of cheek, chin, and throat that make *Teresa*'s face seem harsh and masculine [124–5]. The *Ludovica Albertoni* is also a more intimate work and can be examined from fairly close-by; the group of Teresa's *Ecstasy* always floats away from the observer [71]. The difference extends to the events represented: Teresa's ecstasy was a mystical vision; Ludovica Albertoni died of a fever after a life of good works and Franciscan piety. Despite our proximity to the *Ludovica Albertoni*, Bernini did not choose to differentiate

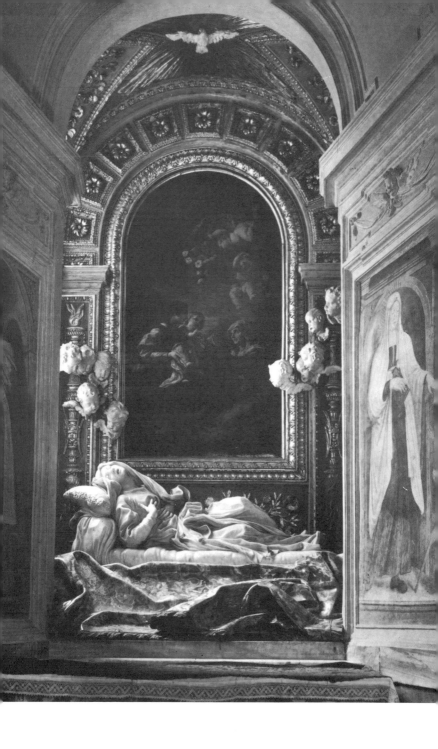

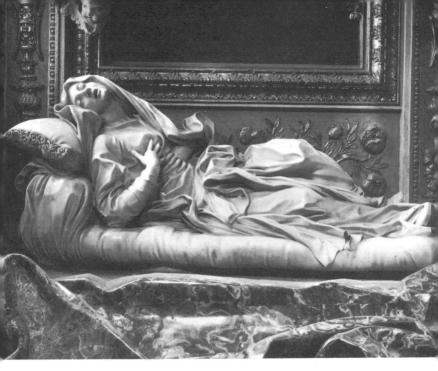

123 and 124 Details of plate 122

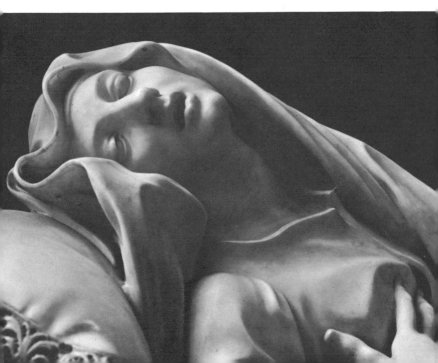

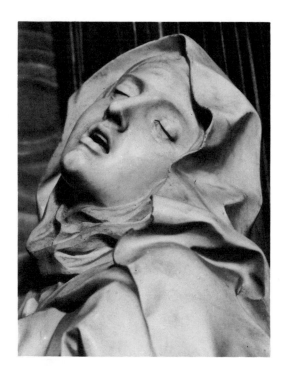

125 Detail of plate 71, *Saint Teresa*

coloristically between skin, garment, and sheet. Apart from the bit
of ornamental lace on the pillow, there is an understatement of
individual colour or texture; the play of light and dark on the
affecting gathering of drapery can be received as pure emotion.
The homogeneity of the white statue, couch, and drapery is made
all the more striking by the waves of coloured marble in front and
by the colourful, gilt-framed painting behind. If we found a con-
trast between Bernini's portraiture and his statue groups at the
beginning of his career (cf. pp. 64 f. above), how much greater the
contrast becomes at the end! The *Fonseca* [119], which matches
the intense emotion of the *Albertoni*, is an exercise in sculptural
colorism; the *Albertoni* eschews local texture and colour for an
over-all emotional impact.

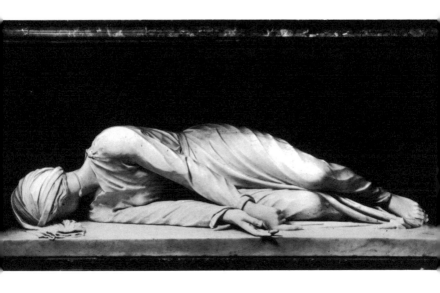

126 Stefano Maderno, *Santa Cecilia*. 1600. Santa Cecilia in Trastevere

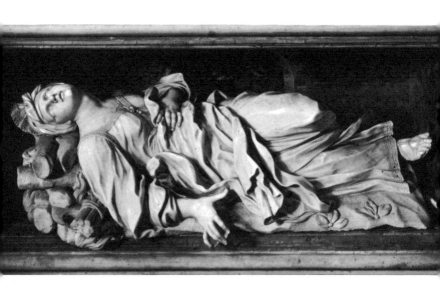

127 Francesco Aprile, *Sant' Anastasia* (finished by Ercole Ferrata)
1685. Sant'Anastasia

The *Ludovica Albertoni* is both novel and traditional. The recumbent image of a saint got its classic expression in Stefano Maderno's *Saint Cecilia* of 1600, a work of touching simplicity [126].* Maderno's statue depicts the dead girl with her face hidden, lying in a niche below the high altar – the customary place for such figures. Bernini, in his early *Santa Bibiana*, portrayed the moment *before* martyrdom – a characteristic choice because of his interest in psychological and emotional contact between worshipper, devotional image, and celestial vision [33]. The *Ludovica Albertoni* combines the recumbent tradition of the *Saint Cecilia* with Bernini's interest in transitory states: the dying woman revealed above the altar seems to exemplify faith, hope, and love of God. Later images of this kind profited from Bernini's innovations although the figures were generally placed below the altar. A good work by Bernini's follower Francesco Aprile, the *Sant'Anastasia* of *c.* 1685, illustrates the post-Bernini treatment [127].* Aprile was one of the better followers of Bernini's late style, but by comparison with *Ludovica Albertoni* we immediately feel a loss of clarity. Is *Sant'Anastasia* alive or dead? Lying in a niche, she does not appear to us as a beatific vision but as a statue, no more or less. The competence of the carving cannot hide the psychological insensitivity and this, unhappily, is typical of many Bernini followers.

Bernini consciously separated out architecture, sculpture, and painting for different roles in the Altieri Chapel and so reversed the process that culminated in the Cornaro Chapel [69; 71]. The later work is, in that sense, more traditional than the earlier one and is a variation on his church interiors of the preceding decades. Both the Altieri Chapel and the Altar of the SS. Sacramento in St Peter's [111] illustrate Bernini's final revelation of the human body in an architectural setting as a paradigm of the contrast between temporal and eternal.*

Bernini's last work was an over life-size bust of the blessing Christ, a *Salvator Mundi*, carved for Queen Christina of Sweden. In his last months he outdid himself in a restoration of the Palazzo della Cancelleria, an exertion that seems to have hastened his death. He died nine days before his eighty-second birthday, on

28 November 1680. The Pope at that time was Innocent XI Odescalchi (1676–89), the eighth he had served. Shortly before the end Bernini's right arm was paralysed, and he commented that it was only fair for it to rest first since it had worked so hard during so long a life. He left a fortune of 400,000 scudi, a huge sum, but Queen Christina remarked that she would have been ashamed to have had him work for her and leave so little.*

Bernini was not a lofty intellectual in the sense that some of his predecessors – Leonardo and Michelangelo – had been. He was, however, unusually sensitive to the cultural events of his time while remaining an outstanding individual, a genius in most of our senses of the word. Bernini's creations, more than any other great works of visual art, are the fulfilment of the religious and political and human aspirations of his age and collectively form a portrait of the face and psyche of his time – are, in short, not simply autobiographical (as were, in a sense, the works of Donatello or Michelangelo) but the autobiography of the age itself. Unlike previous religious art, which told stories or illuminated divine events and emotions, Bernini's point of reference was the human worshipper; his goal was the revelation of divinity to the common man through empathy and analogy, and in this realm he stands alone in the history of art.

When Bernini died his work was already part of history. Despite his myriad pupils and his great influence, European taste had swung decisively to a somewhat decorative classicism, and here as everywhere the source of the new trend is found in France. Roman architecture, too, veered toward a less interesting formalism under Carlo Rainaldi and Carlo Fontana. Bernini's best follower, Raggi, lived only six years longer than his master, and few of his other students combined the form of Bernini's late style with any of its spirit. Bernini must have felt increasingly isolated during his last years. It was clear to him that his time was past, and he predicted accurately that his reputation would wane after his death. Nevertheless, Bernini's style carried on for at least two more generations in various parts of Europe. Italian sculpture of the eighteenth century – a fascinating but so far little-known

chapter in the history of art – is predicated on his achievement. And the powerfully decorative late Baroque and Rococo of central Europe, much of which is of astoundingly high quality, would have been very different without his influence, which was as important for architecture as it was for sculpture. The book you have been reading is only one sign of Bernini's restored reputation; few would deny today that he takes his place, like Donatello and Michelangelo, as the leading sculptor of his century, one of the great image-makers of all time.

Bibliographical Note

Unless otherwise indicated, dates, bibliography, and other information on the sculpture can be found in the *catalogue raisonné* by Rudolf Wittkower, *Gian Lorenzo Bernini*, 3rd edition, London, Phaidon, 1981. The reader is also directed to Wittkower's exemplary treatment of Bernini's art, including architecture and painting, in *Art and Architecture in Italy, 1600 to 1750* (Pelican History of Art), 3rd edition, Harmondsworth, 1973; this book is, moreover, the indispensable introduction to the entire period. See also his *Studies in the Italian Baroque,* London, Thames & Hudson, 1975 (cited in the Notes below as 'Wittkower, *Studies*'). *Bernini* by Maurizio and Marcello Fagiolo dell'Arco, Rome, Bulzoni, 1967, gives bibliography and illustrations for every work by Bernini, including temporary decorations such as catafalques. Hans Kauffmann, *Giovanni Lorenzo Bernini*, Berlin, Gebr. Mann, 1970, has new iconographical insights. A short introduction to Bernini's purely sculptural activities is found in John Pope-Hennessy, *Italian High Renaissance and Baroque Sculpture* (An Introduction to Italian Sculpture, Part III), 2nd edition, London, Phaidon, 1970, which is especially recommended for the sixteenth-century sculptural background to Bernini's art.

The contemporary lives to which I refer in the text and Notes are: Filippo Baldinucci, *Vita di Bernini*, Florence, 1682 (edition cited, ed. Sergio Samek Ludovici, Milan, Edizioni del Milione, 1948; Baldinucci's *Life* is now translated into English by C. Enggass, University Park, Pennsylvania State University Press, 1966); and Domenico Bernino, *Vita del Cavalier Gio. Lorenzo Bernino*, Rome, 1713. In large part Domenico merely repeats and enlarges on Baldinucci, but there are valuable additions as well as new mistakes. The two *Lives* are supplemented by the uniquely fascinating diary kept by Paul Fréart, Sieur de Chantelou, *Journal du voyage du Cav. Bernin en France*, which was discovered and edited by L. Lalanne, Paris, 1885. Later editions or translations are abridged or otherwise untrustworthy.

Bernini's drawings were collected and edited by Wittkower and Heinrich Brauer, *Die Zeichnungen des Gianlorenzo Bernini*, Berlin, 1931 (reprinted New York, Collectors Editions [1970]). The chapters on artistic patronage in the relevant volumes of Ludwig von Pastor's *History of the Popes* should be supplemented by Francis Haskell's fascinating *Patrons and Painters*, London and New York, 1963, now published in paperback (Harper & Row).

Notes to the Text

Introduction

page
19 *Bernini's genius* – Discussing the genius of Mozart, W. J. Turner (*Mozart, the Man and his Works*, New York, 1938, p. 374) stated that 'the man of genius not only possesses a mind of larger general powers, but has as its foundation a physical vitality much above the normal'. This characteristic of Bernini's is constantly revealed in our sources. He would work the marble for hours at a stretch without stopping; when he was old and his assistants wanted him to stop work he resisted, saying, 'Let me stay here, since I'm in love with it' (*Lasciatemi star qui, ch'io sono innamorato* – Baldinucci, p. 139). When working, he seemed to be in an ecstasy and it sometimes seemed to observers that he was animating the statue by sending his own soul into it with his eyes. Cardinals and princes came and went without saying a word in order to leave him undisturbed. In Bernini's time, as in Mozart's, these gifts were considered God-given. Bernini constantly disclaimed any praise given his works, saying that whatever gifts he had came from God. He often said that the more he worked the less he knew, and this was more than rhetoric. The Idea (from God) always excited Bernini; its execution left him increasingly dissatisfied. In this respect he is similar to Michelangelo, with the important difference that Michelangelo was an introverted neurotic who left most of his works unfinished while Bernini, a typical extrovert, often let his assistants finish the job. The prodigious technical facility of a Bernini is the least important aspect of his genius. It was his conception, and his means – usually novel – of visualizing this conception, that should arouse our admiration; the fact that he also had unparalleled gifts for the actual execution is a corollary phenomenon.

19 *Basil Willey – The Seventeenth-Century Background*, Harmondsworth, 1962, pp. 9 ff. and *passim*.

1. The Prodigy

page

23 *Pietro Bernini* – See Pope-Hennessy, text, pp. 92 f.; catalogue, pp. 121 f.

25 *Antinous* – This statue actually represents Hermes. See the notes to p. 202 on p. 244 below (*Angels*, second paragraph).

25 *Amalthea* – The reader interested in checking up on Bernini's Hellenistic models can turn to M. Bieber, *Sculpture of the Hellenistic Age*, 2nd ed., New York, 1961, for an immense repertory of photographs, information, and bibliography; and for Bernini's interest in Hellenistic sculpture with one chief view, cf. Pope-Hennessy, text, p. 107. Comparison with Pietro Bernini's treatment of the theme reveals the immense gulf between father and son even at the very start of Gian Lorenzo's career: see I. Faldi in *Bollettino d'arte*, XXXVIII, 1953, pp. 140 ff.

29 *Santoni* – New facts and speculations about this and other early portraits are published by Irving Lavin, 'Five New Youthful Sculptures by Gianlorenzo Bernini and a Revised Chronology of His Early Works,' *Art Bulletin*, L, 1968, pp. 223–48.

31 *Anima Dannata* – Bernini's Caravaggism is a subject of great interest (cf. pp. 50 ff. above). The literature on Caravaggio is vast; here I can mention only W. Friedlaender's wonderful *Caravaggio Studies*, Princeton, 1955. The reader of this book will be particularly interested in his Chapter III, 'Caravaggio and the Artistic Milieu of Rome', and Chapter VI, 'Carravaggio's Character and Religion'. Wittkower's chapter in *Art and Architecture* gives a brief, balanced assessment.

34 *Aeneas* – I quote from the translation of the *Aeneid* by C. Day Lewis, Oxford, 1952, ii, lines 707 ff. Faldi, *Galleria Borghese: le sculture...*, Rome, 1954, has the relevant information on this and the other Borghese groups.

Aeneas, the legendary founder of Rome and the subject of Vergil's epic, was particularly significant for Romans as the progenitor of the quasi-divine Latin race. The group's iconographic significance may be rather complex. Aeneas's devotion to his father and son is an example of human love ('*amor proximi*'); their common devotion to the gods is '*amor dei*'. These two kinds of love constitute *Caritas*, the greatest of Christian virtues according to Paul. This Christian love ('Charity') was commonly symbolized by a torch or brazier and so the home fires carried by Ascanius may also signify the sacred flame of Caritas (see R. Freyhan in *Journal of the Warburg and Courtauld Institutes*, XI, 1948, pp. 68 ff.). On another level little Ascanius can be equated with an *amorino* or cupid since Aeneas was the son of Aphrodite by Anchises – thus the symbolism

cont. comes full circle, from pagan myth to Christian symbol and back.

Bernini's group was placed in a corner of the room in the Villa Borghese (in our Fig. 1, p. 54, by the door leading outside). It stood under an outstanding painting by Federigo Barocci, *The Fall of Troy*, which shows an analogous group. Bernini must have studied this painting and, although his own group is less stable than Barocci's, the painter's unusual and imaginative colorism may have exerted an influence on the young sculptor.

pp. 281–91.

39 *Neptune* – I quote from the translation by Rolfe Humphries, Bloomington, Indiana University Press, 1957, pp. 11 f. The identification of this source was made by William Collier (*Journal of the Warburg and Courtauld Institutes*, XXXI, 1968, pp. 438–40). It is more convincing than previous proposals (e.g., *Aeneid*, i, lines 133 ff.) and has the unexpected virtue of providing the prelude to the *Triton*, which represents the end of the flood (cf. p. 112 above). The only real drawback to the identification is the absence of Triton in the passage, but since he was Neptune's son, his presence – needed for support – can be condoned. New visual sources are published by L. Grassi, *Burlington Magazine*, CVI, 1964, pp. 170 ff. Pope-Hennessy suggests a date of 1622-3 (*Catalogue of Italian Sculpture in the Victoria and Albert Museum*, II, London, 1964, p. 600, no. 637).

45 *Borghese groups* – The dates were discovered by Faldi; additional information from the archives is found in my note in *Bollettino d'arte*, XLIII, 1958, pp. 181 ff.

48 *Apollo and Daphne* – The iconography is explored in W. Stechow, *Apollo und Daphne*, Leipzig, 1932.

50 *Metamorphoses* – Humphries translation, pp. 19 f. Bernini may have been influenced by contemporary poetry such as Rinuccini's *Dafne*, a 'dramma per musica' of the late sixteenth century, or the 'Dafne' of Giambattista Marino. The *Apollo and Daphne* is Bernini's closest approach to 'Marinism'; never again was he to produce a display-piece of such pure virtuosity. The swift movement arrested, which is un- (not to say anti-) sculptural, is excused by the story; Bernini is, nevertheless, playing with the possibilities of the marble medium just as Marino played on words and ideas in the famous poem:

Deh, perchè fuggi, o Dafne,

da chi ti segue ed ama,

e fuor che i tuoi begli occhi altro non brama ?

Se'molle ninfa ? o duro tronco forse

di questo alpestro monte,

cont. rigida e sorda a chi ti prega e chiama ?
Ma se tu tronco sei,
come al fuggir le piante hai così pronte ?
Come non sai fermarti ai preghi miei ?
Cosi dicea, ma scorse
in vero tronco allor cangiata Apollo
la bella fuggitiva
fermarsi immobilmente in su la riva.

(O why do you flee, o Daphne, from him who follows and loves you, and desires nothing other than your lovely eyes ? Are you a soft nymph ? or perhaps a hard tree-trunk of this flinty mountainside, unbending and deaf to him who begs and calls you ? But if you are a trunk, why are your feet so ready to flee ? How can you not stay for my entreaties ? So Apollo was speaking, but he saw then the lovely fugitive, changed into a real trunk, stay unmovingly upon the bank. [*The Penguin Book of Italian Verse*, ed. G. Kay, Harmondsworth, 1958, p. 218]).

Urban VIII, presumably while still a Cardinal, composed a distich that was engraved on a cartouche set upon the face of the *Daphne*'s base:

*QVISQVIS AMANS SEQVITVR FVGITIVAE GAVDIA FORMAE
FRONDE MANVS IMPLET BACCAS SEV CARPIT AMARAS*

(Whoever, loving, pursues the joys of fleeting forms fills his hands with sprays of leaves and seizes bitter fruits.) Thus did the Church rationalize its bishops' love of pagan pleasures; but Scipione Borghese had an unrivalled collection of ancient pornography in addition to his other treasures and we need not debate his attitude to the sculpture.

53 *Apollo Belvedere* – The illustration is of the unrestored statue. The original bronze must have had a bow in its left hand.

55 *David* – As now exhibited the statue cannot be seen as it was meant to be. It originally stood against a wall with large vases right and left that forestalled the wide range of views we now have.

A contemporary sculptor, Francesco Mochi (cf. p. 84 above) had experimented with the communication of sculpture across space: his *Annunciation* for Orvieto Cathedral, now no longer in place, charged the whole choir of the church with the excited interplay of Gabriel's announcement and Mary's shocked surprise. Mochi was also notable for his attempt to introduce incomplete activity in his statues [cf. 42]. Nevertheless, it would be difficult to point to specific influences from Mochi to Bernini, who was by far the more fertile and imaginative of the two.

62 *Bernini on painters* – Baldinucci, p. 145, gives the list, as does

cont. Domenico Bernini, p. 29; the same statements are found with minor
variations in Chantelou: p. 45 has the encomium on Annibale and
the entire diary is full of Bernini's unbounded admiration for Guido
Reni (cf. our pp. 171, 173).

64 *Galleria Farnese* – See Donald Posner, *Annibale Carracci*, London,
Phaidon, 2 vols, 1971, and Wittkower's chapter in *Art and Architecture*.

64 *Denis Mahon* – I quote from the *Journal of the Warburg and
Courtauld Institutes*, XVI, 1953, p. 335.

64 *Montoya* – According to an authoritative note in a manuscript of
c. 1662 by Fioravante Martinelli (Rome, Bibl. Casanatense, ms.
4984, fol. 63) the architecture of the tomb is by Orazio Turriani. It
seems increasingly probable that all of the incidental architecture in
which Bernini's early works were placed was the work of others; for
another example, see Bibl. Vat., ms. *Urb. lat.* 1707, fol. 172.

Beginning with Baldinucci, writers on Bernini have called the
Monsignore 'Montoya', although he himself signed his name 'P. de
Foix' – the double name is typically Spanish; we should more
properly speak of 'Monsignor de Foix'.

66 *Fabio de Amicis* – See the entry in *Il seicento europeo*, Rome, 1957,
p. 266, no. 351; the attribution is apparently Martinelli's.

2. Bernini in Command

68 *Bernini and Urban VIII* – I quote from Domenico Bernini, pp. 24
and 27. Haskell, *Patrons and Painters*, Chapter 2, 'Pope Urban VIII
and his Entourage', is the indispensable introduction to the patron-
age of this period.

71 *Benediction loggia* – This decoration was a plum dangled before
several leading painters. Under Paul V, Lanfranco was given the job
and planned an extensive decoration. Gregory XV gave the commis-
sion to Guercino but died before anything could be done.

71 *Paintings* – L. Grassi's unreliable *Bernini pittore*, Rome, 1945, is the
only full-length study. See Wittkower, *Art and Architecture*, pp.
172 ff.

71 *Santa Bibiana* – Precedents for the façade of Santa Bibiana are: the
Oratorio di S. Marcello (*c.* 1568); S. Calisto in Trastevere (*c.* 1612,
by Orazio Turriani); and S. Francesca Romana (finished 1615; by
Carlo Lambardi). In the light of these forerunners the façade of S.
Bibiana is not particularly novel – but it does seem to derive from
a design by Bernini.

78 *Baldacchino* – See now Heinrich Thelen, *Zur Entstehungsgeschichte
der Hochaltar-Architektur von St. Peter in Rom*, Berlin, 1967, and his

page 78

cont. *Francesco Borromini, Die Handzeichnungen*, I, Graz, 1967, C 68–73.
Bernini's transformation of the crossing, including the Baldacchino,
is treated by Irving Lavin, *Bernini and the Crossing of Saint Peter's*,
New York, 1968 (College Art Association Monograph XVIII).

78 *Pasquinade* – Prisoners of papal absolutism, Romans were wont to
express themselves anonymously by pinning bitter comments on
current affairs to certain statues in the Roman streets and squares.
The most famous of these 'talking statues' was the 'Mastro Pasquino',
a ruined Hellenistic sculpture still standing behind the Palazzo
Braschi, near the Piazza Navona (see P. Romano, *Pasquino e la
satira in Roma*, Rome, 1932). It seems, however, that in this case the
author of the epigram was the Pope's personal physician, the
egregious Giulio Mancini (Pastor, *History of the Popes*, xxix, pp.
363 f. and 463).

Both of Bernini's biographers relate that Bernini considered the
Pasquino to be the greatest antique statue, although when he said
this to a visitor on one occasion it was taken for a joke. The *Pasquino*
has many of the qualities of the more famous *Torso Belvedere*; of the
two, Bernini probably preferred the *Pasquino* because almost nobody
thought of it as a work of art and he loved to shock the unwary (see
Baldinucci, p. 146, and Domenico Bernini, p. 14).

84 *Longinus* – The groovings on the surface have a coloristic intent in
some ways comparable to the use of shot colours (*cangianti*) by
painters like Lanfranco: the juxtaposition of dissimilar colours,
usually in strips, to make one complex and seemingly changing
colour area. The result of both these techniques is a surface of un-
usual coloristic liveliness. Bernini's ideas may have come to him
from the grooved surface left by certain instruments on the surface
of his clay models; but it may also have come from Michelangelo's
unfinished works [cf. 43], where no colorism was originally in-
tended.

89 *Borghese*–This section is a version of my article in *Bollettino d'arte*,
xLVI, 1961, pp. 101 ff., where the relevant source material is quoted.
Pope-Hennessy, text, pp. 124 f., makes perceptive comments on
Bernini's revision of the lower parts in the second version (cf. his
catalogue, p. 432).

98 *Baker* – See the discussion in Pope-Hennessy, *Catalogue of Italian
Sculpture in the Victoria and Albert Museum*, II, London, 1964, pp.
600 ff. no. 638. Pope-Hennessy thinks the head and hand are auto-
graph, the lace weaker but not necessarily by Bolgi. The blank eye-
ball could be the result of the unfinished state in which Bernini
presumably left the bust since the work is not otherwise classicizing.
We know from the detailed reports of his working procedure in Paris
that the pupils were the very last thing he executed (see above, p. 177,

cont. and Wittkower, *Bernini's Bust of Louis XIV*, Oxford, 1951, pp. 9 ff., which has a summary of the treatment of eyes in sculpture).

105 *Tomb of Paul III* – Della Porta's tomb was originally free standing, with four Virtues around its base – a dim reflection of Michelangelo's early projects for the tomb of Julius II. See the entry in Pope-Hennessy, text, pp. 114 f. and catalogue, pp. 398 f.; and H. Siebenhüner, in *Festschrift für Hans Sedlmayr*, Munich, 1962, pp. 302 ff.

110 *Fountains* – The date of the Triton was discovered by C. D'Onofrio, *Le fontane di Roma*, Rome, 1957, p. 192. Bernini's organic treatment of what had previously been geometric is already seen in his Barcaccia fountain of 1627–9 in the Piazza di Spagna (see Hibbard and I. Jaffe, in *Burlington Magazine*, CVI, 1964, pp. 159 ff.).

115 *Bernini as artistic dictator* – See Haskell, pp. 36 ff.; I quote from his translation from Passeri's *Vite*, ed. Hess, p. 236.

3. *Disaster and Triumph*

For this and the succeeding chapters, see Haskell, Chapter 6: 'The Decline of Roman Patronage'.

120 *Four Rivers Fountain* – An alternative version of the story, written by the Este envoy in Rome, tells how the infamous Donna Olimpia was won over by a silver model of the project (S. Fraschetti, *Il Bernini*, Milan, 1900, p. 180, note 2). The iconography is explained by Norbert Huse, *Revue de l'art*, 7, 1970, pp. 7 ff.

Bernini had plans for even more extravagant fountains: one idea was to transport the column of Trajan to the Piazza Colonna in order to convert both of those immense antique spiral monuments into a fountain display. In such schemes we indeed see the overblown, extroverted qualities usually associated with the term 'Baroque' in its unreconstructed sense.

125 *Innocent X* – I reproduce the bust first published by Faldi in *Paragone*, VI, 71, 1955, pp. 50 f.; he dates it *c.* 1647 and correspondingly advances the date of the bust in Wittkower, *Bernini*, cat. no. 51 (2), to *c.* 1650.

128 *Cornaro Chapel* – The chapel and its antecedents are discussed thoroughly by I. Lavin, *Bernini and the Unity of the Visual Arts*, New York, London, 1980 (also Italian edition). Bernini's Raimondi Chapel in San Pietro in Montorio, begun *c.* 1640 and wholly executed by pupils, is a precedent for the Cornaro Chapel and shows a preliminary stage of sculptural and architectural integration that is seen *in nuce* in the Matilda monument [52]; the monochromatic Raimondi Chapel may be based in part on Bernini's study of the transept chapels of the same church (cf. Pope-Hennessy,

cont. catalogue, pp. 376 f.). The Raimondi Chapel is also significant be-
cause of its use of indirect lighting, a device that Bernini already had
used above the statue of Santa Bibiana, as Professor Lavin reminded
me.

134 *Painted decoration of the Cornaro Chapel* – Executed on Bernini's
design by Guido Ubaldo Abbatini. See the photograph repro-
duced in *Art Bulletin*, XXXIX, 1957, opp. p. 303 (fig. 6). Bernini had
previously used painted stucco within an architectural framework
in the Pio Chapel in Sant'Agostino.

136 *Bernini's decoration in the Pauline Chapel of the Vatican* – De-
scribed in an *avviso* of 6 December 1628, it is one of the significant
documents of his early 'theatrical' activity since it was related to one
of the most solemn church services, the 'Forty Hours' Devotion'.
(Bibl. Vat., *Urb. lat.* 1098, fol. 701 : '. . . a most beautiful setting was
made, representing the Heavenly Glory shining brightly without
any lights being visible since over two thousand lamps were hidden
behind the clouds, an invention of Cavaliere Bernini, the celebrated
Florentine sculptor and architect so admired in these times, which
was highly praised by all the crowd gathered for this Devotion.') If
Bernini produced these effects for solemn papal ceremonies in the
1620s it is hardly surprising that he also began to use them in per-
manent materials; nor need we turn to his secular dramas and stage
settings to understand this development.

137 *Life of St Teresa* – I quote from J. M. Cohen's translation, Har-
mondsworth, 1957, p. 210 and *passim*. The English-speaking reader
is not accustomed to the representation of this kind of religious ex-
perience and there have been few writers of our language who tried
to communicate comparable emotions. One, Richard Crashaw,
understood and at times approached the religious ecstasy shown by
Bernini, and his poems on Teresa may be recalled:
O how oft shalt thou complain
Of a sweet and subtle PAIN.
Of intolerable Joyes;
Of a DEATH, in which who dyes
Loves his death, and dyes again.
And would for ever so be slain.
And lives, and dyes; and knowes not why
To live, But that he thus may never leave to DY.
How kindly will thy gentle HEART
Kisse the sweetly-killing DART !
And close in his embraces keep
Those delicious Wounds, that weep
Balsom to heal themselves with. Thus
When These thy DEATHS, so numerous,

page 137
cont. Shall all at last dy unto one,
 And melt thy Soul's sweet mansion;
 Like a soft lump of incense, hasted
 By too hot a fire, and wasted
 Into perfuming clouds, so fast
 Shalt thou exhale to Heavn at last
 In a resolving SIGH. . .

Crashaw's poem seems at times to be inspired by a representation of the scene of Teresa's vision, although he saw Bernini's group only after he wrote the poem. Its sequel describes the state Bernini desired to create in the mind of the beholder better than any other English poem, and if Anglo-Saxons are, as has often been maintained, more susceptible to literary than visual imagery, it may be useful to approach the *Ecstasy of St Teresa* through Crashaw, remembering that his poetry and Bernini's art are not the same except in ultimate goal:

O sweet incendiary! shew here thy art,
Upon this carcase of a hard, cold, heart;
Let all thy scatter'd shafts of light, that play
Among the leaves of thy large Books of day,
Combin'd against this BREAST at once break in
And take away from me my self and sin;

O thou undaunted daughter of desires!
By all thy dow'r of LIGHTS and FIRES;
By all the eagle in thee, all the dove;
By all thy lives and deaths of love;
By thy large draughts of intellectuall day;
And by thy thirsts of love more large than they;
By all thy brim-fill'd Bowles of fierce desire
By thy last Morning's draught of liquid fire;
By the full kingdome of that finall kisse
That seiz'd thy parting Soul, and seal'd thee his;
By all the heav'ns thou has in him
(Fair sister of the SERAPHIM)
By all of HIS we have in THEE;
Leave nothing of my SELF in me.
Let me so read thy life, that I
Unto all life of mine may dy.

 Less than a century later the President de Brosses wrote of Bernini's group : '*Si c'est ici l'amour divin, je le connais.* . . ' In his catalogue of important works in Rome he notes: '. . . *ravissant et merveilleux au dernier point. Composition pleine d'esprit et de finesse mais trop libre. L'amour divin doit être sculpté avec plus de modestie.*

page 137
cont. *Il tient ici un peu trop à l'humanité*. . .' (*Lettres familières*. . ., ed. Y.
Bezard, 11, Paris, 1931, pp. 68 and 478). These murmurings of
criticism grew stronger as the eighteenth century progressed and
became crushing in the nineteenth. But Bernini fully understood
how to interpret Teresa's painful joy; his critics, pre- and post-
Freud, object to the character of Teresa's experience rather than
to its representation. Bernini's images constantly resolve the dual-
ism of Christianity through their physical record of spiritual states.
Teresa's words left little to be imagined and Bernini made her
vision concrete in accord with the principles laid down by St Ignatius
in his *Spiritual Exercises*. Cf. Robert T. Petersson, *The Art of Ecstasy*,
New York, Athenaeum, 1970.

4. *Two Churches and St Peter's*

142 Franco Borsi, *Bernini architetto*, Milan, 1980, is the most compre-
hensive discussion of Bernini's architecture; Wittkower's summary
in *Art and Architecture in Italy*, pp. 174 ff., is masterly and the
discussion of the Piazza closing his chapter is especially recommended.
In a book that is essentially on sculpture I can only sketch the
development of Bernini's architectural thought as it grew out of
his other enterprises. (R. Pane, *Bernini architetto*, Venice, 1953, is
useful chiefly for its illustrations, among which are several works
wrongly attributed to Bernini.)

148 *Sant'Andrea al Quirinale* – I quote from Domenico Bernini, pp. 108 f.

150 *Church at Ariccia* – I quote from *Art and Architecture*, p. 180 f.
Bernini's third church, at Castel Gandolfo, is analogous but less
interesting; see ibid., p. 178 f.

159 *Piazza before St Peter's* – The interest in the ancient sanctuary of
Fortuna at Praeneste is shown by several reconstruction drawings
and engravings of the seventeenth century, chiefly by Pietro da
Cortona, who was also the most influenced by its architecture. See
Wittkower, *Studies*, VI.

For the criticism of the colonnades, see Haskell, p. 152, and for
various projects submitted by others, Wittkower, *Studies*, III.

159 *Cathedra* – R. Battaglia, *La cattedra berniniana di San Pietro*, Rome,
1943, can be supplemented by the interpretation of H. von Einem
in *Nachrichten der Akademie der Wissenschaften in Göttingen*,
Philol.-Hist. Klasse, 1955, pp. 93 ff. Summary of construction in
Pope-Hennessy, catalogue, pp. 437 f.

5. *Le Cavalier en France*

The basic source for this chapter is Chantelou's *Diary*.

page 168

168 *Invitation to Paris* – Haskell, p. 153, points out – apparently for
the first time – that Bernini's trip to France was forced upon the
Pope: it was only one of a series of political humiliations he suffered
at the hands of Louis XIV.

173 *Theory* – See E. Barton in *Marsyas*, IV, 1948, pp. 81 ff.
Classical models – see Wittkower, *Studies*, V.

176 *Louis XIV* – All the information about the bust is gathered to-
gether in Wittkower's fascinating lecture, *Bernini's Bust of Louis
XIV*, Oxford, 1951.

178 *Louvre* – Cf. A. Blunt, *Art and Architecture in France, 1500–1700*
(Pelican History of Art), 2nd ed., Harmondsworth, 1970, pp. 197 ff.

6. The Late Works

187 *Chigi Chapel, Santa Maria del Popolo* – This was itself a progressive
work; see W. Lotz in *Mitteilungen des kunsthistorischen Institutes in
Florenz*, VII, 1956, pp. 214 f.; J. Shearman, in *Journal of the Warburg
and Courtauld Institutes*, XXIV, 1961, pp. 129 f., postulates a spiritual
and spatial relationship between the altarpiece presumably planned
by Raphael (an *Assumption of the Virgin*) and the mosaic of *God the
Father* in the dome. It was this kind of interrelation that Bernini
constantly sought.

It is not always understood that when Bernini began work in the
chapel the two statues by Lorenzetto were flanking the *entrance* – the
two niches by the altar were empty (D. Gnoli in *Archivio storico
dell'arte*, II, 1889, p. 321). Bernini moved the Raphaelesque *Jonah*
and turned it on its axis in order to make it relate compositionally to
his *Habakkuk* at the other side of the altar.

The unusual subject of Bernini's statues is partially explained by
Alexander VII's scholarly interests; his library contained the only
known Septuagint text of the book of Daniel from which the story
is drawn (Wittkower, *Bernini*, p. 10).

198 *Resolution against Bernini* – I quote from Haskell, p. 162, who cites
other '*avvisi*'.

202 *Angels* – See Mark Weil, *The History and Decoration of the Ponte S.
Angelo*, Pennsylvania State University Press, University Park and
London, 1974.

The qualities of the *Angel with the Superscription* in Sant'Andrea
delle Fratte that we have been discussing – the attenuation, and a
slight awkwardness in the pose that give it a 'Gothic' quality – are
the more surprising since a drawing (Wittkower, *Bernini*, p. 232,
Fig. 88) shows the ultimate source of Bernini's inspiration to have
been the *Hermes-Antinous* in the Vatican (cf. the note to p. 25

cont. above). It is fascinating to find Bernini, at the end of his career, turning to the statue that had been his inspiration at the beginning. In Paris he told the assembled members of the Academy: 'In my early youth I drew a great deal from classical figures, and when I was in difficulties with my first statue I turned to the Antinous as to the oracle.'

207 *Tabernacle* – The composition is familiar from other Renaissance examples, such as the free-standing tabernacle supported by four angels in the Sistine Chapel, Santa Maria Maggiore. Moreover, Bernini's first project dates back to 1629; he must have had it in the back of his mind for decades.

212 *Equestrian Louis XIV* – See Wittkower, *Studies*, IV.

213 *Elephant* – I quote from W. S. Heckscher in *Art Bulletin*, XXIX, 1947, pp. 155 ff.

217 *Fonseca* – For the statue in adoration, see L. Bruhns in *Römisches Jahrbuch für Kunstgeschichte*, IV, 1940, pp. 255 ff. One of Bernini's few statues of high quality not discussed in this book, the *Roberto Bellarmine* in the Gesù (see p. 64 above), dated 1623, is also of this type (Wittkower, *Bernini*, Plate 31 and cat no. 15).

217 *Caricature* – Some years ago T. S. Eliot wrote the following on the subject of Christopher Marlowe's development: '. . . the direction in which Marlowe's verse might have moved . . . is quite un-Shakespearian, is towards this intense and serious and indubitably great poetry which, like some great painting and sculpture, attains its effects by something not unlike caricature.' ('Christopher Marlowe', *Selected Essays*, 3rd ed., 1961, p.125.)

220 *Ludovica Albertoni* – See V. Martinelli in *Commentari*, X, 1959, pp. 204 ff. The hidden window at the right is now almost entirely walled up, diminishing the effect of the cherub heads as emanations of a heavenly light. Pope-Hennessy (text, p. 114) concludes a not wholly sympathetic discussion of 'Bernini and the Baroque Statue' by saying of the *Ludovica*: 'It is on this sublime figure . . . that his claim to be accepted as the peer of the very greatest Italian artists must ultimately rest.'

227 *Saint Cecilia* – Despite pious legend, the statue is apparently based on traditional iconography; but cf. Pope-Hennessy, catalogue, p.440.

227 *Sant' Anastasia* – Aprile died young; the statue was completed by his uninventive master, Ercole Ferrata. For later Baroque sculpture in general, see Wittkower, *Art and Architecture*, pp. 305 ff. and 433 ff.

227 *Other late works* – Bernini's earlier revolutionary principles are carried to triumphant conclusion on the vault of the Gesù, painted between 1672 and 1683 by Gaulli, the painter of the altarpiece in the

page 227

cont. Altieri Chapel, and stuccoed by Antonio Raggi, the most successful follower of Bernini's late style [cf. 110]. The subject of this overwhelming decoration is the *Triumph of the Name of Jesus*, and even in the church the spectator has a hard time separating paint from sculpture and architecture. The Gesù vault combines the arts by force of the painting rather than by sculpture or architecture, as in Bernini's own works, but there can be no doubt that it represents an extension of Bernini's ideas. He was especially insistent that such large ceiling decorations be made believable in this way rather than through a painted architectural extension of the real building (*quadratura*), which is convincing from only one point of view below. See Wittkower, *Art and Architecture*, p. 174; R. Enggass in *Art Bulletin*, xxxix, 1957, pp. 303 ff.; and Haskell, pp. 80 ff. and *passim*, which has a good discussion of Jesuit art and Bernini's relationship with the Jesuits, an important aspect of his later works.

228 *Last works* – See Irving Lavin, 'Bernini's Death', *Art Bulletin*, LIV, 1972, pp. 159 ff. and LV, 1973, pp. 429 ff.

Index

Abbatini, G. U., 240 n. (134)
Academy of St Luke, Rome, 42
Aeneas and Anchises, 34–6, 39, 57, 61, 234 n. (34); pls. 8, 10, 11
Aeneid, 34, 39, 234 n. (34), 235 n. (39)
Agasios of Ephesus, 27
Alberti, Leon Battista, 175, 181
Albertoni, Blessed Ludovica, 220–2
 Death of, 220–7, 244–5 n. (220); pls. 121–4
 Cardinal Paluzzi degli, 220
Alexander the Great, 177
Alexander VII Chigi, 19, 142, 151, 163, 168, 185–7, 198, 207, 213–15, 243 n. (168), 243 n. (187)
 tomb, 215–17; pls. 75, 118
Algardi, Alessandro, 107–9, 116, 124–6, 172
 Innocent X, 124–6; pl. 67
 Tomb of Leo XI, 107–9; pl. 57
Altieri chapel, *see* S. Francesco a Ripa
Altieri, Emilio, *see* Clement X
Amalthea, 25–7, 29–30, 234 n. (25); pl. 2
Amicis, Fabio de, 30, 66, 237 n. (66); pl. 30
Angel with the Crown, 198–206, 243–4 n. (202); pl. 105
Angel with the Superscription, S. Andrea delle Fratte, 198–206,

243–4 n. (202); pl. 106
 Ponte S. Angelo, 204–6, 243–4 n. (202); pl. 109
Anima Beata, 33
Anima Dannata, 31–3, 64, 94, 234 n. (31); pl. 6
Antinous (Hermes), 25, 234 n. (25), 244 n. (202)
Api fountain, pl. 60
Apollo and Daphne, 45, 48–55, 57, 61–2, 173, 209, 235 n. (50), Fig. 1 (54); pls. 20–22
Apollo Belvedere, 25, 53, 56, 62, 236 n. (53); pl. 23
Aprile, Francesco, *S. Anastasia*, 227, 245, n. (227); pl. 127
Ariccia, S. Maria dell' Assunzione, 148–51, 173, Fig. 4 (148); pls. 78–9

Baciccio, *see* Gaulli
Baker, Thomas, 96–8, 114, 238 n. (98); pl. 49
Baldinucci, Filippo, *Life of Bernini*, 23, 29, 30, 34, 54, 89, 90, 107, 121, 125, 151, 168, 170, 231
Baratta, Francesco, *Rio della Plata*, 121; pl. 65
Barberini family, 78, 116
 heraldry, 79, 105, 112
 Cardinal Antonio, 90
 Monsignor Francesco, 89; pl. 44
 Maffeo, *see* Urban VIII

Barcaccia fountain, 239 n. (110)
Barocci, Federigo, *Fall of Troy*, 235 n. (34)
Bel and the Dragon, 187
Bellarmine, Cardinal Roberto, 64, 244 n. (217)
Bellori, Giovanni Pietro, 172–3
 Lives, 182
Belvedere Torso, 238 n. (78)
Bernini, Domenico, *Life of Bernini*, 23–6, 29, 90, 101, 135, 148, 156
Bernini, Gian Lorenzo, *Self-Portraits*, frontispiece, pl. 91
Bernini, Paolo, 168
 Pietro, 23–5, 30, 34, 61, 68, 78, 105, 234 n. (23, 25)
Bibiana, saint, 71
Bolgi, Andrea, 83–4
 St Helena, 78; pls. 36, 38
 Mr Baker, 98; pl. 49
Bologna, 42
 see also Giovanni Bologna
Bonarelli, Costanza, 101–3, 115; pls. 53–4
Borghese, Camillo, *see* Paul V
Borghese Gallery, 45, 94–6, Fig. 1 (54)
Borghese, Cardinal Scipione, 25–7, 34, 45, 48, 54–6, 61, 89, 90, 236 n. (50)
 bust, 89–96, 97–9, 101, 125–6, 130, 176, 218, 238 n. (89); pls. 45, 48
 caricature(?), 99; pl. 51
Borghese Warrior, 27, 61
Borgo, 153
Borromini, Francesco, 20, 116, 118, 174, 182
 churches, 118–20, 147–8
Boy Bitten by a Lizard (Caravaggio), 31, 50–3; pl. 7
bozzetti
 Angel with the Crown, pls. 107–8

Angel for SS. Sacramento, pl. 113
St Longinus, pl. 40
Louix XIV equestrian statue, pl. 115
Bracciano, Castle, pl. 50
Bracciano, Duke of, *see* Orsini, Paolo Giordano
Bramante, Donato, 75, 181
 House of Raphael, 181
 Tempietto, 208
Brosses, Président de, 241 n. (137)
Buonarelli, *see* Bonarelli

campanili, *see* St Peter's
Capitoline hill, 209
Cappella Paolina, *see* S. M. Maggiore and Vatican
Caravaggio, Michelangelo da, 20, 31–3, 42, 88, 93–4, 173
 Boy Bitten by a Lizard, 31, 50–3; pl. 7.
Carracci, Annibale, 20, 24, 62–4, 75, 88, 94, 172–3, 236 n. (62)
 Polyphemus, 62; pl. 28
Cartari, Giulio, 176–7, 204–5
 Angel on Ponte S. Angelo, 205; pl. 109
 Truth on Tomb of Alexander VII, 215; pl. 118
Castel Gandolfo, 148
Cathedra Petri, *see* St Peter's
Chamber of Deputies, *see* Palazzo Montecitorio
Chantelou, Paul Fréart, Sieur de, 62, 172, 182
 collection, 172
 Diary, 170–1, 173–4, 176, 242 n. (168)
Charles I, King of England, bust, 96–7
 Triple portrait by Van Dyck, 97
Chigi, Agostino, 187

Chigi chapels, *see* S. M. del Popolo; Siena, cathedral

Chigi, Flavio, *see* Alexander VII

Chigi-Odescalchi palace, *see* Palazzo Chigi-Odescalchi

Christina, queen of Sweden, 227–8

churches, *see* under Saint

Circus of Maxentius, 120

Clement IX Rospigliosi, 198

Clement X Altieri, 198, 207, 220

Colbert, 168, 170, 172, 182, 212

Column of Trajan, 239 n. (120)

Constantine, emperor, 166
see also Vatican, Scala Regia

Cornaro, Cardinal Federigo, 128

Cornaro chapel, *see* S. M. della Vittoria

Cornaro, Doge Giovanni, 128

Cortese, Guglielmo, *Martyrdom of St Andrew*, 147; pl. 77

Cortona, *see* Pietro da Cortona

Courtois, *see* Cortese

Crashaw, Richard, 240–1 n. (137)

Damned Soul, see *Anima Dannata*

Daniel, book of, 187, 243 n. (187)

Daniel, see S. M. del Popolo

Daphne, see Apollo and Daphne

David, 45, 54, 55–7, 61, 63–4, 66–7, 74, 90, 94, 236 n. (55); pls. 24, 26–7

Domenichino, 42, 114
Sibyl, 94; pl. 47

Donatello, 228–9

drawings, pls. 46, 51, 84, 88–9, 91, 97–9, 116

Duke of Modena, 125–6, 177–8; pl. 68

Duquesnoy, Francesco, 172
St Andrew, 80, 85

Ecstasy of St Teresa, 128–31, 134–41, 222, 241 n. (137); pls. 69, 71–2, 74, 125

Elephant carrying obelisk, 213, 244n. (213); pl. 117

Elijah, 187, 243 n. (187)

Este, Francesco, see Francesco I d' Este

Evelyn, John, *Diary*, 19

Faldi, Italo, 54–5

Fancelli, Jacopo Antonio, *Nile*, 121

Farnese Gallery, 62–4, 237 n. (64); pl. 28

Feed My Sheep, 162; pl. 102

Ferrata, Ercole, 245 n. (227); pls. 117, 127

Fire in the Borgo (Raphael), pl. 9

Florence, 29, 57, 105, 168
Bargello, *see Bonarelli, Costanza*

Fonseca, Gabriele, tomb, 215, 217–18, 220, 225, 244 n. (217); pl. 119

Fontana, Carlo, 228

Forty Hours' Devotions, 136, 240 n. (136)

fountains, *see* Api, Barcaccia, Four Rivers, Moro, Neptune, Triton

Four Rivers Fountain, 120–3, 213, 239 n. (120); pls. 63–5

France, 115, 168–82

Francesco I d'Este, 125–6, 177–8; pl. 68

Fréart, Paul, *see* Chantelou

French Academy of Art, *see* Paris; Rome

Freud, Sigmund, 242 n. (137)

Galante, Angelica, 23

Galleria Borghese, 45, 94–6, Fig. 1 (54)

Galleria Farnese, 62–4, 237 n. (64); pl. 28

Gaulli, Giovan Battista (Baciccio), *Holy Family*, 220; pl. 122
Gesù vault decoration, 245 n. (227)

Gesù, church, 115, 245 n. (227)
 Bellarmine, 64, 244 n. (217)
 Triumph of the Name of Jesus,
 245 n. (227)
Giambologna, *see* Giovanni
 Bologna
Giotto, 88, 115
Giovanni Bologna, 34, 39, 45–8,
 57, 61, 85
 Rape of a Sabine Woman, pl. 17
Girardon, François, *Marcus Cur-
 tius*, 182, 212
Giulio Romano, 25, 62
Goat, see *Amalthea*
Gregory VII Hildebrand, 101
Gregory XV Ludovisi, 42–5, 237 n.
 (71)
 portraits, 42
Guercino, 42, 84, 237 n. (71)

Habakkuk and the Angel, *see* S. M.
 del Popolo
Hals, Frans, 130
Head of a Boy, 23
Henrietta Maria, queen, 97
Henry IV, emperor, 101
Hercules Gallicus, 212
Hermaphrodite, 27
Hermes, see *Antinous*
Houdon, Jean-Antoine, 103

Ignatius, saint, *Spiritual Exercises*,
 88, 138, 168, 242 n. (137)
Innocent X Pamphilj, 107, 116–18,
 121, 128, 142, 209, 217
 bust, 124–5, 239 n. (125); pl. 62
 bust by Algardi, 124–6; pl. 67
Innocent XI Odescalchi, 228

Jerome, *see* Siena, cathedral, Chigi
 chapel
Jerusalem, Holy Sepulchre, 208
Jesuits, 115, 137, 245 n. (227)
 novitiate, 144

John of the Cross, saint, 137
Julian the Apostate, emperor, 71
Jonah, 187, 243 n. (187)
Julius II della Rovere, 75
Jupiter, see *Amalthea*

Kircher, Athanasius, 213

Lambardi, Carlo, 237 n. (71)
Lanfranco, Giovanni, 84, 114, 138,
 237 n. (71), 238 n. (84)
 *Ecstasy of St Margaret of Cor-
 tona*, pl. 73
Laocoön, 25, 191; pl. 96
Leonardo da Vinci, 20, 175, 211,
 228
Longinus, see *St Longinus*
Lorenzetto, 243 n. (187)
 Elijah and *Jonah*, 187, 243 n.
 (187)
 St Peter, pl. 104
Louis XIV, king of France, 142,
 168, 170–1, 176–7, 182, 213,
 243 n. (168)
 bust, 93, 125, 128, 142, 176–8,
 243 n. (176); pl. 87
 equestrian statue, 182, 211–13,
 244 n. (212); pls. 115–16
Louvre, *see* Paris
Ludovisi, Alessandro, *see* Gregory
 XV
Ludovisi, Cardinal Ludovico, 42,
 48
Ludovisi, Prince Niccolò, 120–1

Maderno, Carlo, 75, 116, 155–6
Maderno, Stefano, *Saint Cecilia*,
 227, 245 n. (227); pl. 126
Magdalen, *see* Siena, cathedral,
 Chigi chapel
Maglia, Michele, 215
Mahon, Denis, 64
Maidalchini, Donna Olimpia, 239 n.
 (120)

Mancini, Giulio, 238 n. (78)
Mansart, François, 171
Mantegna, Andrea, 62
Marcus Aurelius, 209
Marcus Curtius (Girardon), 182, 212
Mari, Giovan Antonio, 123; pl. 66
Mariani, Camillo (?), *Fabio de Amicis*, 66, 237 n. (66); pl. 30
Marino, Giambattista, 235 n. (50)
Marlowe, Christopher, 244 n. (217)
martyrdoms, *see* under names of saints
Mastro Pasquino, 238 n. (78)
Matilda, countess of Tuscany, *see* St Peter's
Mattia de'Rossi, 168, 181
Mazarin, cardinal, 115
Mazzuoli, Giuseppe, 215
Medici, Duke Ferdinando de', 168
Meudon, 171
Michelangelo, 20, 25, 29, 45, 61–2, 86, 151, 155, 176, 228–9, 233 n. (19), 238 n. (84)
 David, 56; pl. 25
 Last Judgement, 63
 Medici tombs, 105
 Pietà, Florence cathedral, 29
 Pietà, St Peter's, 29
 Risen Christ, 34
 Slave, 86; pl. 43
 Tomb of Julius II, 239 n. (105)
Mochi, Francesco, 84, 236–7 n. (62)
 Annunciation, 236 n. (62)
 St Veronica, 84; pl. 42
Montalto, Cardinal Alessandro, 39
 see also Sixtus V
Montoya, Monsignor Pedro de Foix, 66
 tomb, 64–7, 89, 96, 126, 218, 237 n. (64); pl. 29
Moro fountain, 123–4, 206; pl. 66

Naples, 23

Neptune and Triton, 39–40, 45, 48, 55, 57, 87, 112, 235 n. (39); pls. 12–15
Neri, St Philip, 136
 Oratory of, 136
New York, Pierpont Morgan Library, 93
Nicephorus, 209

obelisks, 120, 156, 213
Odescalchi, Benedetto, *see* Innocent XI
 palace, *see* Palazzo Chigi-Odescalchi
Olimpia, Donna, 239 n. (120)
opera, 19, 136
Oratorians, 115, 136
oratorio, 136
Oratorio di S. Marcello, 237 n. (71)
Oratorio di S. Filippo Neri, 136
Orsini, Paolo Giordano, 96, 99
 bust, pl. 50
Orvieto, cathedral, *Annunciation* by Mochi, 236 n. (62)
Ovid, 48, 87, 110, 235 n. (39, 50)

Palastrina, sanctuary, 155
Palazzo Bernini, 39, 115
 Braschi, 238 n. (78)
 della Cancelleria, 227
 Chigi-Odescalchi, 142, 180–1; pl. 90
 Farnese, *see* Farnese gallery
 Montecitorio, 142
 Pamphilj, 118
 Quirinale, 23
 di Spagna, *see* Anima Dannata
 Vaticano *see* Vatican
Palladio, Andrea, 155, 181
Paluzzi, *see* Albertoni
Pamphilj, Cardinal Camillo, 144
 heraldry, 120; *see also* Innocent X
Pantheon, 78, 148
paragone, 175

Paris, French Academy of Art, 173–5, 191, 244 n. (202)
Louvre, 168, 178, 180; façade projects, 142, 178–82; pls. 88–9
Tuileries palace, 171
Val-de-Grâce, 171
Pasce oves meas, 162; pl. 102
Pasquinade, 78, 238 n. (78)
Passeri, *Lives*, 115
Paul III, tomb, *see* St Peter's
Paul V Borghese, 23, 25, 30, 42, 182, 237 n. (71)
bust, 30–1, 126; pl. 1
Paul, saint, 107, 234 n. (34)
Peretti, Cardinal Alessandro, 39
Persephone, see Pluto and Persephone
Peter, saint, 160
grave, 75, 159–60
Piazza Barberini, 110, 114; pls. 60–1
Colonna, 239 n. (120)
Navona, 118, 120–4, 238 n. (78); pls. 63–6
di Spagna, 115, 239 n. (110)
Pietro da Cortona, 20, 75, 168, 182
Pluto and Persephone, 45–8, 53, 55, 57, 60–1, 63–4, 87; pls. 16, 18–19
Polyphemus (Carracci), pl. 28
Ponte S. Angelo, 198, 204–6; pls. 104, 109–10
Porta, Giacomo della, 123
Porta, Guglielmo della, 105, 239 n. (105); *see also* St Peter's, Tomb of Paul III
portrait busts, *see Amicis, Baker, Barberini, Bellarmine, Bonarelli, Borghese, Charles I, Fonseca, Francesco I d'Este, Gregory XV, Innocent X, Louis XIV, Montoya, Orsini, Paul V, Santori, Urban VIII*

Poussin, Claude, 121
Poussin, Nicolas, 20, 114, 171–5, 182
Praxiteles, 27

Quignone tomb, 207; pl. 112
Quirinal hill, 144
palace, 23
Quos Ego, 39

Raggi, Antonio, 228, 245 n. (227)
Angel with the Column, 205–6; pl. 110
Danube, 121
St Andrew, 147; pl. 77
Raggi, Maria, tomb, *see* S. M. sopra Minerva
Raimondi, Marcantonio, 235 n. (39)
Raimondi chapel, 239–40 n. (128)
Rainaldi, Carlo, 168, 228
Rape of Persephone, see Pluto and Persephone
Raphael, 25, 62, 172–4
Chigi chapel, 187, 243 n. (187)
Fire in the Borgo, 34; pl. 9
Rembrandt, 20, 130, 185, 213
Reni, Guido, 20, 53, 62, 75, 114, 173
Annunciation, 171, 217
Massacre of the Innocents, pl. 35
Rinuccini, *Dafne*, 235 n. (50)
Rome, *see* under individual monuments
Academy of St Luke, 42
French Academy, 182
Rospigliosi, Giulio, *see* Clement IX
Rossi, Mattia de', 168, 181
Rubens, Peter Paul, 20, 88, 107, 173–4

Sacchi, Andrea, 172

S. Agnese fuori le mura, ciborium, pl. 37

S. Agnese in piazza Navona, 118–20, 122

S. Agostino, Pio chapel, 240 n. (134)

S. Anastasia (Aprile), 227, 245 n. (227); pl. 127

S. Andrea delle Fratte, Angels, 198–206, 243–4 n. (202); pls. 105–8

S. Andrea al Quirinale, 144–8, 178, 242 n. (148), Fig. 3 (144); pls. 76–7

S. Andrea della Valle, Barberini chapel, 68

S. Bibiana, façade, 71–4, 237 n. (71); pl. 32
 statue, 71–5, 83, 87, 191, 227, 240 n. (128); pls. 33–4
 frescoes, 75

S. Calisto in Trastevere, 237 n. (71)

S. Cecilia (Maderno), 227, 245 n. (227); pl. 126

S. Croce in Gerusalemme, tomb of Cardinal Quignone, 207; pl. 112

S. Francesca Romana, 237 n. (71)

S. Francesco a Ripa, Altieri chapel and Death of the Blessed Ludovica Albertoni, 220–7, 244–5 n. (220), 245 n. (227); pls. 121–4

St Helena with the True Cross (Bolgi), 80, 84–5; pls. 36, 38

St Lawrence, Martyrdom, 29; pl. 3

St Longinus, 80–8, 105, 130, 140, 191, 238 n. (84); pls. 38–41

S. Lorenzo in Lucina, Fonseca chapel and tomb, 215, 217–18, 220, 225, 244 n. (217); pls. 119–20

S. Marcello, oratory, 237 n. (71)

S. Maria Maggiore, Sistine chapel, tabernacle, 244 n. (207)

Pauline chapel, 23, 105

S. Maria sopra Minerva, Fabio de Amicis (Mariani), 30, 66, 237 n. (66); pl. 30
 Risen Christ (Michelangelo), 34
 Tomb of Maria Raggi, 109–10, 128; pls. 58–9

S. Maria di Monserrato, Monastery, 64

S. Maria del Popolo, Chigi chapel and Daniel, Elijah, Habakkuk, and Jonah, 185–91, 195, 243 n. (187); pls. 93–5, 97–9

S. Maria della Vittoria, Cornaro chapel and Ecstasy of St Teresa, 128–41, 220–22, 227, 239 n. (128), 240 n. (134), 241 n. (137), Fig. 2 (134); pls. 69–72, 74, 125

St Peter's, 23, 75, 78, 80, 159, 166, 206, 209
 apse, 162
 Architect of, 75, 116–18, 151
 baldacchino, 75–80, 89, 162, 206, 237–8 n. (78); pls. 36, 38
 benediction loggia, 68, 152, 237 n. (71)
 campanili, 116–18, 122, 155, 185
 cappella del SS. Sacramento, 206–9, 227, 244 n. (207); pls. 111, 113
 cathedra petri, 151, 159–63, 198, 203–4, 206, 215, 242 n. (159); pls. 83–4, 102–3
 crossing, 80–85, 105, 206; pls. 36, 38
 dome, 149
 Early Christian columns, 78, 80
 façade, 116–18, 155, 163, 166–7, 209; pls. 80–81
 nave decorations, 118, 206
 piazza, 112, 151–9, 162–3, 166, 206, 242 n. (142, 159); pls. 80–82

St Peter's (*cont.*)
Pietà (Michelangelo), 29
Tomb of Alexander VII, 215–17;
pls. 75, 118
Tomb of Leo XI, 107–9; pl. 57
Tomb of Matilda of Tuscany,
101, 130, 239 n. (128); pl. 52
Tomb of Paul III, 105–7, 159,
162, 239 n. (105); pl. 56
Tomb of Urban VIII, 105–9,
159, 162, 215–17; pl. 55
S. Pietro in Montorio, Raimondi
chapel, 239–40 n. (128)
S. Prassede, Tomb of Santoni,
29–30, 60, 64, 66, 126, 218;
pl. 5
St Sebastian, Martyrdom, 29, 34;
pl. 4
St Veronica (Mochi), 80, 84; pl. 42
Salvator Mundi, 227
Sandrart, Joachim von, 82
Sansovino, Jacopo, 207
relief, pl. 112
Santoni, Giovan Battista, 30, 234 n.
(29); *see also* S. Prassede
Self-Portraits, frontispiece; pl. 91
Seneca, 27, 36
Siena, cathedral, Chigi chapel,
Jerome and *Magdalen*, 191–5,
198, 203–4; pls. 100–1
Sistine chapel, *see* S. M. Maggiore
and Vatican
Sixtus V Peretti Montalto, 30, 39,
156
Spiritual Exercises, *see* Ignatius
Stone, Nicholas, 98

tabernacle, *see* St Peter's, cappella
del SS. Sacramento
Teresa, saint, 135–41, 270 n. (137)
Testi, Fulvio, 93
Tezio, Caterina, 114–15
theatre, 19, 135–6, 171

Thomas à Kempis, *Imitation of
Christ*, 168
throne of St Peter, *see* St Peter's,
cathedra
Titian, 62, 173
tombs, *see* S. *Anastasia*, S. Cecilia,
S. Croce in Gerusalemme,
S. Francesco a Ripa, S.
Lorenzo in Lucina, S. Maria
Maggiore, S. M. sopra Min-
erva, S. M. di Monserrato, S.
M. della Vittoria, St Peter's,
S. Prassede
Torso Belvedere, 238 n. (78)
Treaty of Westphalia, 116
Triton fountain, 110–14, 123–4,
128, 239 n. (110); pls. 60–1
Truth Revealed by Time, 185, 191;
pl. 92
Turriani, Niccolò, 237 n. (64)
Turriani, Orazio, 237 n. (71)

Urban VIII Barberini, 25, 29, 54,
56–7, 66–7, 68–71, 75, 79, 89,
97–8, 101, 105, 112–16, 128,
142, 151, 183, 198, 236 n. (50)
bust, 105; pl. 31
tomb, *see* St Peter's

Van Dyck, Anthony, *Triple portrait
of Charles I*, 97
Vatican, *see also* St Peter's
166, 198, 206, 209
palace, 152, 156, 163; pl. 82
Pauline chapel, 136, 163, 240 n.
(136)
Scala Regia and *Constantine*,
163–6, 209–12, Fig. 5 (163);
pls. 85–6, 114
Sistine chapel, 68, 163
Stanze, *Fire in the Borgo*
(Raphael), 34; pl. 9
Velázquez, 20, 71
Venus and Cupid (Praxiteles), 27

Vergil, 26, *see also Aeneid*
Versailles, 178
 Marcus Curtius, 182
 see also Louis XIV
Vignola, Giacomo Barozzi da, 181
Villa Borghese, 45, 94, 96, Fig. 1
 (54), *see also Aeneas, Apollo,*

Borghese (Scipione, bust),
 David, Pluto, Self-Portrait
Villa Montalto, pond, 39; pl. 14

Warrior, 27, 61
Willey, Basil, 19
Wittkower, Rudolf, 36, 150, 209